GRANTA

12 Addison Avenue, London W I I 4QR | email: editorial@granta.com
To subscribe visit subscribe.granta.com, or call +44 (0)1371 851873

ISSUE 165: AUTUMN 2023

p.69 'mutilation with a goal' by Elfriede Czurda is part of the author's first published book *ein griff - eingriff inbegriffen*, Berlin, 1987; p.233 'Where the Dragons Live' by Clemens Meyer, copyright © 2021 by Faber & Faber Verlag GmbH, Leipzig; p.257 'Model Country' by Shida Bazyar is an extract from her debut novel *Nachts ist es leise in Teheran*

MIX
Paper | Supporting
responsible forestry
FSC® C023419

The KENYON REVIEW

PATRICIA GRODD POETRY PRIZE FOR YOUNG WRITERS
SUBMISSIONS OPEN NOVEMBER 1–30, 2023

POETRY CONTEST
SUBMISSIONS OPEN NOVEMBER 1–30, 2023

SHORT NONFICTION CONTEST
SUBMISSIONS OPEN DECEMBER 1–31, 2023

SHORT FICTION CONTEST
SUBMISSIONS OPEN JANUARY 1–31, 2024

All adult contest winners receive publication in the print edition of *The Kenyon Review* and full scholarships to attend the 2024 Kenyon Review Writers Workshops, and all runners-up receive publication on our website.

The winner of the Patricia Grodd Poetry Prize for Young Writers receives a full scholarship to the 2024 Kenyon Review Young Writers Workshop. The winner and two runners-up will have their selected poems published in the print edition of *The Kenyon Review.*

CONTENTS

Ich weiß aus Träumen, daß wir alle mehr erleben könnten. Es ist ja eine Schande, wie wenig wir erleben. Der Alltag ist schändlich leblos.

– Peter Handke, *Der Spiegel*, 15 April 1990

Introduction

1

The *Granta* office in Berlin is located in the district of Friedenau. It's a neighborhood of shuttered vinyl record shops and thriving funeral parlors that few visit, and fewer seem to leave. In the 1970s and 1980s, Friedenau became home to a concentration of West German writers, several of whom would make significant contributions to *Granta*: Hans Magnus Enzensberger, Günter Grass, Herta Müller. Today, on Niedstraße, in Enzensberger's old building, piano lessons are offered on the ground floor; in Grass's stout brick house next door, his widow runs an Airbnb (€145 a night). The residue of the Cold War is thick on the ground. A plaque commemorates the spot where two American pilots crashed into a building during the Berlin Airlift. The discotheque frequented by US soldiers that Gaddafi bombed in 1986 – Reagan duly bombed Tripoli and Benghazi in return – is now an organic supermarket. These days, the Americans you see high-fiving in the playgrounds tend to be leisure migrants, who have come to work less and for more affordable child care. Literary culture in Berlin has moved elsewhere – to Neukölln, to Wedding, to Lichtenberg, though it no longer has much of a reliable address.

In the early mornings in Friedenau, old, hard delivery men, sometimes barefoot, push trundle carts carrying newspapers the size and quality of which still shame the rest of Europe, while the local bookstore, Der Zauberberg, exudes an air of almost pharmaceutical seriousness. Such vital signs might seem like evidence that literary culture in Germany, if not in rude health, still holds its own. Not so. Here is an unspoken scandal: the most economically important country on the continent suffers from both a lack of literary ambition and exposure. Everybody knows the inheritors of the language of Kafka, Brecht and Mann are less widely read today than they have been in decades. One of the enduring mysteries about post-war German writing is why so much of its heavy lifting happened outside of Germany – in Austria, Switzerland, Romania. The last German writer to make a major international breakthrough was WG Sebald,

who grew up twenty miles from the Austrian border, lived most of his life in England, and considered himself a student of Peter Handke.

The national reunification of Germany in 1990 did not do the same wonders for literature as it did for the art world. In the years that followed, writers began easing themselves into Anglo-American forms: the road novel, the well-researched historical novel (about primmer periods of the German past), the 'state of the nation' novel. Much was made at the time of the pursuit of the elusive *Wenderoman* – the 'fall-of-the-wall' novel – though its early masters, Monika Maron and Uwe Tellkamp, were, inconveniently, soon-to-be partisans of the New Right (something only now being countered by the appearance of *Wenderomane* by Lutz Seiler, Jenny Erpenbeck and Felix Stephan). The literary pioneers of the 1990s were interlopers with migration backgrounds, for whom the German language was not taken for granted. Few of these could keep pace with Emine Sevgi Özdamar, whose early books broke ground that has since been more routinely tilled. Reams of 'memoir'-styled novels appear every year. They resemble magazine articles stretched to book length, as if only to satisfy the rules of literary marketing and get their authors on the trail of festivals and readings, which in Germany pay better than writing.

Cinema was the primary zone of avant-garde operations in post-war Germany. Led by the daemonic Rainer Werner Fassbinder, the fury of its finest production was fed not by the fact that the country was still fascist, but rather that it could be so smug about its economic miracle without so much as a glance backward at the ruins and carnage (see Owen Hatherley's 'Wild and Tattered Kingdom', *LRB*, 29 June). Fassbinder and his fellow auteurs worshipped American popular art, but they were savage about the seepage of American power on the continent. Where Fassbinder was subtle – capturing in the cheap interiors, the plastic tablecloths, of his dramas the mimicry-ridden culture of post-war Germany – his contemporaries went for the jugular. Recall the plot of Werner Herzog's *Stroszek* (1977), in which a West Berlin couple, Stroszek and Eva, visciously persecuted by a gang of pimps, resolve to move to Plainview, Wisconsin – the promised land – where farmers joust with shotguns on tractors, and Eva has sex with truckers to pay an impossible mortgage on their mobile

home that, no sooner is it delivered on a flatbed truck, gets wheeled away by the same lanky affable young banker who sold it to them. 'Nobody kicks you here. No, not physically,' Stroszek reflects. 'Here they do it spiritually . . . they do it ever so politely, and with a smile.'

As it was with cinema, so post-war German literature was most potent when it was oppositional, when its targets were the rottenness of the US-aligned Federal Republic in the West and the rottenness of the Soviet-aligned Democratic Republic in the East, when, in other words, it conceived of itself as an anti-colonial force. In East Germany, many of the leading writers – Uwe Johnson, Wolfgang Hilbig, Brigitte Reimann – still looked with tenderness at the ideals of their state, and took its perversions as one of their subjects. In West Germany, the most seismic art was made by those – Gerhard Richter, Jörg Immendorff, Alexander Kluge – who saw the US less as the liberator from the Nazis than as the enabler of the thousands of former Nazis still in power. The summit of West German literature was an interregnum in the late 1970s, between stringent high modernism and consumerist postmodernism. It was more self-consciously stylish than Heinrich Böll, more polished than the radical counterculture experiment of 1968, but also more intense, more serious, and not yet too ironic. The moment faded out in the early 1980s with Otto Waalkes's first film and Modern Talking's first Top 10 single.

The novelist Daniel Kehlmann once remarked that German literature originated in the parsonage, and has always been trying to get back there. Historically, it has been preoccupied by the trials of the individual conscience. Austria, by contrast, has the paradoxical status of being both peripheral (to German power) but also a former core (of the Hapsburg empire). With the memory of its imperial past and court culture, Austria has nourished irony, subterfuge, wordplay, and other elements of fictional artifice. Its leading post-war figures – Ingeborg Bachmann, Thomas Bernhard, Peter Handke, Marlen Haushofer, Elfriede Jelinek – never felt themselves cut off from their modernist precursors (Kafka, Musil, Doderer, Broch) in the way Germans did. When Böll began publishing novels after the war, it was as if modernism had never happened. Austrian writers who came of age in the 1960s had the advantage of sharpening themselves against

a more retrograde society than their peers in northern West Germany, where all was permitted. They still had enough tradition in themselves to hate it properly. You needed stronger legs to scale the steep walls of hidebound post-war Austria, where, as Bernhard noted in his autobiography, the 'brainless scepter of Catholicism' had swept the land, and where the new crucifixes on the walls barely covered the 'conspicuous white patches' where portraits of Hitler had hung.

But there may be another, deeper reason for the sheer *Wucht* and pressure of Austrian prose that you can feel right down to writers like Josef Winkler, and to the younger generation, from Mareike Fallwickl to Teresa Präauer. Put simply, Austrian culture is on closer terms with death, the great authority, the great editor and punctuator, that makes lives tellable. When Handke's mother dies in *A Sorrow Beyond Dreams* (1972), the assembled mourners sip wine and look carefully at the corpse in the cold bedroom. When I passed through the small town of Engelhartszell in Upper Austria this summer, I found skeletons neatly displayed in glass cases along the pews of the local church, bedecked in Mardi Gras-style plastic jewelry. Across Europe, as Walter Benjamin observed, there was once scarcely an interior where no one had died. It took Ingeborg Bachmann, author of the *Death Styles* trilogy, to register the chill of first hearing the term *Livingroom* pop up in Austrian conversation.

Young writers in Germany today enter a literary system designed to keep them provincial. The country has a large enough internal market, enough funding, enough posts for *Stadtschreiber* and places in its two creative writing factories (in Hildesheim and Leipzig) to keep a sizable number of writers steadily afloat, turning out fellowship prose and countless worthy offerings. The European Union has become so naturalized in their minds that one has to look elsewhere – to Hjorth in Norway, to Houellebecq in France – for fiction that flies in the face of Brussels. With nothing like the Anglo critical press, novels sail through the culture without much engagement beyond wan stamps of approval in the books pages of the major dailies. Many of the most talented German writers burn themselves out writing 1,000-word articles for the feuilletons, or clickbait for digital outlets.

It would be tempting to say that much of the best German writing

is untranslatable, that there's no way, without a cumbersome footnote, to convey the piquancy of a writer like Rainald Goetz, who has his character Johann Holtrop go to the bathroom in a *Barschelstimmung*. But in fact we may be living in a golden age of German translators into English. The demandingness of its syntax, the sensitivty of its shades of meaning, the tolerance of ambiguity are what often makes German so capacious as a language, and come off with such splendor in the hands of an adept translator.

Yet just as a kind of inward satisfaction is a risk among the German writers who become too comfortable with domestic publishing, there's an opposite risk for those who tailor themselves too much to Anglo-American appetites, or pare down their prose to make it more palatable in translation, another sleek product for the *Weltmarkt*.

2

Earlier this year the German state embarked on an unfortunate literary genre. It produced a National Security Strategy document modeled on the White House's annual briefing about America's security agenda. Amid standard-issue bullet points about building a stronger Europe, the paper read like a brochure advertising Berlin's renewed loyalty to Washington. Only half a decade ago, Chancellor Angela Merkel announced that Germany could no longer rely on its American partner. 'We Europeans really have to take our fates in our own hands,' she declared. The Russian invasion of Ukraine has put an end to such magical thinking: no major politician in the land outside of Sahra Wagenknecht speaks like that anymore.

The illusory autonomy of post-1990 German culture, as well as its opportunistic self-sufficiency, used to be reflected in Germany's place in the world, where it got along well disciplining states in southern Europe, exporting cars to China, buying cheap Russian fuel, and conducting a global seminar on human rights. In April, Merkel's successor, Chancellor Olaf Scholz, announced a *Zeitenwende* – a turning of the times – which meant Germany would no longer make any pretense about its own autonomy within the US-led alliance. Instead it would finally pay up its NATO obligation of 2 percent of

the annual budget, and send heavy weaponry to Ukraine. For the German Social Democrats, who once took pride in their party's robust relations with Moscow, this was a pointed reversal. Even if the amount of actual weaponry Germany sends is paltry compared to the US outlay, even if German rearmament is not terribly real, there is little doubt that the dreams of a European-led future have gone up in smoke. As Jürgen Habermas told *Granta* for this issue: 'I no longer believe that the EU will play a globally influential role.'

But if the Russian invasion of Ukraine has ended some dreams, it has advanced others. For the German Greens, the sudden cut-off from Russian energy was a thrilling moment of asphyxiation: the chance to build a post-fossil future. For the first time, a major, wealthy Western public became not merely interested, but self-interested, in renewable energy schemes that would have seemed utopian just months before. The Greens, who found they looked dashing in military helmets, could now harness national security into their arguments. However briefly and hesitantly, the other parties in the ruling coalition – the Social Democrats (SPD) and the Liberals (FDP) – had to acknowledge that the Greens were the only ones with ideas about the future.

Robert Habeck, one of the leaders of the German Greens, defies the country's moratorium on charisma. When I saw him speak in Berlin this summer, he was determined not to let the moment slip from the Greens' grasp. Listening to Habeck – the author of a dissertation titled *The Nature of Literature: On the Genre-Theoretical Foundation of Literary Aestheticity* – was like watching an excited man about to leap from a cliff in a hang glider, only the lift to Habeck's sails was the prospect of running Germany off renewable hydrogen. If the public failed to follow, the answer was not to meet the people where they were, but to build the new consciousness of where they could be.

As I moved among the Greens at the gathering, the younger Greens seemed more mundane. One giddy man was celebrating the party's success in nearing a deal with a Silicon Valley firm that would rationalize rail-ticket buying across Europe, and save customers of Deutsche Bahn the arduous journey to the Deutsche Bahn website. It was hard to distinguish these Greens from their more avowedly pro-business FDP peers. But this was the needle that Habeck was

threading: the effects of capitalism on the environment could only be counteracted by capital itself. How far one was from the Greens of yesteryear, who furiously knitted sweaters, decried the consumer society of the Cold War, and writhed on the floor at their founding party conference in 1982. The image of Joseph Beuys taking to the microphones, and the iron demands of Petra Kelly, whose stand against nuclear power included her sister's chemotherapy, was distant history.

Whatever their electoral fortunes, the German Greens are today the vanguard party of Western elite consciousness. They are the party that Ivy League professors, Silicon Valley mavens, Wall Street progressives, and British liberals would vote for if they could. The irony that the Greens' rejection of nuclear power was what made Germany so reliant on Russian fuel in the first place is not one on which they care to linger. In the Ukraine war, Germany, after some wavering, has begun to follow US instructions to the letter, and put its weight into the conflict, with no small thanks to the Greens' efforts. But a reckoning may come should Washington pressure Germany to decouple from its fourth-largest export market, China. For that severing, the Greens will face tougher domestic opposition. As Covid subsided, the first foreign leader to visit Beijing was Olaf Scholz.

Germany's contemporary political landscape has been marked most by the Greens, but the larger story may be the implosion of the SPD and the rightward shift of the Christian Democrats (CDU). Each of the three largest parties polls poorly with a public increasingly attracted to hard-right solutioneering. Each of them is a shell for a down-at-the-heel ideology. The CDU has displayed a newfound willingness to coordinate with the Alternative for Germany (AfD) for votes in regional parliaments, and to use the AfD's hate-sowing tactics to garner electoral support. The party's jet-setting leader, Friedrich Merz, is a BlackRock veteran, not a beer-swilling nativist in a Tracht jacket – he just plays one on television. The core of a conservative reaction is as hollow and unfelt as the SPD's commitment to workers or the Greens' to the environment.

In the post-Merkel *Zeit*, Germany is in a more precarious position. Having played by the rules of the US-led order, in which competition

was the driving principle that gave Merkel grounds to pursue the cheapest energy her administration could secure, Germany has now entered a world where the rules of the game have changed. The country that tethered itself most tightly to the world market is poised to lose some of its reputation for stability, though how that will affect its culture is another question.

<div align="center">3</div>

This issue of *Granta* collects writing headed full tilt in the opposite direction from the literary lassitude of the land. Leif Randt follows the consciousness of Merkel-era young professionals with a lunar-like stillness. Judith Hermann wanders outside the lines of Anglo autofiction, while Shida Bazyar inverts the story of migrant alienation. And Clemens Meyer inhabits the passion of youth in a story centered around a budding tourist trade in neo-Nazi memorials.

Lauren Oyler dwells in the projective space of generations of Anglos who have come to Germany with an idea of culture in their heads, only to realise that it had reached them like the light of a distant star that long ago collapsed. Michael Hofmann, in counterpoint, finds that the Germany to which he never wished to return to has, behind his back, accrued unforeseen virtues.

Jan Wilm details last year's attempted seizure of power by a Frankfurt real-estate developer, while Peter Richter tells the murder story behind Berlin's urban-planning disaster. The perversion of Germany's once-hallowed memory culture is the subject of Adrian Daub's essay, which maps a new territory of forgetting. Our symposium discusses how the German project of reckoning with the past has lately become a bludgeon of the Right to stymie attempts to prevent the return of some of its ugliest features.

Lutz Seiler and Durs Grünbein present eastern memories that the German body politic still has difficulty digesting. The issue also explores resources under the surface, as Fredric Jameson shows in his essay on the thwarted utopian impulses of East German painting.

When *Granta* magazine was re-founded in 1979, the editors wanted to go on the offensive against what they took to be the sedate state of the English novel, and the sterility that had befallen long-form journalism. Today the magazine faces different challenges. Nonfiction writing in the Anglosphere has rarely been healthier. There are newspapers, even British ones, that publish reportage, sometimes on the old *Granta* model, much more frequently than *Granta* itself does. What marks *Granta* out in this more-varied landscape is that the writing it publishes still aspires to the condition of literature. We believe there is a surfeit of moralism in contemporary journalism, and a shortage of accurate reconnaissance about the real political conditions of particular cities, regions, and countries.

And what about fiction? We remain committed to the tradition of realism. As long as people continue to hate reality, and do anything to defend themselves against it, realism will not have exhausted its possibilities. We believe great literature is political, but not in the sense that is commonly meant: literature is most enduring, not when it is most saturated with political ideals, but exactly when it is not, and because it is not, it is.

Bill Buford mostly got what he wanted when he dreamed of Amis and McEwan occupying the front tables at Waterstones. No one today is looking for the perfect synthesis of American and English writing, nor does the once-hailed global novel seem like much of a starter. But that does not mean *Granta* is not interested in making connections across space and time. Upcoming issues of the magazine will be devoted to the global extraction regime underpinning the Green 'transition', as well as special numbers on China and the subcontinent. We are looking for writing that takes readers to the edge of contemporary consciousness, and which demonstrates maximal control. The reigning principle at *Granta* is that the prose must give pleasure. Pleasure is in command.

I thank Sigrid Rausing for her confidence. ∎

TM

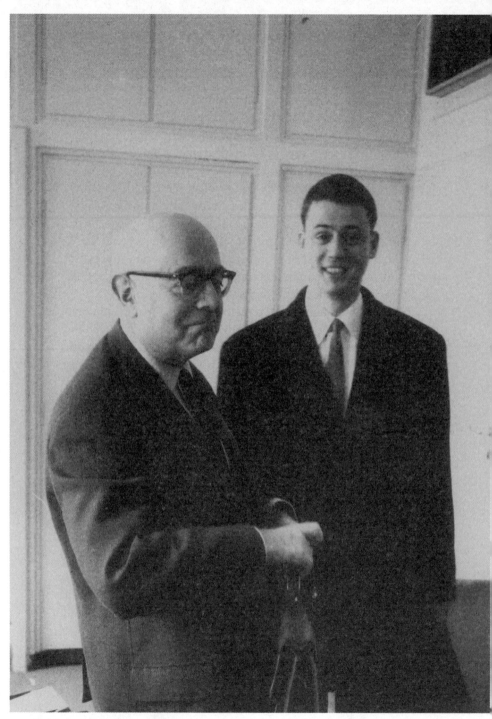

Theodor W. Adorno and Alexander Kluge
Courtesy of the author

TODAY WE JUST SAY GERMANY

Alexander Kluge

TRANSLATED FROM THE GERMAN BY PETER KURAS

Keyword: Germany

Today we just say Germany. It saves intellectual and emotional effort. Like Heiner Müller says, it is better to speak of PEOPLE than of THE PEOPLE.

Germany

I would like to propose a brief filmic experiment, with a nod to Karl Kraus. Imagine this sentence, written on a blackboard:

> The more closely you look at a word, the further back it looks.

Now, concentrate on imagining this sentence. And now, write underneath it, on the imaginary blackboard in your head:

> Germany.

Look at the word 'Germany' for a while. I would now ask that those of you who believe the word has moved further away raise your hand. Who is for further? Who is for closer?

[The majority votes further]

I Was a Translator in Minsk
(*Report from 2015*)

I was a witness to the legendary evening session that led only to a sham peace that was nevertheless a (hole-filled) ceasefire. I noticed the chancellor closely watching the Russian president. It was in the fourth hour of the night. Aside from her, no one else in the room was wide awake. Later, I questioned the chancellor on the plane. She had checked, she said, to see whether, in the sitting posture and the president's facial muscles, she could observe a sudden stiffening, a 'craziness', which would tell her negotiations had failed. She could read the signs; although Putin sought to maintain a poker face, a mask, the movements of the facial muscles are not subject to willpower. Just as experienced foresters in Mecklenburg-Western Pomerania can deduce from the posture and flews of foxes running toward them whether it is an 'accidental attack', a case of rabies or *crazy fox* syndrome. For forester Heinz Ullman, whom the chancellor knew, assumption alone is no reason to shoot an animal. You have to closely examine their muzzle, dentition, saliva secretions, the whites of the eyes and the body. In a figurative sense, the chancellor acted as a forest guardian. To the chancellor, the Russian president seemed to be 'trapped in a communicative cage'. According to what she said on the return flight, she did not think he was making decisions alone. Rather, she opined, his decisions seemed to be formed by someone caught in the middle of a raging group of schoolchildren at recess. Was he reliable? She didn't know but certainly hoped he would turn out to be, on a case-by-case basis.

Steamship Docking at the Federal Chancellery

A few tourists arrive at the Tourist Ship Docking Station: Federal Chancellery. They do not wish to visit the Federal Chancellery. They want to visit the House of World Cultures. On the lawn in front of this building – a protected historical monument – two stands offer a choice of beer with either baked potatoes or bratwurst. On the roof of the building, a band is rehearsing loudly for the evening. The rehearsal serves to mark their territory in the cultural garden.

Visitors to the Federal Chancellery do not disembark from any of the steamers at the dock. From the rear entrance to the chancellery, which faces the steamer docking station, the business of governance is invisible. How would you recognize the business of governance from the front, for example? Nothing reveals it externally. Even inside, visual impressions are not very informative. The business of governance is also nearly inaudible.

A spy who had researched all of the chancellery's operations (though such a feat would be neither physically nor technically simple) would still not know what was happening in the government. To fully understand, he would have to investigate the PRECEDING ACTIONS and their circumstance, then the OBJECTIVE POSSIBILITY, which limits all actions and resolutions. He would have to gain experience of how decisions are made. Maybe he would say: We're dealing with a FEDERAL CHANCELLERY OF HESITATION. The chancellery attempts, among other things, to avoid or delay bad decisions. The structure of the chancellery reflects the work of the individual ministries in the form of functional units. With the help of this structure, the chancellery keeps a braking organ at the ready to reduce the excess of impulses. It is similar to the human brain. It too is only apparently the site of resolutions. In reality, the brain, physiologists tell us, merely contains the stormy desires coming from the body.

The GOVERNING EFFECT of the office is therefore clearest when the chancellor and her chief of staff are gone. Out of 2 billion potentially bad decisions today, 60,000 are prevented simply by the fact that the chancellor and her inner circle were forced to postpone their return from the US because of a cloud of ash over Iceland.

On another day, the chancellor's plane succeeded in making a detour around the lava cloud to the south. She landed in Rome. From there, it took the buses two days to get to Berlin. Of course, the buses, though they were rented, contained communication devices. The Chancellor of the Third Reich would have been forced to stop the train to make a phone call (he never traveled in buses).

It's different today. Still, no one expects the head of the government to make decisions while 'wandering about'. Furthermore, one bus got a flat while passing through South Tyrol. Politically, it was appropriate for the chancellor to wait until the damage had been repaired to avoid splitting the group. It would have created a divide between a 'Group of the Superfluous' and an avant-garde. One too many among the many decisions. The whole group spends the night at a hotel in Bozen. Thanks to a natural occurrence in distant Iceland, a generous provision of six days (between departing from the US and arrival in Berlin) had been granted to the function of the chancellery.

During this time of intensive, high-performance functioning of the office, external observers in orbit heard a shrill, very high-pitched noise, an angel's chorus of crisis-avoiding politics. Late-morning languor led to the band continuing to practice its acoustic scraps until midday. Simply to show they were fulfilling their contract which included scheduled time to practice. They couldn't go to the hotel and just wait and be silent until their performance late in the afternoon. After all, they were being paid for DOING and not OMITTING.

For the Lioness, Homecoming Remains Foreign

A charitable organization dedicated to rewilding colonized animals in their native places returned a trained lioness to the wilds of Togo, a former German colony. (This was after the enactment of a ban on keeping and displaying such animals in circuses.) She was transported in a comfortably appointed cage under veterinary supervision.

Released into the wild, this homecomer was kept under observation by a team of experts. It soon became apparent that the change of location (which was incomprehensible to an animal) had not caused the creature to forget her training. The lioness did not join in with the other lionesses, who begged for scraps from tourists. Instead she often performed jumps when a copse of trees reminded her of the rings she had been trained to jump through. She was often melancholic when her 'art' was not rewarded. Not now, and not later.

A pride of lionesses patrolled the area where she was released, but the lioness did not join them. Who was she? Was she a wild animal? Was she African or European? Had she been 'civilized' by the circus? Did she oscillate between two identities? Of the two of them, the part of her which had been proven to originate on the savannahs and woods of northeastern Togo, from which her ancestors were proven to have come from, constituted the smaller part of her character. She behaved like a foreigner.

She acted strangely. The tourists watching her through binoculars liked it. The team of experts was irritated. So what is emancipation? That's what the reporters who followed the case for the public broadcasters NDR and WDR as well as the *Süddeutsche Zeitung* asked. What does 'rewilding' mean for a creature who still trusted its training, who still mourned the training that had challenged and rewarded it?

For a long time one could see the lioness, who was still young, standing 'thoughtfully', 'somehow passively' under the trees. Hesitantly,

after many long, hungry days, she began to hunt. 'She didn't want to be wild,' claimed the reporter in her Jeep, holding her precision binoculars as she watched patiently. She thought she could see that the rewilded lioness was 'waiting'. She expected a 'task' from her environment. Something that deserved a reward. It was possible, the reporter concluded, that the lioness would have performed without a reward. But where – in the savannah or in the jungles – could she have found an audience? A brief, affirmatory gesture from her trainer, where could she find such a thing in the FIRST NATURE of wilderness? The lioness, as the reporter who came from Bergisch Gladbach put it, was addicted to glory. The lioness soon interpreted a bush as a WHEEL OF FIRE, through which she sprang.

News of the failed emancipation of the animal (you probably also can't simply 'return' works of art, which are like living creatures) could not be printed in the *Süddeutsche Zeitung* or broadcast on NDR or WDR. The reporter had trouble justifying her substantial expenses. She had observed for longer than seemed necessary given the unattractive report.

Diary, Night of 3–4 November 2020. Wednesday Morning. Four o'clock.

My wife and I are in front of the television. It's rare for us to get up at four in the morning and sit in front of the television. We're watching CNN. My daughter uses her iPhone to transmit news from the individual US states, from regional coverage and from the web. A surfeit of news makes for an indecisive picture. It's possible that President Trump will prevail for another term. We go back to bed. At seven, we take another look at the data through our TV window. Never in my life have I felt as politically incapacitated as now. We citizens of the Federal Republic do not take part in the elections of the superpower. Neither the German chancellor nor other instances

of the EUROPEAN PUBLIC SPHERE – just like those in Africa and other continents – have much influence on the decision upon which war and peace depend, at least in the distant future.

The almost insoluble problem consists in letting neither the power of others nor our own impotence render us dumb.

Almost insoluble. Which means soluble. Adorno's sentence, in which I believe deeply (irreducible through facts), is nevertheless difficult to apply at the moment. It can only be true through the most difficult imaginative work. Would it make sense for me, my relatives, my companions, the people I work with – my crew, if you will – to go to work for a public opinion influencing foundation in Washington, so as to have an influence there even without being registered to vote? What's to be done? At the same time, we would have to split our efforts: some of us would have to appear before Chinese students, while the rest worked in the USA. I don't believe that anyone would want our services in either place. Hard work (for the balance of the world) in Switzerland, in Davos? Or at the Munich Security Conference? Or at a conference in Africa? I only know one thing: there will be something (we have yet to discover, it must be sought urgently), which will shore up faith in and provide evidence for Adorno's sentence.

Keyword: *Bildung* (*Eruditio*)

*B*ildung = *eruditio*. To craft something from raw wood (Latin: *rudis* = raw).

Educatio = to lead someone out of the wild woods. Orientation. Knowing the paths, for children but also for adults. Getting to know the pathways, animal crossings and finally the streets that pass through the woods. The danger of BILDUNG: that the forest would be

devastated by designated routes. But untraversed forests don't belong to humans. There must be a balance between the destruction of the forests and the impenetrability of the wilds. With cathedral schools, we enticed the raw minds of the Saxons. We protected *Bildung* from the parries of local potentates. We distilled it into books, into pathways, into the habits of the educators. We, the philologists, the *Bildungskünstler*, the caretakers of LANGUAGE, the only humane form of dominion over people, our CONSTITUTION, which lodges and works before and in the midst of all given works of law. *Eruditio*: a grammar of magnanimity.

He Is Full of Worry

On the day after his birthday, I call Jürgen Habermas. He is outraged about the delayed response from the European Central Bank, which has admitted that a fiasco portended during the crisis from 7 to 9 May 2010. It threatened to be more severe than the scenario that arose after the fall of Lehman Brothers in 2008. The public should have been told! How could the political have a chance if such information remains hidden from people, at the time when major decisions are made, partially on the telephone, partially in a great haste over the course of three sessions over a weekend. Habermas spent his birthday in Dublin. Now the family is planning on spending their vacation in the south of France. He is full of worry. The thin veneer of civilization beneath which the terrible course of reality is charted resembles an ice sheet growing ever more transparent. A philosopher will reflect on the world from any place.

End of Life

At the age of ninety-one, a young-at-heart Russian born in the year 1929, who lost both of his parents in 1937, stayed at the Brandenburger Hof Hotel in Berlin. He went for a late-night walk through the streets of the Scheunenviertel, which he had last seen as a soldier in 1945. The sidewalks, irregular because of the war, were still as desolate as they had been back then, but with fresh grass sprouting up between the cobblestones. Now the entire area was surrounded by new buildings, buildings with which he could no longer form a connection.

How Does One Tell a Story About Closeness?

It snows all night and all day. The branches of the trees are covered with a forearm-thick layer of snow. My daughter hesitates to leave Munich and drive back to Berlin in this weather. We talk about the book she wants to write. She gets angry whenever my suggestions remind her of the ideas I have in mind for my own work. I concentrate on putting myself in her shoes and only giving *her* ideas narrative advice. We walk through the park seven times, taking detours.

I suggest she write love stories, observations about the state of relationships. Such love stories could cover three successive generations, following three women from the same family, even if they are staggered in their relationship, i.e. cousin, aunt, grandmother, mother or daughter. I notice in the first sentences that the words don't fit the closer observation of relationships or family relationships that well. Where it would be interesting to bring together many distinctions, they use a metaphorical, proverbial, even schematic word

that only evokes a general idea. To avoid this the words would first have to wage war with one another a while, to reforge one another. There needs to be a kind of friction between them to allow for distinctions to bubble up. What interests me is how the rules people follow to either approach or separate from one another, that is, enter and exit the realm of intimacy, and thus the course of love stories over three or four generations, over the period from about 1914 to 2021, have fundamentally changed. I see cycles: a bond in 2021. It casts its shadows back to 1942. The two of us, my daughter and I, know the case. Our sentences become shorter and more rapid as we exchange observations. 'One word leads to another.'

In 2043, the education of a child born this very week will have lasted twenty years. The child, a corona child, will be looking at an alien world in 2043. This leads us to the conclusion – the paths of the park form figures of eight and can easily be covered several times – that a characteristic century like that from 1815 to 1945 contains different love stories than the time thereafter, as the canon of getting to know each other and the canon of separation through divorce or death are strikingly different from a story taking place between 1945 and 1989. Then another push: noticeably different pop lyrics, hit songs and stories in the period from 1989 to 2043. I won't be there at the end. My daughter is grappling with the fact that the cycles we're talking about are of such different lengths:

130 years – 44 years – 54 years.

What I mean, I say, is that the sequence of 'centuries of intimacy', that is, of love stories, is accelerating. I think that the cycles of economics and politics are accelerating even more. Where are the resting points? Where are the lagoons in the 'waters of love'? Where is there something flowing at a speed that suits us humans? My daughter waves away the words 'the cycles of politics and economics'. She is interested in observing relationships. We come to the key term 'semantic fields'. To talk about them nowadays we don't need a new

grammar, but countless new ways of paraphrasing. Not because love is becoming more complicated, but because the distance between the LEVEL OF TELLING STORIES and the MASSES OF FACTS OF OUR TIME is widening enormously. ■

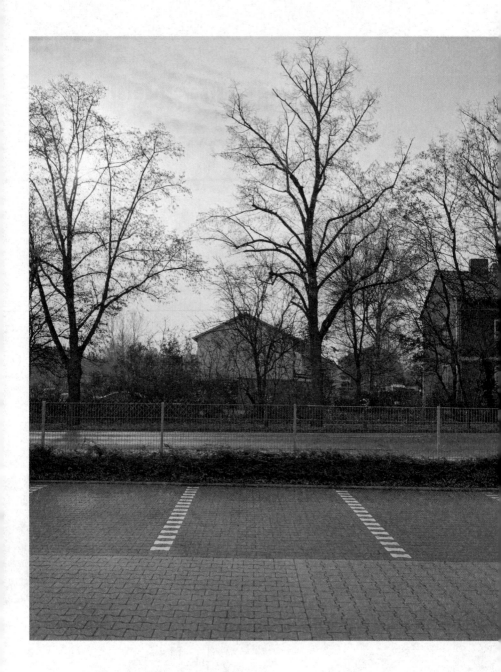

EVA LEITOLF
Parkplatz, Helmstedt, 2007
From *Deutsche Bilder – Eine Spurensuche* (*German Images – Looking for Evidence*)

AUTO MIND

Adrian Daub

It was one of the more ingenious disappearing acts in a city famous for them. Rudolf Heß, at one time Adolf Hitler's second-in-command, was Berlin-Spandau's last remaining inmate when he died in the prison set aside for major Nazi offenders in 1987. To prevent the place from becoming a commemoration site for neo-Nazis, the Allies decided to tear down the old structure and replace it with a shopping mall for British servicemen. Today, the area appears to be a Kaufland supermarket. Or more accurately: most of the area was never a shopping structure nor a Kaufland supermarket. The most efficient way to erase the past, to prevent neo-Nazi pilgrimages, to turn an erstwhile prison complex into non-geography was and remains: a parking lot.

Parking lots are an architecture of use and they are an architecture of amnesia. They are, perhaps in Germany more clearly than elsewhere, about amnesia through use. The walls of the Spandau prison were ground down and scattered in the Baltic Sea, as if they were literally contaminated. The site itself, by contrast, was filled with quotidian substance: shopping carts, sad patches of grass and minivans backing into too-small spots. Every visitor to Berlin will have come across the *Stolpersteine* – little brass plaques put into the sidewalk to memorialize Jews murdered by the Nazis. The

Stolpersteine – 'tripping stones' – are meant to arrest you in your everyday routines, if only for a moment, to force memory from thoughtlessness. The paving stones of a parking lot are their opposite: smoothing stones, handmaidens of thoughtlessness.

The photographer Eva Leitolf spent twenty years assembling the series *Deutsche Bilder* (*German Images*): photos of places where racist attacks – arson, assaults, murders – have occurred. There is one picture in the set that reminds me of the Kaufland in Spandau. A four-lane road, two houses and three parking spots. The street itself is in Helmstedt, Lower Saxony, but the image feels like it could have been taken anywhere.

The attack that happened here in 2007 – a Turkish-German man was smashed against the fence and threatened with death – is so ordinary that news reports about it are almost impossible to find today. As is the setting: the road with the leafless trees on the other side; the pretty two-story houses that suggest an urban planning rationale long since abandoned or forgotten; the metal fence that seems to be the preordained perimeter of suburban supermarkets across Germany. And the three tiled parking spaces, separated by lines of white tiles: I've always found them deeply oppressive, perhaps because they're not – as in Californian parking lots with their washed-out markings on failing asphalt – evidence of neglect. Someone cared enough to set down these stones, to hammer them in just right, to engineer this pattern, to go the extra inch. This surface is uncaring by design, not by neglect.

The small parking lot feels as though it looks the way it does in order to shrug off what would one day happen. This projective amnesia, as though whatever violence and misery could take place in this location could never truly find a home there in memory – this ability feels deeply connected to the fact that it is traffic architecture. Pictures of roads, intersections or sidewalks don't make up the bulk of Leitolf's pictures. But they show up in a lot of them.

Leitolf photographs to emphasize absence: she nearly always keeps human figures out of frame. But whenever I've seen any part

of the cycle, it has taken me a few pictures to catch on – for the simple reason that these are places we are conditioned to imagine depopulated. The parking lot makes you want to move on. It is inhospitable to lingering, looking carefully, asking questions. The car has become the outer contour of what goes without saying.

Today, Germany knows it's supposed to talk about cars. The new government of Chancellor Olaf Scholz has made the *Verkehrswende* a priority: a climate 'turn' in transportation policy. But *wende* is one of those words Germans like to use when absolutely nothing changes. Traveling through Germany in the summer of 2023, you saw more people than usual taking public transportation. Drawn in by a discounted ticket meant to kick-start a shift toward more rail and tram travel – but, characteristically, not matched by new investments in new trains or tram lines – the public seemed to briefly explore a foreign territory, knowing that they'd return to their normal mode of transportation. And normal meant cars.

Decades of unequal investment have created an unequal field of disturbances in German transportation systems: as the number of cars continues to climb, people have come to understand the ubiquitous traffic jams as an expected and calculable risk, whereas every rail journey has become a baffling cascade of Buster Keaton-esque mishaps. People wait for the next train announcement with barely concealed glee glimmering through their frustration: what will it be this time, a cow on the tracks, a brush fire, a broken-down connecting train? Wait till folks back home hear about this! Cars are the dysfunction we have learned to live with, but which we have forgotten how to narrate.

The sense that automotive architecture was almost intentional in its hostility to reflection and memory is much older than Leitolf's pictures. Theodor Adorno left Frankfurt in 1933, when the Nazis came to power – and when all of Germany had about 300,000 cars. He returned in 1949, when there were about half a million cars in Germany. In 1959, when he gave a lecture on 'The Meaning

of "Working Through the Past"', in which he pointed to 'a lack of self-reflection, in the end an incapacity to experience' among his contemporaries, there were about 3.5 million.

He had spent the intervening years in Los Angeles (1.5 million inhabitants, 1 million cars in 1940), and in *Minima Moralia: Reflections on Damaged Life*, he referred again and again to the car. 'Every intellectual in emigration,' he wrote, 'lives in an environment which necessarily remains incomprehensible, even if one can manage to find one's way among trade union organizations or automobile traffic; one is forever getting lost.'

The car, and that sense of alienation, followed Adorno home. In 1962, he wrote a letter to the editor of the *Frankfurter Allgemeine Zeitung*. He demanded a traffic light for a crossing close to his institute's new building.

> When crossing the Senckenberganlage, near the corner of Dantestraße, one of our secretaries was recently run over and seriously injured, only days after another pedestrian had died in the same crossing. On your way to university you have to run across the street in an altogether undignified way, as though running for your life. Should a student or a professor be in the state that is actually appropriate for them, namely in their thoughts, then there is an immediate threat of death.

Years after the philosopher's death, the city of Frankfurt put a traffic light in place at the crossing – the 'Adornoampel', as it is known today. The traffic-light episode is often told as one of the more light-hearted moments in a fairly downbeat biography. But there was surely a very dark dimension to Adorno's worry: the professor had reflected for years on what the 'immediate threat of death' might do to thinking. The letter to the editor suggested that the effect of the exploding car traffic around the German metropolis raised the same concern for him. Amid the mindless mania for rebuilding, Adorno

detected not just an allergy against recollection, but also a readiness for repetition.

The letter reflected less a change in Adorno's thinking than one in his choice of transport. He had gone from being a driver in California to being a pedestrian in Frankfurt. The Californian landscape had appeared to him 'disconsolate and inconsolable', and it had appeared that way behind the windows of a speeding car. 'For what the hurrying eye has merely viewed from the car is not retained, and the landscape drops away without a trace in the mind, just as all traces on the landscape fade away.'

By the 1960s, Adorno was no longer concerned about what driving might do to the driver's psyche. When crossing the Senckenberganlage, he became concerned with the alienation felt by the car's potential victims: that is, pedestrians. The car was, just as in the United States, a mode in which a society made its peace with mass death. But, as Adorno was keenly aware of, closing their eyes to mass death was something that Germans had considerable practice in. It seems at least possible that Adorno sensed a continuity between their tacit acceptance of one and their acceptance of another.

In early September 2019, a Berlin man drove his car into a group of pedestrians on Invalidenstraße. The driver had had a malignant brain tumor removed only weeks before and had been told not to drive; nevertheless, he had packed his mother and his six-year-old daughter into his Porsche Macan Turbo to drive to a nearby restaurant. Four people paid with their lives when he suffered an epileptic seizure, his cramping leg pushing down on the gas pedal, and the Macan – 2,000 kilograms of steel – sped to 100 km/h and charged at pedestrians waiting at the stop light.

In opening statements at his trial, the driver, Michael M., claimed that he had no reason to think he was not in full control of his body that September evening – why else would he have allowed his mother and child to ride in his car? The court decided that M. *ought* to have known, but didn't address the larger falsehood contained in

that statement: that thanks to the massive weight and fancy safety features of the Macan Turbo, M. was never putting his child or mother at risk. He left his house, chose convenience, chose control, not gambling on his child's life, or his mother's. German technology ensured he didn't have to. He instead gambled on the lives of perfect strangers. That, after all, is the promise of the SUV: its safety features are safety features for those on the inside; those same features often mean certain death for those on the outside. If the judges refused to make that connection, the people living near the intersection did: CARS ARE TERRORISM said one sign put up on the site of the accident. If that is true, it is a terrorism that a society visits voluntarily upon itself.

As with the Porsche Macan Turbo decades later, the cars Adorno dodged on the Senckenberganlage mostly came from Germany, welcome symbols of a country that could once again show its face in the world, so long as that face came with sufficient horsepower. After the war, the car industry became the bearer of a new nationalism, and the car the emblem of recovery and a source of collective identification.

The car had a funny way of negating the supposed 'year zero' in 1945. Take Wolfsburg, the city founded by the Nazis to build the Volkswagen, the 'people's car'. By the end of the Second World War, Wolfsburg was exactly none of those things: the Nazis' planned city was half finished and already in ruins. What production facilities existed were heavily damaged by Allied bombs. As for the people's car – the facilities in Wolfsburg had produced about 600 KdF-Wagen (the car that later became the VW Beetle). All of them had gone to the Wehrmacht. The only German families that had ever driven the car to a lakeside or down an autobahn had done so for propaganda pictures.

In spite of its Nazi-ish-sounding modern-day name, Wolfsburg wasn't even called Wolfsburg. Only at Allied insistence was the 'City of the KdF Car near Fallersleben' rechristened (after a nearby castle)

into Wolfsburg. So what Volkswagen celebrated ten years later, when the one millionth VW Beetle rolled off the line in Wolfsburg, a gold version with rhinestone bumpers, wasn't so much a recovery from the Nazi period and from the war. It was – even though no one would have acknowledged it at the time – the fact that the Nazis' vision for the company had finally been realized. The automotive future that the Nazis had to fake for propaganda postcards: the post-war 'economic miracle' had made it real.

The pride many Germans took (and still take) in being 'world champions in exports' is largely an artifact of car manufacturing: frequently cars account for more than half of Germany's excess exports. By way of cars, post-war Germans could 'once again' take pride in their country's prowess, and, yes, even take a pride in their own dominance, something that the country in the political arena sidestepped compulsively. As the psychologist Oliver Decker has argued, after the war Germans developed a 'secondary authoritarianism' – focused not on the dictates of any one political figure, but on the supposedly apolitical demands of industry. 'The authoritarian personality,' Adorno had said in 'The Meaning of Working Through the Past', 'identifies with power par excellence, before any particular content.' The car was the perfect icon for the absence of content. The reliance on the car became an important ideological buttress to post-war Germany: it took, as Bernhard Rieger writes, a 'historical carwash' to the Nazi past, and it gave the ambitions of those years a new, more acceptable shape. It suggested continuities with a time for which, in politics, Germans had little wish for continuities. And the frenzy with which it imbued the country, and which Adorno recoiled from in Frankfurt, made the continuities harder to spot, easier to put out of mind.

In Robert Musil's *The Man Without Qualities*, a couple walking down the street come across a car accident. They reconstruct what happened and observe the approach of the ambulance. 'One almost left with the justifiable impression that a law-like and orderly event

had taken place,' Musil's narrator concludes. The car is, or can feel like, an instrument of law, even if it is an agent of chaos.

For a few years in the 1980s I grew up near what's called an *Ausfallstraße*, an arterial road that connected a historic city center to the autobahn and the periphery. Unlike in the United States, where new highways required by the car boom of the midcentury drove massive wedges through organic urban environments, these are often preexisting country roads, simply widened and provided with all the accoutrements of commuter existence: expansive gas stations, parking-intensive shopping, fast food.

Our house lay on an old street with heavy cobblestones and no road markings. Behind the houses lay cow pastures and behind them a rail line on one side, an autobahn on the other. Bisecting it all was the *Ausfallstraße*, the outer perimeter of our childhood activities. I recently visited the area, after more than thirty years away. On one side of the arterial I remembered almost every street; the other might as well have been on another planet. In the 1980s, we kids were allowed to traverse the cow pastures, the old cobblestone road, the orchards. The limits of our world were automotive, that is to say, the limits of our world were the threat of being run over by a car.

Unlike in the US, where the car dominates biographies (especially childhoods) with banal obviousness, German biographies – at least in my generation – are still filled with bikes, buses and explorations on foot, by the absence of parents and by adventures far from home. But that can make invisible the very real limits automobility imposed on our freedom. At some point, there was a hard stop, and more often than not, its nature was vehicular. Where we belonged, and what belonged to us, was dependent on cars, trucks, buses – not because they took us anywhere but because they barred us from certain spaces under penalty of death.

B eyond the people's car, the car was a way of determining who constituted 'the people' – who counted and who didn't. Cars are a perfect agent of segregation and if that segregation was far more obvious in US car culture than in Germany's, it doesn't mean it wasn't powerful in its own right. After all, a four-lane *Ausfallstraße* orders not just space, but also social classes: there are those who are inconvenienced, hurt, maybe even killed by it; and there are those whose convenience the four-lane street enhances, and whose seigneurial privilege to endanger and maim it sets in stone and asphalt. Every German city has arterials with tall, slapdash apartment buildings on either side with half-drawn shutters trying to shut out the traffic noise, with Turkish and Arabic names on many doorbells; and it has cobblestone streets with large houses set back behind leafy trees, where you imagine every second doorbell must say 'Müller'. The car ordered this geography and the car made it plausible, naturalized it.

Of course, the car also became a way into citizenship, into belonging. Wolfsburg became a city only due to the arrival of Italian 'guest workers'. In the 1960s, many other immigrants found their footing in this new country of theirs by working unionized jobs in the automobile industry. Very few of them were able to purchase the newly constructed homes in the suburbs. By the time they could, they were largely priced out. Perhaps as a legacy, the rate of homeownership among the descendants of *Gastarbeiter*, and among German citizens with a 'migration background', is much lower than among the 'Alman' majority. Instead, it seems, the disposable income goes far more toward cars.

In the parts of Berlin where many people own their apartments, the inhabitants often seem not to own cars, making use of bikes and public transport. In those areas – immigrant areas like parts of Kreuzberg, Neukölln, Reinickendorff and Spandau – where most people rent, you are often struck by the number of luxurious BMWs and Mercedes. That amid a radical increase of real estate values (and hence rents), these citizens invest in an asset that famously

depreciates the moment you drive it off the lot, says volumes about who within German society accrues wealth and who is left to simply consume. But it also speaks to a desire to belong: on Saturdays one still sees these Berliners scrubbing down their cars by the side of busy city streets, as though in some suburban cul-de-sac. Home is where you suds your car.

A dorno likely would have looked at the veneration of the car in post-war Germany as a form of Americanization. The brands may have been German, but the car culture growing up around them was the same that he had glimpsed twenty years earlier in southern California. Germans identified with the car industry, but they didn't tend to identify with their own car culture. It's something homegrown about which they could reassure, perhaps delude themselves, that it was a foreign import. Musil's couple, after observing the accident, likewise think that what they've seen is something American: 'According to American statistics,' the gentleman claims, '190,000 people are killed and 450,000 injured by automobiles there every year.'

Maybe it's my imagination, but when it came to visualizing the promises of freedom that came with the car, post-war Germans frequently turned to the United States. New German Cinema in the late 1960s and all of the 1970s gravitated toward the road movie as a form, and while Wim Wenders's early trilogy was set mostly in Europe, whenever their budget allowed their driving took them to America. Whether Werner Herzog's *Stroszek* (1977), Wenders's *Alice in the Cities* (1974), *Paris, Texas* (1984) or Volker Schlöndorff's *Voyager* (1991), whether a novel like Peter Handke's *Short Letter, Long Farewell* (1972), or Max Frisch's *Montauk* (1975): for a long time, Germans seemed to visualize what their cars promised them by imagining an American wind in their hair. Even when the Volkswagen Beetle began its filmic career – in *The Love Bug* (1968) – the film was made by Walt Disney and the titular car, Herbie, is a Californian.

Another thing that came late, at least to my recollection, was the sense of giddy anarchy that characterized the act of driving on American crime shows and movies. The sheer destructiveness of the great chase sequences of 1970s cinema in the US were carnivalesque counter-imaginaries to everyday suburbanites' boring morning commute. Their screeching tires and misused curbs were expressions of all the insane stuff you might daydream of stuck in traffic, but would never do. Not by accident did many of the most classic chase sequences lay waste to cities many US moviegoers had abandoned between 1950 and 1970, but often still commuted to. But even small gestures, such as Michael Douglas and Karl Malden being able to pull up to any store and double park – with pointed shoddiness – in *The Streets of San Francisco* (1972–77), were about what cars could be in principle, even if they were never that for you.

Starting in the early 1970s, Germany's ARD television station began airing the weekly procedural *Tatort*, which continues to run – more than a thousand episodes later – to this day. Fielding multiple teams of investigators across various German cities at any point in time, the series is something of an ice core sample. Over its long run, it has further submerged – and at other times gently interrogated – barely acknowledged national anxieties and obsessions. In the early 1970s the show implicitly grappled with what it meant to root for a cop who may or may not have been on the clock under National Socialism; in the 1980s with erstwhile 1960s radicals finding themselves a cog in the machine of state; questions of immigration, religion, privilege, feminism all find their way into the ninety minutes on Sunday night.

Cars feature everywhere, and while it's impossible to speak in absolutes about 1,200 episodes, it's noticeable that cars are hardly ever used with the kind of sloppy, anarchic joy with which American TV cops drove, parked, crashed. Their make could speak volumes about an investigator's attitude to the German past, to authority, to privilege, to culture. Differing driving styles provided a quick portrait of the personalities involved. It spoke about gender and autonomy.

Cars are important in *Tatort*, but they are important as stolid icons. They were shorthands at characterization and social location, they were brands and they moved the plot from A to B.

The twenty-first century has created a conundrum for Germany's relationship to the car: what if that object which always embodied what went without saying or thinking about, becomes the thing one must talk about? German media today is full of car talk, and a system of value and signification that was previously experienced as self-evident and not requiring defense, has become a site for endless culture wars. What happens when an identification that you never much reflected on hits a limit? When your conception of freedom becomes fused with the potential for maiming and destruction?

To even the most gentle suggestion that certain aspects of German car culture need changing, more and more Germans react with absolute hysteria. When the conservative CDU entered a coalition government in Berlin last year, their number one target – amid record heat, drought, forest fires – were bike paths. The very notion that the state might subsidize cargo bikes became a political landmine for Germany's Greens. The new German government has persistently frustrated the EU's attempts at comprehensive climate legislation in an attempt not just to safeguard Germany's auto industry, but, it seems, in an attempt to shield that auto industry from having to change anything about their design and production. The car lobby's favored futuristic phrases – 'clean diesel', 'biodiesel', 'carbon capture' – all appear to be largely code for things staying exactly the same at a time when everyone acknowledges they can't. What is being defended is not so much a way of life, a car culture in the strict sense of the term, as a more general right to thoughtlessness.

The transition to electric cars, whether smoothly or not, whether gradually or suddenly, is under way across the globe. In Germany it's accompanied by newspaper editors lamenting that 'anyone can build an electric car; gas cars are High Culture'. As the world continues to

burn, most countries face some kind of reckoning. But Germany's spectacle is in a sense both universal and unique. Not because the car is central to national identity (though of course it might be). Not because the car industry employs so many Germans (though of course it does). But the sheer fever pitch of car discourse stems from another fact: that the impact one's car had wasn't just something one put out of mind, but rather that it was the very quintessence of everything one put out of mind. Through the car, the world champions in memorialization preserved for themselves the reassurance of a broader amnesia. The ability – to quote another novel that famously culminates in a car crash – to smash up 'things and creatures' and then retreat into 'their vast carelessness or whatever it was that kept them together'. In the absence of this 'whatever it was', they may be coming apart. ■

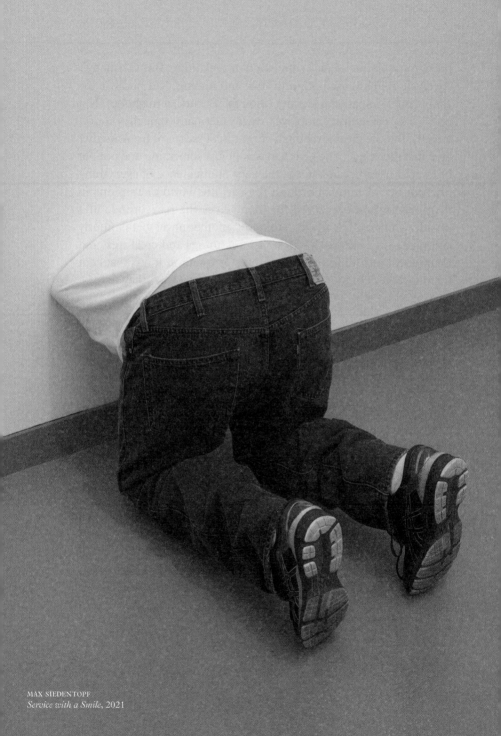

MAX SIEDENTOPF
Service with a Smile, 2021

LIVING WITH GERMANNESS

Nell Zink

It's not fair to generalize, even about myself. Were a team of grad students to spend years preparing a detailed sociological analysis of my life, complete with statistical tables, I would appreciate it. All I can offer in its place are snippets of experience that rubbed off on my brain as it was being dragged through a long wormhole from 1964 to the present; as evidence, they could hardly be more anecdotal or less disinterested. Furthermore, to quote Fyodor Tyutchev (1803–73), 'A thought, once spoken, is a lie.' An essay, which as a rule consists of two or more thoughts, is at best doubly mendacious; at worst, a big steaming heap of self-serving fantasy.

One bright day about twenty-five years ago, I caught a ride from Haifa to Tel Aviv with a famous Israeli journalist. He was fresh off his divorce and not quite upbeat on the subject of women. After a few abortive attempts at communication, he suggested I be quiet. Power lies in male hands and is exchanged in male-only spaces, he said. Women can neither travel nor socialize freely, especially in Mediterranean countries. Their experience of public life is mediated by art and culture, most of it created by males. As a result, they're boring.

Being me – always eager to accept imputations of inadequacy – I sensed the justice of what he was saying. I felt those limits every day.

Femininity is a drawstring, pulling the horizon close. Its ancient symbol is a mirror. Men I didn't know, when I took an open interest in the things they were saying to other men, would finish their sentences and go mum. Dreaming of Yemen, Morocco and Kashmir, I had toured Belgium and Wales.

However, my first impulse was to defend myself, so I attacked his sexism. I lectured him from on high, claiming that we each generate our own social milieu in an evolutionary process. By looking down on ignorant homebodies, he inadvertently repelled the courageous adventuresses he'd like to know.

Instead of driving me home, he let me out by the side of the highway. Soon thereafter, he hooked up with a self-confident feminist, and I fled Asia for Europe. I refused to return to the US. I'd had enough of falling in love.

It would be hard (i.e. embarrassing) to do justice to the ease with which I used to get crushes on men, particularly in America, a nation of – among other things – high-minded, egalitarian Eagle Scouts earnestly struggling to make sense of life, rigorous and forthright in their pursuit of total integrity. Also, my beauty standards were more than lax. It could charitably be argued that I demanded good skin. In consequence, I was always obsessively infatuated with some dude.

But never, ever a German. I had spent nearly two years of my life in Tübingen, a lovely university town on the Neckar, south of Stuttgart, visiting friends I met hitchhiking in the summer of 1983. At home, I led a checkered existence of fateful randiness; in Germany, I never once got a crush. I can't even claim that it's because I generated a self-selecting sample of horrible Germans via some unconscious evolutionary process. I met uncouth, bossy motormouths through their girlfriends. I met them at events of every conceivable stripe. I met them everywhere but the women-only discotheque.

It sounds like a stand-up comedy routine, but it's true: I moved to Germany to get away from attractive men. Maybe there are women who can get deeply involved with a loving and lovable sexual partner

without it taking up most of their time and money in one way or another, but I'm not one of them. Left to myself, I don't need a comfortable home or a varied diet, and my fixed costs go way down. I wanted to write and have shallow affairs.

A few years before my bad car ride with the reporter in Israel, when I was still married, I had joined a subset of West Philadelphia's anarchist scene that practiced polyamory. All relationships were public, though showing off was considered poor form. Prior to sex with someone new, one would run the name past current partners, to be sure no one objected. In short order I had up to three hot dates per day. I still loved my abandoned husband desperately, but I was having way too much fun to move home. It was an emotional education akin to psychoanalysis, unraveling the fabric of my personality to see the individual threads. I became acquainted with my needs – for attention, flattery, respect, beauty, pleasure, ideas – and saw that in concert they had composed my desire for 'love'. I swore off one-stop shopping (marriage) forever.

When I moved to Germany, I had no intention of embarking on a career in illicit sex. I thought I would continue to engage in ethical non-monogamy. But within weeks of my arrival I had a proposition from a desirable German who was not remotely single. When I suggested he run my name and those of my other partners past his partner, he graciously scoffed. Knowing about us, he said, would only cause her undue annoyance. His life might be her business, but mine was definitely not.

To fans of personal integrity, a move from polyamory to infidelity might seem like a step down. Through years of private suffering, I had cemented a conviction that sex in the absence of sexual freedom is as sexy as worms. In Philly I bought a T-shirt that read, I AM OUT, THEREFORE I AM from some lesbians, and wore it all the damn time.

But freedom isn't only the capacity to do what you want and get away with it. It's also the belief that no one knows you're doing it. In 1983, to the chagrin of data-mongers such as the companies formerly

known as Facebook and Google, the German high court enshrined a right to 'informational self-determination'. The knowledge that others might be cognizant of one's actions, its decision said, has an inhibiting effect. So true! There's a difference in quality – not just degree – between picking cherries from a collective tree by the roadside (Germany has a lot of public fruit) and buying an RFID-chipped box of them with your phone. Electronic surveillance turns the castle doctrine ('a man's home is his castle') inside out. At home, you're a sitting duck. The castle is riding your bike with a picnic basket. It's Europe, where the police don't put a mugshot online after they book you for a misdemeanor.

'Out' lifestyles replace freedom with publicity. Personal integrity – the individual's reconciliation of warring impulses – becomes congruence between the public and private self. Failure to attain it is no longer private self-deception but public hypocrisy.

German sexuality isn't closeted – you can sometimes guess who's in the market for what – but it's castled. Not marriage, of course. That's out in the open. People get married in public and dance together at the reception. Assigning children to specific fathers is crucial for the regulation of inheritance under patriarchy! I'm talking about the sexual facts, *wer mit wem* ('who with whom') – a question which, many Germans have assured me, stumps inquiring minds even after years of exposure to the couples in question. The principle behind the secret ballot can extend to so much more. For example, my boyfriend's son, whom I've never met, recently alerted him that there's a rumor going around the village that he has a *Geliebte* ('beloved'). We've been an exclusive couple for ten years. That doesn't mean I know where he is.

Americans like to claim that German has words for things English doesn't – for instance, that 'schadenfreude' expresses a Continental emotion for which we lack a concept. (Not so; the concept would be 'spite', if the connotations of 'spite' hadn't been spoiled by widespread awareness of what it means.) On the contrary,

by combining German with Latin and welcoming new additions rather than policing them, English has developed the largest vocabulary of any language.

Two of our terms that German borrows, not having its own equivalents, are 'nerd' and 'one-night stand'.

Socially awkward overachievers run the country. To possess specialized knowledge and have a habit of expressing it in long, solo disquisitions is not regarded as Pervasive Developmental Disorder-Not Otherwise Specified (PDD-NOS), but as the key to social and professional success. For instance, several years ago, my little town rebelled by electing a relaxed, friendly liberal – a regionally famous rock musician who makes a living by not acting nerdy – as mayor. His mismanagement bankrupted the town. The citizens recalled him and installed a professional firefighter whose entire campaign consisted of indicating that he is in possession of the degree *Diplom-Ingenieur*. Is he on the left or the right? No one professes to know. Like his predecessor and 44 percent of German mayors, he lacks a party affiliation. He said that under his leadership the town would accept precisely as many refugees as the state requires, no more, no less; he was supported by everyone from the neo-Nazis to the polyamorist hippies at the free love commune. Germans regularly come down from Berlin on the weekends to attend expensive love-themed seminars here, paying serious money for instructors to tell them when to touch each other. One of the leading polyamorists informed me, in awed tones, that the new mayor could calculate the cost of a bike path in his head.

It wouldn't surprise me if the rather capacious American definition of autism were eventually expanded to include people of German ancestry. Recall that something like 40 percent of Americans are living with Germanness. Far fewer self-identify, but don't forget the world wars; two of my American friends had 'Irish' grandmothers who proved, when death gave access to their paperwork, to have been German. It could be helpful, next time you're confronted with a tightly wound geek who hits the ceiling because you touched his car,

to consider that he might be on the German-American spectrum. Recently, a German couple sicced their dogs on me for trespassing, and the tetchy, excited way they released the hounds was like a balm to my homesickness. The only thing missing to make the effect complete was a gun.

German lacks a term for one-night stands because *einmal ist keinmal* ('once means never'). How can there be stigma and shame about a non-event? I was slut-shamed here exactly once, forty years ago, by a woman probably born circa 1905. When a German friend (misguidedly, in my view) fucked her next-door neighbor on the living-room couch, her husband's remark was that it weakened his bargaining position in their property line dispute. When I (stupidly, at a big party full of journalism students) outed myself to a lover's wife, she took me aside to caution me against flattering myself that he would leave her. I was one, she reminded me, of many.

Programmatically monogamous Americans tear themselves into little pieces trying to remain consistent in thought, word and deed, their steadfast loyalty torturing all involved into agonies of fetishism and farcical attempts to rekindle the ashes. Meanwhile, who cares? One can so easily learn not to care. One can regard fidelity as a neurosis. I've heard it called *sexuelle Abhängigkeit* ('sexual dependence'). One can accept personal integrity as a dubiously Neoplatonic impossibility.

Germany's baby boom peaked the year I was born, just as the US version was ending. Its children were a breed apart, with parents who had fought, like it or not, for Hitler, and lost. These eerily wooden, wounded parents saddled them with problems their own children don't have. Germans are bounding onto the world stage, whining nonstop about how their industrial technocracy reduces them to the role of EU cash cow and dreaming of a more charismatic regime based on emotion – German soft power, a contradiction in terms – while neighboring countries stand aloof, dispensing dirty looks as the Germans burn lignite coal, export wind power, import nuclear, ban internal combustion engines, buy lithium mines, save

green space, pave green space, take in millions of refugees, elect nationalists, etc., dithering endlessly all the way to the bank.

Keats praised something he called negative capability ('when a man is capable of being in uncertainties, mysteries, doubts, without any irritable reaching after fact and reason'), citing Shakespeare as a rare example. Meanwhile, Goethe had his character Faust bitch at length about the conscious inability to reconcile conflicting drives (*Zwei Seelen wohnen, ach! in meiner Brust* / 'Two souls dwell, alas, in my chest'), literally calling them 'drives' in 1808. I remember the bitterness with which I recalled Keats when negotiating with a German friend to found a band. He longed to do it, he absolutely did, he wanted to play and sing in a duo. But he couldn't, he absolutely couldn't, he had to be on his own.

In short, if you want to experience Shakespearean richness, mystery and ambiguity on a daily basis, just learn some German and move here. Berlin is getting crowded, though, and like the UK, it's punishingly far north. I'd recommend the discreetly prosperous, centrally located Hessian city of Fulda. ∎

SUZIE HOWELL
Untitled, 2022

WE WOULD HAVE TOLD EACH OTHER EVERYTHING

Judith Hermann

TRANSLATED FROM THE GERMAN BY KATY DERBYSHIRE

Some time ago, in a 24-hour minimart on Berlin's Kastanienallee, in the middle of the night, I happened to run into my psychoanalyst – two years after the end of my analysis and for the very first time outside of the room where I'd lain on his couch for years.

I was out that evening with G, my only writer friend. We'd eaten at an Italian place on Eberswalder Straße, drunk a few glasses of wine together outside a bar, then G had walked me to my tram and on the way to the tram we'd started talking about our mothers. It was that mother conversation, our slight drunkenness and the fact that we were retracing old paths – Arkona, Rheinsberger, Wolliner, streets where we'd spent our youth an actual quarter-century ago; that is, in the days when snow still fell and the world around us was black and white and pure poetry – that led me to skip one tram after another and to sit down with G on the steps in a doorway on Kastanienallee, both of us immediately craving a cigarette, even though we'd given up smoking ages ago.

A girl walked past us, smoking. I asked her for a cigarette and she apologised for not having any more, but over there – she pointed at the late-night shop across the road – you could buy single cigarettes: like in the old days. We crossed the street, went into the minimart; the Arab shopkeeper was behind the counter and in front of the counter

was my psychoanalyst, Dr Dreehüs, paying for a nice soft yellow pack of American Spirit Lights.

Many times in my life, I have not recognised people when I've met them outside their usual settings. I had never encountered Dr Dreehüs outside his office; nor strictly speaking inside his office. He would open the door to me three times a week, I would walk past him down the hall, enter the room, take off my jacket and hang it over the chair provided for that purpose; then I would lie down on the couch and he would take a seat behind me. At the session's end, we followed the same procedure backwards – I would get up, put my jacket back on while gazing out of the window, embarrassed, and he would walk down the hall in front of me, open the door, we'd shake hands, and then he'd close the door behind me; it was a miracle that his face, his figure and appearance had made any mark on my memory at all. In the late-night minimart, I was faster than him – I recognised him first, or, I realised first, and I was alert enough to find the situation remarkable and not to give any sign that I found it remarkable. I said a polite and surprised hello to Dr Dreehüs and introduced him to G, which was amusing because they both knew about each other; G had come up in stories during analysis sessions and had, in turn, been forced to listen to a good deal of stories about the sessions.

This is G. So this is G.

G, at the end of the night and after all these years, this is in fact Dr Dreehüs, my analyst.

My former analyst. All three of us feigned bows. In my memory of the moment, I have regretfully lost sight of the shopkeeper, his eyes on us, on Dr Dreehüs, who seemed to be a regular customer and might not yet have revealed himself to be an analyst. Whatever the case, I embraced the curious opportunity to ask Dr Dreehüs for two cigarettes. We left the minimart, exchanged a few words, how are you, fine thanks, how are you, as he elegantly tapped the cigarettes out of the pack, offered them to us and was kind enough not to mention the fact that I'd given up smoking during my years of analysis. He

seemed nonchalant, whereas I was having trouble maintaining my composure. I wanted to commit everything to memory at once: gestures and expressions, his slightly extravagant suit, the way he gave us a light, then smiled and kept a relaxed distance. I had assumed Dr Dreehüs did not exist. I had of course brooded at length about Dr Dreehüs's life outside his office and had come to the conclusion that he didn't have one, which was partly to do with him, as a professional analyst, never having betrayed the slightest detail of his existence other than his presence, his slightly dandyish shirts, ironed trousers, the interior design of his practice room and the occasional book placed as if coincidentally on the desk. For me, Dr Dreehüs lived in that room, with its couch by the window, its scruffy armchair at the end of the couch, its half-empty bookshelf, its empty desk. Outside that room, he didn't exist. But suddenly there he was – I lit my cigarette with the light he offered. I was aware of his hands, close to my face. I was aware that he was slightly drunk and, like me, had let go, in a sense, as the night progressed. He gave G a light too. And then he wished us goodnight, walked three or four yards down the road and vanished inside a bar, which to my mind opened solely in that instant, materialising only for him, and then closed tight behind him. Outside the minimart was a crooked bench. I had to sit down; G had to sit down as well. We smoked our forbidden cigarettes in perplexed companionship, G's sympathy for my shock at the encounter consolatory. He said that he wasn't at all sure the scene had really just happened, or instead had taken place, like in a Woody Allen or Jim Jarmusch film, in a wormhole, an illusion prompted by the wine, the conversation about mothers, the paths into the past. The situation seemed as surreal to him as it did to me, and he too had never noticed the bar into which Dr Dreehüs had vanished like Alice into Wonderland before, and when I said I absolutely had to follow Dr Dreehüs G said that he'd thought as much. He said: But I'll walk you to the door, at least.

Trommel – Dr Dreehüs's bar was called Trommel, like the drum. Front window blocked off, dim light emanating through the

gap in the door, Trommel could have been a brothel, a darkroom
– which I wouldn't have put past Dr Dreehüs – an Irish pub, or a
club; we stood clueless outside. In the end, G said: You know what, I
think I'll just have a bit more of a sit-down here on the bench. Just
because. I'll just hang out here for a bit longer. And if you don't come
out again in fifteen minutes, I'll assume everything's fine. Then I'll
go home.

He said: Is that alright with you?

I said: Yes, that's fine by me. More than fine.

G nodded, gave me a brief but firm touch on the shoulder,
returned to the crooked bench and sat down again; he straightened
his back, then raised his hand like a boxing referee.

I raised my hand.

Took a deep breath, opened the door to Trommel – and went in.

In the years after my analysis I had written my fifth book, *Lettipark*.
Seventeen short stories about people between the ages of forty
and fifty, perhaps at the end of their tethers and on the brink of new
insights, a book that had come about after my novel *Where Love Begins*
and had come easily to me; there had been something liberating about
that return to the short form; writing it had made me happy. Looking
back, I think that happiness was linked not only to the act of surviving
the novel-writing process, but also to the end of my analysis, my
willingness to sort things through on my own, to grow up, let go. One
of the stories is entitled 'Dreams'; only a few pages long, it describes
a narrator's psychoanalysis as she goes to see the same analyst as a
friend of hers. During the analysis, the women's friendship breaks
up, whereas the narrator's relationship with the psychoanalyst has a
distanced constancy to it. Naturally enough, the story is closely linked
to my analysis with Dr Dreehüs – that's what I write: I write about
myself. I write along the lines of my own life; I don't know any other
way. The character of Dr Gupta is narrated along Dr Dreehüs's lines,
Dr Gupta's clothing is Dr Dreehüs's clothing, the furnishings in the
office are his real-life furnishings. There is one point when Dr Gupta

opens the door with a black eye, to the narrator's surprise, and that black eye too really existed. And naturally enough, that first-person narrator is me, I am her – the woman named Teresa, who dreams of slugs and elevator shafts, cries continuously, can't move for grief, can't speak in the first months of the analysis, can't possibly say what is making her sad. And naturally enough, that first-person narrator is precisely not me and nor is Dr Gupta the same as Dr Dreehüs; on the contrary, the two characters are dreams, wishes on paper, and what I imagine as I put down those words is hard to grasp. Despite the characters' fragility, what I have in mind is something unhurt, undamaged. Something I don't possess at the moment, but that I know I once possessed and may possess again, something I yearn for, an exquisite distension, a lacuna. The story is a protective space for the narrator, housing her like the shell of a nut. The narrator is the smallest doll in a Russian *matryoshka*, the story the cocoon around her. I don't write what she talks about, what she talks to herself about in the analysis sessions; the protective space grows out of that deliberate silence. It is up to empathetic readers to imagine it: trauma, loss, abuse, grief, absence, death and fear, life at its most normal, or to remain on the outside. It suffices for me to know what the narrator is grieving, and I'd like to keep it to myself. The story is tidy. The narrator's apartment, her everyday life, the books she reads, the paths she takes, all that has an orderly, presentable structure – in contrast to the apartment I live in, the books I read, the paths I take – I would never depict all that in a story without making alterations. The story distracts the readers from the heart of the matter; it distracts them from me. A magic trick – the readers see the magician's hocus-pocus and miss the trick. I tell the story of my psychoanalysis and hand it over to a character who is the way I've always wanted to be, never was nor ever will be; never in all my life have I dreamed of slugs. And finally, the story is of course also a love story; the narrator falls in love at some point with Dr Gupta, and remains in love, and nothing changes – like I too, after perhaps five or six years of three forty-five-minute sessions a week, at some point fell in love with

Dr Dreehüs and at some point fell out of love. And then it was over. And then I left him.

It came as no surprise, on Kastanienallee that night, that I walked into Trommel with my heart thudding.

When *Lettipark* came out, I had taken a copy to the practice. I wanted Dr Dreehüs to know he'd become part of a story in a book, that a story existed that was dedicated to him. I knew hardly anything about him, but I did know he was a reader, he loved books. I had gathered as much from the tiny sounds of agreement or disapproval he had sometimes uttered when I'd talked about books; and I had given him the other two books I'd written during my analysis, he had read them and made restrained comments about them. I had put *Lettipark* in his letter box on the ground floor of his practice building – addressed to him. He shared the practice with a woman with his surname, though I was never able to establish whether she was his sister or his wife; I preferred the former. I had delivered *Lettipark* in person, hoping to run into him, to put the book into his hands – a brief, highly charged contact. Perhaps I wanted to show him I was alive. Had written a fifth book. Was doing well, was capable of going on without him; I was certain he'd have been glad of it. I didn't run into him. I had put the book in an envelope with a note, three polite lines, placed the envelope into his letter box and gone back home, and in the years leading up to our encounter in the minimart he had responded neither to the book nor to the note.

He had simply not reacted.

The story 'Dreams' has a third character: Effi, who suggests the narrator could go and see her analyst in an emergency – *if you're ever in a really bad place, a really shitty place, I mean* – and that character too is based on a woman I was friends with for a long time, or rather: a woman I used to know.

Ada.

These days, I wonder why I didn't dedicate the story to Ada as well, why I didn't put a copy of *Lettipark* in Ada's letter box in the hope of running into her. Why did I not think in the same way of Ada,

without whom, in reality as in the story, I wouldn't have started my analysis. Without Ada, I wouldn't have met Dr Dreehüs, I wouldn't have written *Alice* or *Where Love Begins*; like in 'Dreams', it was Ada who'd recommended her analyst to me. Every decision in favour of a sentence is a decision against countless other sentences. Every decision in favour of a story passes up countless other stories. One word destroys another word. Writing means obliterating. I decided in favour of Dr Dreehüs and against Ada.

That's one way I could look at it.

I met Ada in the early nineties. She was the same age as me, the uncrowned queen of a far-reaching urban tribe in which most, like Ada, came from Frankfurt an der Oder on the border with Poland. This origin, according to Ada, from a city taken by storm by the Red Army at the end of the Second World War, explained why the children of Frankfurt were so incapable and auto-aggressive, so excessively unstable: Frankfurt was a traumatised city, and the people born there continued to carry the trauma inside them. Ada lived out her trauma in a large, shady apartment on Helmholtzplatz in Prenzlauer Berg, which someone had occupied on her behalf in the chaotic months after the Berlin Wall came down and which couldn't be taken away from her – for a while. A huge asymmetric kitchen-living room, wicker armchair with lambskin at the rear window, where Ada often sat and breastfed her baby. She was the first young mother I met, and she occupied her role with the air of the primordial mother; that wicker chair was her throne. The room full of shadows in motion, always pebbles and marbles on the long, scratched table, bouquets of branches and wild wasteland flowers in carafes, black-and-white photos pinned to the bare wall next to Shiva with all his golden arms next to newspaper clippings crackling in the draught. Candles and incense sticks, someone constantly tinkling away on the piano. The baby born in that room was delicate, rarely cried, big dark eyes fixed unwaveringly on the visitors who came and went, the front door unlocked. Inside the room there was no distinction made between

day and night, the light always chalky as if underwater, no rules, barely a line to be crossed. It was evidently possible to be a reliable mother and to lose oneself at the same time, to give oneself up; I remember Ada at the counter of the bar we often went to at the time, I remember the dispassion with which she unbuttoned her shirt, took it off, sat before us with her upper body bared, upright and attentive; she wanted us to admire her bare breasts at two in the morning, she said they were the most beautiful out of all the breasts in the world – and we did, and we presumably assumed she was right. Where was the baby on those long nights, I think these days; at the time, I never wondered about it. Ada had a husband who amazed us by managing to study law, graduate, go about a regular job, earn money and still be with us when we set out to climb down into the nights that descended like deep dark wells. It was Ada who pointed out to me that the family I came from, had grown up in, didn't necessarily have to stay my family, that it was possible to leave them and look for another, a better one; she herself had cut herself loose from her Frankfurt origins and gathered a chosen family around her, made up of her husband, her child and a close circle of other women and men. That family was good and affirming, in contrast to her biological family, whose only purpose had been to bring Ada into the world. Strangely, Ada never gave the impression while deliberating on such things that she needed any affirmation or consolation. She was invariably very composed, distanced, ironically cheerful and possessed with a defiant aloofness; she seemed always to know something I didn't know. Her deliberations on the family unsettled me; as harmless as they seem to me these days, they were amazing and important to me then. My family was a cocoon in which I was pupated, bound up and safe. Ada's views tugged a thread loose from that cocoon, pulled it apart, loosened it; it was other things that then led to its dissolution, but Ada, with the baby at her beautiful breast and her husband behind her and the others behind her husband, made the first cut.

I assume she didn't know that.

When I had my baby, five years after hers, we began to spend the holidays together in my family's summer house on the North Sea. Tides and dykes, the treeless coast, the eternal *triste* rain were alien to these people from Frankfurt, Brandenburg, East Berlin. The house, once my grandmother's home, made up for that lack of familiarity. Old, decrepit, provisionally furnished, with no curtains, light perforated through the windows via a tangle of climbing plants, in one room a fantastic uncle who took part in the nightly parties and could quote Heine, albeit rather patchily; an overgrown garden with trees for hammocks and lanterns, and friends came and went over the weeks, extended and chosen family, taking it ever more for granted. It was that house where Ada explained her family principle to me, and she did so with a gentle gesture at everything around us. Furniture, framed certificates, turn-of-the-century photographs, stopped clocks with bent hands, chipped crockery and the name of the house, which someone had hammered in golden letters beneath the gable a hundred years ago.

Daheim: home.

All this, Ada said, is yours but it doesn't have to be. You can accept it – or let it go. You can be here but you don't have to feel responsible for anything. Anything at all. And then she stood up, walked away and left me alone with her suggestion.

I remember a dress made of tatty indigo-blue silk that she often wore, bought for ten euros at the market on Kollwitzplatz; of all the dresses I've seen, this was the most beautiful. She took it off the only time just the two of us went out to the mudflats, as far out as possible, up to the North Sea's edge. It can't have been a coincidence that this was the one evening we spent without the others. We'd cycled to the wild beach, to the spot where the promenade ended and the dunes began. We leaned our bikes against each other, removed our shoes and walked out towards the open sea; once we reached the water, Ada took off her dress and stood naked next to me. Dusk, the sky above the land far behind us now night, the sky above the water still bright, the water mother-of-pearl, Ada's body pale and slow against the dark

seam of the sea. I didn't take my dress off. She had put hers back on at some point; then we'd walked back, cycled back to the house. On another afternoon, she embraced me fiercely and unexpectedly, in the hall by the rack of rain-soaked coats, between the children's countless wellington boots, Ada's scent suddenly so perceptible, dark, sandy, almost masculine.

In every one of those summers back then, Ada gave me flowers on my son's birthday, an August bouquet picked on the edges of the fields the night before; she was the only person who considered that tradition important. The summers were exhausting. Nerve-racking, making us happy in an exorbitant way that was painful for everyone, our goals all variable and movable, life one long lyrical transit. Once Ada's child was old enough to go to school alone in Berlin, she sometimes let her husband and child return to the city without her. One summer, her husband called me after getting back home to thank me for his stay and sum up how important it had all been for him, and then he asked me to get Ada on the phone, only to tell her the washing machine was broken and the fridge was mouldy. After that conversation, she sat down on the bench by the front door and cried. I'd never seen her cry before, and never did again. I'd like to say she left her husband shortly afterwards, met another man and had a second child; in real life, years passed between that crying on the bench and the second child, years that feel only in retrospect like a single step from one room to another. With her second child and that child's father, Ada still spent her summers at the house; we stayed close. The second child's father got the place at the head of the table; he left that spot after every meal as if he were the youngest of all the children. There was a walk on which he and Ada set out, and when they got back his glasses were broken, his shirt ripped, and his nose was bleeding. Things didn't seem to get easier.

And yet – it's unforgettable how Ada would retire at noon with her second child, still toothless and chubby-cheeked, for a nap. How she drank a big glass of milk before the nap, the baby perched on her

hip, snuggled into the curve of her arm, round cheek laid on Ada's shoulder, how she held the glass with her free right hand, downed it in one, head tipped all the way back, in deep, earnest gulps. Ritually, as if it were not milk but something far more exquisite, essential, not a drink but a colour, a material she was ingesting before she escaped with her child into the in-between world of sleep, which I knew would be deep, heavy with dreams and genuinely delicious; nothing compares to a nap shared with your own child. She put the empty glass back on the table, ran the back of her hand, her wrist over her mouth, gave me a mysterious and tender smile, went to her room and closed the door gently behind her. In the years of her separation from her first husband, the dissolution of her chosen family, her love for the father of the second child and the birth of that child, she attended analysis with Dr Dreehüs, something I didn't know at the time; she only told me about it once the analysis, the restructuring, was over. She disbanded her family. Or her family disbanded itself. The father of her first child had a baby with a woman from Tierra del Fuego, the father of the second left Berlin. The building on Helmholtzplatz was sold and its tenants were evicted. Ada moved into a small apartment a few streets away, in a building with a camera hooked up to the doorbells, which was the beginning of the end, domesticating us all.

My child got older.

The summers were limited; sometimes school resumed in early August and we had to go back to Berlin, dog days in the city, days which always made me melancholy, full of yearning for the water, the garden, the bed in the attic room with the sandy sheets, listening to my child's breathing in the night. On one of those dog days, I was sitting in a cafe with Ada, and as she went to leave, she said in passing that she had to go to her analysis session, one of the last. She gestured down the street, towards where the practice must be. She said: A good analyst, if you ever need one.

And that was all.

That tiny scene – the cafe, the remark, the gesture in the direction – crops up in my story 'Dreams'. Two or three sentences that deliberately conceal all else – the indigo dress, the light on the mud-flats and the water, the glass of milk and the nap, the chosen families, the children, mine and hers – negating them. Those two or three sentences sum up something that's impossible to grasp. They decide in favour of a single instant, a snow-globe moment. They cast all the rest overboard.

Omission.

Writing imitates life, things disappearing, images constantly being left behind, falling out of focus, sputtering out. But the autonomous decision in favour of that omission – not the glass of milk, not the dress, but yes to the cafe scene, although the milk and the dress are more sensual – makes it easier, balances out anguish and grief over loss and time elapsed. The father of Ada's second child once said that above all else he fell in love with her hands, her gestures; a remark I could instantly relate to. I always found Ada's hands even more beautiful than her breasts: their distinctive knuckles, slim fingernails, the explicitness with which she stretched out those hands, spread her fingers when she made her decisive, capricious observations, the elegant nonchalance with which she touched things, moved them, dropped them. She was a beautiful and quite cold woman with an upright, always rather defiant posture, although her gait might suddenly become bouncy, light-hearted.

I never trusted her; perhaps that's why it's hard for me to say I was friends with her. I'd rather say I used to know her. It would be easier to say I used to love Ada. After that occasion in the cafe we lost touch, I broke off contact. It may have been because I took her comment seriously, made an appointment with Dr Dreehüs, began my analysis. Too much closeness, perhaps: Ada's sessions on the couch, my own sessions on the same couch. Dr Dreehüs, I thought, knows something about me that I'd never tell him of my own accord, he knows things about me that Ada told him. I must have felt the need to regain control, to place the other at a safe distance. In the first years of my

analysis I crashed, and I didn't want to expose myself to Ada in that state, have her observe me. We lost one another; I can't remember missing her. I was busy leaving my own family, and I didn't intend to start a new one.

I wanted, I think these days, to be alone.

The story 'Dreams' describes a realisation – a retrospective classification of a relationship, the insight that we delude ourselves, fool ourselves, how glad we are to be fooled. Ada may have felt a vague sense of endearment towards me, but she never let me out of her sight; I would never have become a member of her family. In the summers with the children, she always wanted us all to do a reading of Chekhov's *The Cherry Orchard* together. A scene she dreamed of – the circle of friends around the long garden table by night, with white wine, cigarettes, candlelight and the classic yellow Reclam paperbacks, reading roles she'd already allotted, but that had never gone any further. Those paperbacks are still on the bookshelf in the house by the sea. What would have happened if we'd agreed to Ada's suggestion? No one wanted to read *The Cherry Orchard*. Everyone wanted to drink to excess, smoke, tell stories, let themselves go, take different roles, and perhaps that was the only sign of Ada's vulnerability – that she wished we wanted to put on a play together. We didn't play together. And now our children have left home. The story focuses on the separation, a futility. Putting a copy of *Lettipark* in Ada's letter box would have been a superfluous gesture – and beyond that, I assume Ada would prefer to leave me in the dark about her possible reading of my view of our years.

In Trommel, Dr Dreehüs was sitting alone at the bar, with his back to the door. The barman saw me coming and Dr Dreehüs followed his eyes, turned round to me over his shoulder and smiled – he hadn't expected me but he promptly patted the bar stool next to him, ridding me of my embarrassment. To an outsider, it might have looked like we'd arranged to meet. Dr Dreehüs seemed to like being alone in a bar, we were the only guests. He smoked. The light

was dim, the bar not clearly of any particular persuasion, and the slightly thuggish-looking barman seemed to sense that the encounter between Dr Dreehüs and me was – let's say, somewhat shady. A little illegitimate.

I took off my jacket, asked him for a second cigarette. Dr Dreehüs casually tapped one out of the soft pack and held it out to me.

He said: What are you drinking? He said: It's on me.

At that point in time, he and I had spent over a thousand hours of our lives together. I had talked about all sorts of things I usually kept to myself. Dr Dreehüs knew a good deal about me, I knew nothing about him, and our encounter in Trommel was an unexpected expansion of our configuration, a small and puzzling mutation. To this day, I'm not sure whether Dr Dreehüs was a competent analyst. When other people talk about their analyses, I get an impression of lively and heart-warming communication; Dr Dreehüs, however, almost never spoke to me, I remember perhaps five utterances in ten years. The minutes passed while I spoke to myself, searchingly, pausing between my sentences, posing questions and reaching for the answers alone. These days I think that kind of analysis was exactly right for me: it was ideal.

In one of our first sessions, I had told Dr Dreehüs about my fear of no longer being able to write at the end of the analysis, having to sacrifice writing to the analysis. He had replied that that remained to be seen, and submerged after that mysterious remark into a silence from which he did not reappear for ten years. More or less. I'm exaggerating, but that is what I remember, and that is what the narrator in the story remembers: Dr Dreehüs-Gupta never said anything, and in some moments she was certain – as I was – that he'd fallen asleep. He would always sit behind me, at the top end of the couch, I would never turn round to him, having the superstitious impression it would bring bad luck to turn round to him. Sometimes we'd laugh together – he had a sense of humour. Occasionally, he might express sympathy or understanding through half a sigh or a longer exhalation. But whenever I'd ask him a question

he would ask me why I was asking him, and refuse to answer. There had been sessions when I'd arrived early, paced up and down the park outside the building, looked up at his windows and seen him smoking a cigarette on the balcony, and I'd felt great satisfaction that Dr Dreehüs had his own addictions, was dependent on such an unhealthy habit. He played classical guitar, the guitar rested against his desk in an expensive bag every Monday. And that was all I knew about him. The night-time encounter in Trommel brought with it the risk of gazing at a face that wasn't what I thought I knew. Instead, the face of a stranger to whom I had entrusted my whole life in the mistaken assumption that he understood me – and now it might prove that he'd understood nothing at all and aside from that was a know-it-all, unlikeable and cold. I was afraid Dr Dreehüs might simply not be the man I had taken him for, might, to use a preferred phrase from Ada's chosen family, be an utter idiot. *A total and utter idiot*. Ten years would collapse in on themselves, crumble into nothingness:

Cinders.

Realisation in time-lapse – a little more specific than the realisation over years that the person you love is not the person you think they are, a gradually dawning awareness that you are alone in the world, your partner a mirror image of your needs, a reflection which will fall away the moment you let go. Held by nothing, responsible for no one, least of all for you.

You are, in Turgenev's words, alone like a finger.

I didn't know what to drink, but Dr Dreehüs ordered for me in a manner that had a clear and absurd touch of the paternal: a gin and tonic. The barman mixed the drink placidly as I watched on. And then I took the first sip, lit my second cigarette myself, turned to the side, gathered my courage and looked at Dr Dreehüs. His expression was friendly, rather arrogant in a way that was familiar for no good reason, a little weary, beneath the weariness essentially: earnest.

He was perfectly fine.

His gaze was perfectly fine, as was his gentle and mockingly

interested amusement; he was nothing but a man in the late years of his life sitting at a disconsolate bar at two in the morning – on a weekday; he'd get up early and go about his specific work – and that fact alone had something deficient about it, and the deficiency had something calming about it, and I had evidently not, at least not at this first glance, been wrong about him.

He said: You were brave to come into Trommel. You were brave to come in, I'm glad, and it was clear he meant what he said.

I said: Does this barman here know what your job is?

He said: This barman here thinks I'm an electrician.

I said: I can imagine you doing almost any job but that. ∎

Elfriede Czurda

mutilation with a goal

I

they met and made love on the edge of a bed to the cheers of thirty
christmas tree vandals the newspaper said
when he got up and buttoned his pants his father's face was red
mistresses are customary in aristocratic circles
mistresses are customary in aristocratic circles she thought while
watching him make a thick rice soup
such harmony of hands and knee
ate homemade chocolate balls with you remember
his straw hat with pipe at the typewriter noted: a load of buckshot
banged in front of his toes a blackbird dropped from the tree down
into the ravine
through narrow alleys to the landing up the stairs rest on the land-
ings look up across roofs and chimneys at the cluster of trees at
the end of the stairs follow the gravel-strewn icy asphalt up to the
niche in the archway under the cable car and back of it on the left
open the gate in the fence with the mailbox laden with significance
and once you've closed the squeaking hinges sneak around the
corner and enter by the back door
such harmony of hands and knee
mistresses are customary in aristocratic circles she thought when
she saw him put the letter in his pants pocket
when he got up from the edge of the bed his father's face was pink
you know how to make rice soup he said
at the time the newspaper said christmas tree vandals
i love eating the rice soup you make in every respect a man
such harmony of hands and knee

your friends her ladyship the countess as noble as they were stupid
slept in the coffins and the pallor of your hair bleached to white heat
their knights-of-the-holy-grail-breath fabled into rings
when she left he stood there in slippers and words and teddy the
dog was waiting for her by the fence gate's squeaking hinges
her room in winter a shovel of coal two briquettes and clean out
the ashes already again the heat so fully absorbed the stove two
degrees centigrade instead of four
hello . . . yes with you . . . yes father . . . yes saüerkraut . . . yes . . . in
an hour . . . yes photos . . . mistresses are customary in aristocratic
circles and buttoned his pants
held on to his suit and a cane with silver handle instead of his
glasses: forcibly and in anger pushed under his own bed
such harmony of hands and knee
when he put on his coat and clasped his briefcase under his arm
he couldn't find his knitted sheep's wool fez anywhere
mistresses are customary in aristocratic circles she thought and
handed him his persian fur hat
her room a leather couch with the dust of decades in the cracks
and horsehair coming out of the slits below
una casa fondata nel bianco two rooms and closets with brass cur-
tain rods and corduroy bedspreads
his father's face was red
bought a car and *you are my chauffeur* whereto may i chauffeur you
father sir with your ambitions
christmas tree vandals the newspaper said
when he got up and buttoned his pants *i don't know you* and shook
his head in a straight line forward and backward
not learned to invite you for dinner just for fun in *una casa fondata
nel bianco*
when she drank wine the glass slipped from her hand to her groin
la merde commence and went to the bathroom to rinse her pants

such harmony of hands and knee
had an epileptic fit and lost two front teeth remember
the bus and change at the station till the last but one stop take the
right uphill not the dead end the corner house with the pants store
and three flights up the left door toward the garden and without light
his father's face is pink she thought when she watched him run hot
water for his bath
you would have to stay if you were obliged to but perhaps you are not
when he climbed out of the tub he slipped and fell flat on the floor
che cosa c'è and carried him to the couch
the density in the brain telescoped and collapsed with a scream
mistresses are customary in aristocratic circles
your home is *my castle fondata nel bianco* and women belong at the
hearth when he got up he left a moist chair
mistresses are customary condensed into magic circles no to regu-
lar bowel movements and red and pink and red and pink convul-
sive twitching of the intestines
sucked on the nipple till it popped out of place remember
when he came at her with the kitchen knife she laughed *haha your
tie's crooked* and rubens's fat women splashed on the pavement
such harmony of hands and knee
ours she thought when he brought the kitten jeremy home who left
a manifesto when he disappeared

Translated from the German by Rosmarie Waldrop

MATAN RADIN

In November 2022, a group of Jewish protesters in Berlin attempted to join the annual Antifascist march but were physica[lly] obstructed from participating in the demonstration due to their banner by Antideutsche protestors, who accused them of being anti-Zionist agitators. In December 2023, following the judicial overhaul in Israel undertaken by the Netanyahu government, the banner was hoisted again at a rally in front of the German Foreign Ministry

ONCE AGAIN, GERMANY DEFINES WHO IS A JEW

George Prochnik in conversation with Emily Dische-Becker and Eyal Weizman

G ermany's reckoning with its history of atrocities began as an undertaking by left-leaning German civil society. Today it has become a highly bureaucratized lever of the state that often serves a reactionary agenda. Three recent controversies in Germany involving allegations of antisemitism have reshaped the state's relation to its memory culture, Israel, migration and colonial past.

In the summer of 2020, Cameroon-born philosopher Achille Mbembe was poised to be disinvited from the Ruhrtriennale Festival by Germany's antisemitism commissioner amid reports that Mbembe had compared Israel to Apartheid South Africa and was a supporter of Boycott, Divestment, Sanctions (BDS) principles. The allegations proved correct in the first instance and inexact at best in the second.

In the summer of 2021, a fierce debate flared up in the wake of a polemical article – published in response to Mbembe's treatment – in the Swiss online journal *Geschichte der Gegenwart* by A. Dirk Moses, the Australian scholar of genocide. Moses observed that people like Mbembe would be persecuted if they questioned certain articles of faith, such as the German state's uncritical support of Israel, which

form the basis of post-war German identity. Likewise, Moses argued that one risks being barred from public discourse in Germany today if one questions the uniqueness of the Holocaust or links it to Germany's genocidal colonial past. Moses dubbed these articles of faith the 'German Catechism'.

In the summer of 2022, additional disputes erupted around antisemitic imagery in a large political banner created by an Indonesian art collective and displayed before the main venue of Documenta, the contemporary art exhibition staged every five years in Kassel. While the banner (which contained hundreds of figures) focused on injustices of the Suharto regime, two of its subjects were depicted in a manner consistent with classic European antisemitic propaganda. After the banner was withdrawn from the exhibition, the lapse in curatorial judgment that allowed it to be exhibited became a rallying cry against not only Documenta as a whole, but also the wider discourse of post-colonialism in Germany.

In this interview, George Prochnik discusses these topics with Emily Dische-Becker and Eyal Weizman, two practitioner-theorists who are actively engaged with Germany's new 'anti-antisemitism' and its larger political fallout.

Prochnik

Emily, can you begin by describing how Germany's memory politics have repurposed the country's antisemitism controversies to advance a right-wing agenda? What is the historical context for this startling turn of events?

Dische-Becker

German state memory culture flourished in the aftermath of German reunification in 1990, which had to do in part with the need for a new kind of statecraft. The reunified German state had to communicate that it was neither a threat to other countries nor to Jewish communities, and that meant showing that it was dealing with its past, since there were concerns that a reunified Germany would mean a menacingly powerful one. Memory culture didn't have much to do with Israel at the time – that came later and was exemplified by Merkel's 2008 speech in front of the Knesset declaring Israel's security to be Germany's *Staatsräson* ('reason of state').

Weizman

One unexpected consequence of this radical commitment to Israel is that German nationalism began to be rehabilitated and revivified under the auspices of German support for Israeli nationalism. Indeed, one of the criteria for being allowed to participate in German public life today is a person's acceptance of Israel's 'right to exist'. This qualification positions Israel not as a geopolitical reality, but as a symbolic entity that necessitates a test of faith. Yet if one tries to concretize what exactly this test applies to, things become murky. What exactly is it that Germany has singled out as possessing an absolute right to exist? Jews in Palestine? Surely. The Israeli state as an ethno-nationalist structure? That state's oppressive mechanisms towards the 7 million Palestinians who live under its control? The axiomatic status of Israel's right to exist as an ethnic state, together with the lack of definition around that sacrosanct position, means that in effect Germany becomes committed to buttressing Israeli Apartheid, while at the same time the tools used to confront it are

criminalized. Meanwhile this axiomatic status itself has become politically weaponized. When the state is challenged as a repressive political system, that contestation is often manipulated to suggest that it is the Jewish people's right to exist that is being questioned.

Within Europe today, significant numbers of people – including many diasporic Palestinians and anti-Zionist Israelis – call for the exclusion of Israeli state institutions from general funding and participation in public events under the aegis of the BDS principles. At the same time, supporters of BDS are themselves being boycotted by German institutions citing the Bundestag resolution of 2019, which declared that 'the argumentation patterns and methods used by the BDS movement are antisemitic'. The BDS resolution has had enormous repercussions across the cultural sphere because it has allowed many Palestinians, who naturally want to find a means to protest their dispossession, along with migrants from other parts of the region, to be excluded from public positions and funding. A new jargon has lately sprung up, in which terms such as 'BDS-*nah*' – meaning 'BDS-proximate' – are used not only for critics of Israel, but indeed to delegitimize anyone coming from an Arab or African country, suspected of harboring such thoughts. They can automatically be branded antisemitic and outside the sphere of permissible discourse. For this reason alone, it is important for me as a Jewish person to openly support BDS, and by extension those people excluded by attacks on it. Yet my ethical obligations on this issue have led to Forensis (Forensic Architecture's sister agency in Berlin) being disinvited from exhibitions across the country.

While support for BDS is deemed antisemitic by Germany, the Israeli government has designated BDS-aligned organizations as 'terroristic'. Six Palestinian human-rights organizations that support BDS and whose main function thus far has been to collect evidence against Israeli crimes for use in international forums have been designated, without evidence, as 'terror organizations' by the Israeli

minister of defense. Among the groups on this list is the Palestinian human-rights group Al-Haq, with which Forensic Architecture (FA) has formed a long-term partnership and co-investigated the case of the targeted killing of Al Jazeera journalist Shireen Abu Akleh. While no other country accepted this designation, and even the CIA acknowledged that there is no evidence for it, Germany's home minister is pushing the German government to accept the label. Whether by being designated 'antisemitic' abroad, or 'terroristic' inside Palestine, positions offering legitimate opposition to Israel are thus branded as 'beyond the pale'.

This sinister situation is also the consequence of an increasingly aggressive version of Israeli *hasbara* – that is, propaganda – which, in another historical twist, takes its legitimacy from Germany's memory culture. To borrow a term from our friend the philosopher Adi Ophir, the state of Israel has established a 'discursive Iron Dome'. While the original Iron Dome was an anti-missile defense system capable of shooting down rockets midair, the discursive equivalent is a preemptive practice of delegitimization, meant to shoot down critiques of Israel before they cause damage.

Dische-Becker

The trouble with German memory culture in its current manifestation is that it no longer offers an effective subversion of German nationalism. Instead, memory culture has become axiomatic to state-sanctioned national identity and, in that capacity, a tool to discipline and exclude undesirable minorities and troublesome ideas. I'm drawing a distinction between the early post-war decades when German memory culture represented a civil-society initiative aimed at confronting Germany's refusal to face its crimes, and what it is today: a vehicle for projecting Germany as the most civilized nation

by virtue of its having committed genocide and then having reckoned with that gargantuan atrocity. Coupled with an approach to fighting antisemitism that assumes antisemitism to be ubiquitous among opponents of Israel, it is Palestinians who (because of their opposition to the self-declared Jewish state) are positioned as the greatest danger to Jews. I'm being a bit hyperbolic here, but I do see this basic dynamic as a key factor in the trend whereby German memory culture ceased to be self-critical, and became instead a reflexive, self-congratulatory posture. Worse than pro forma, it has become a platform from which to lecture other people – including Jews – about their need to embrace Jewish nationalism.

Here's one example of what I'm talking about: in 2020, at the Weißensee Academy of Art Berlin, a group of Jewish, Israel-born students developed a reading group called the School for Unlearning Zionism, made up of people of various political persuasions, or levels of politicization, who'd come together to grapple with the national mythology they'd grown up with. One of the students made the group's premise the subject of her graduation project. Various overeager functionaries who now consider it their duty to manufacture scandal around any kind of criticism of Israel as antisemitic raised a furor. Funding for the students' graduation exhibition was withdrawn, and this event was subsequently included in the chronology of antisemitic incidents for that year published by the Amadeu Antonio Foundation, one of Germany's leading anti-racist organizations. So you have a reading group of Israeli students listed alongside incidents that include a Jewish prayer-goer being hit over the head outside a synagogue in Hamburg and Jewish graves being defaced with swastikas. In an interview a couple of months later, Felix Klein, Germany's Federal Commissioner for Jewish Life in Germany and the Fight Against Antisemitism – who's been in this position since it was created after an Israeli flag was burned at a Berlin protest over President Trump's decision to move the US Embassy in Israel to Jerusalem in 2018 – asked that left-wing

Israelis please show some sensitivity toward Germany's historical responsibility and be measured in how they speak about Israel while in Germany.

Prochnik

Scholars who've weighed in on these debates have spoken to me about the panic induced in Germany by the hard-right turn of Israeli nationalism – the erosion of a particular figuration of the Jew – and about what it's been like for them to be lambasted by non-Jewish German Zionists for whom criticism of Israel is a sign of weakness, while dissent from the dominant historical narrative is a symptom of inauthenticity. Such experiences typify that of many targets of the so-called 'Anti-Deutsche', who sprang up after the fall of the Wall. At first, the Anti-Deutsche was a nominally leftist movement determined to prevent the rise of a Fourth Reich in a united Germany. In practice (and increasingly in recent years), the movement views Germany's special responsibility to the Jews as a blanket commitment to protect Israel from all criticism.

Once again, one could say that Germany is engaged in a monolithic mythologization of Jewish identity, and once again, as A. Dirk Moses's essay suggests, the end result of this process is German redemption on the new world stage. The redemption is achieved through a valorization of the Jews that requires the exclusion of other traumas: in particular, the Palestinian trauma inflicted by Israel.

Dische-Becker

In a stunning lecture-performance last year, Eran Schaerf, an Israel-born artist who's been living and working in Germany for forty years, said that many Germans can't imagine that they don't star or feature in all Israeli Jews' memories – that there are other memories, also of violence, that aren't about Germans. It is almost as if there's a monogamous relationship between Jews and Germans, as Jewish Studies scholar Hannah Tzuberi put it, and everyone else is an interloper.

It should be noted that many German Jews, including Jewish officials in state-sponsored organizations, also react with fury whenever Israelis in Germany weigh in on cases where individuals or groups have been accused of antisemitism because of their stances on Israel. These officials claim that the Israelis in question aren't representative of German-Jewish opinion and don't understand antisemitism. Growing up as the dominant group and majority in Israel is very different from the experience of living in post-Holocaust Germany. But Israelis do know Israel, which to many German Jews is primarily an idealized insurance policy.

Prochnik

Can you provide examples of how German memory culture becomes even more regressive in an overtly political sphere?

Weizman

One instance would be the change of attitude toward antisemitism that's become prominent in the extreme-right AfD's discourse. Beyond their use of dog-whistle antisemitism in opposing Holocaust commemoration, they also attempt to make their form of racism and proto-fascist attitudes more palatable by forming an anti-Muslim alliance. They propose that antisemitism is an import to Germany, arriving like a virus through the channels of migration. This tendency to exteriorize the origins of antisemitism exists well beyond the AfD, manifesting across the political spectrum (as well as in other extreme right-wing organizations in Europe and elsewhere) and results in migrants being regularly targeted with accusations of antisemitism. The pro-migration Left, which is accused of fostering antisemitic tendencies, is caught up in this as well. All this condemnation is of course deployed to fuel resistance to the arrival of migrants themselves, who then come to embody the demographic shift away from a European white consensus, which now says 'No to immigration, Yes to Israel'. As a Jewish person in Germany I find this trend dangerous, politically and personally.

Prochnik

You and Emily seem to be identifying a conflation between Israel and the Holocaust that goes beyond ways that the Holocaust has become associated with Israel's own *raison d'état*, as a safe haven for Jews suffering persecution in the diaspora, into something more conjunctive and sacrosanct, whereby Israel exists as a kind of memorial state to the Shoah perpetrated by Germany. There is the abyss of the Holocaust and then Israel becomes the edifice mirroring that void extrusively and unassailably. Within these terms of discourse, Israel's

existence becomes a tool for advancing different autocratic endeavors worldwide, including the GOP's USA and Tory Britain. All these models represent the effort to circumscribe 'evil' within the trope of antisemitism, and to demonize, concomitantly, anyone who challenges the identification of Israel with the Holocaust as contaminated by antisemitism, thereby opening more space for the implementation of autocratic, repressive agendas. Hannah Arendt wrote a famous essay on the Jew as Pariah, but in an inversion of that notion, Israel becomes a Pariah-Saint to rally and ring-fence neo-nationalistic endeavor.

Dische-Becker

We've established the appeal for Germany of the logic whereby Israel is designated an exceptional nation state that practices a 'good' nationalism and praiseworthy militarism. But what does Holocaust commemoration achieve today? Very few survivors remain, so it's not about their feelings, nor about justice for them. We continually observe ways that this memory culture is not actually about justice, since there are material things that could be done by the state that are not being done. For example, Christian Lindner, Germany's current finance minister, who is the head of the neoliberal Free Democratic Party (FDP), which has championed the anti-BDS cause on the grounds that it is antisemitic, recently attempted to cut pensions to Holocaust survivors. Two weeks later, he went out for a photo op, lighting the world's biggest menorah at the Brandenburg Gate – a favored stunt of German career politicians. So if it's not about justice for victims is it then about preventing a resurgence of exclusionary nationalism? Extraordinary resources are being poured into memory culture as part of the state-sanctioned program for the fight against antisemitism. Berlin alone currently employs five antisemitism commissioners representing different institutions and constituencies. It's fair to ask, then, what is the efficacy of all this?

While the fight against antisemitism has been escalating, the AfD, a neo-fascistic party, has begun polling ahead of the ruling Social Democrats, and at the same time there's been a rise in far-right terrorism that is often bound up with the police, army and intelligence services, many of whose agents harbor right-wing sympathies and connections to right-wing terror networks. Yet these developments are rarely discussed in the context of antisemitism. It is apparently not within the mandate of Felix Klein, Germany's Federal Antisemitism Commissioner, that there are German police officers sending each other *Heil Hitler* text messages every morning as a greeting. Rather than addressing the things that are actually a threat to the life and limb of *all* racialized minorities in Germany, the commissioner prioritizes policing anti-Zionism among artists.

There is also a sneaking revisionism afoot at the moment. I'll give you a recent example of something I found shocking, and which no official Jewish community group in Germany has spoken about. On the occasion of the celebration of Israel's seventy-fifth 'birthday' (as the Germans refer to it), Ursula von der Leyen, the European Commissioner and a German Christian Democrat, said that in the wake of 'the greatest tragedy in human history' – not crime, note, tragedy – 'we see the "miracle" of Israel's birth'.

Prochnik

It's a very Christological position in the sense that the crucifixion makes possible the birth of humanity's – or in this case Germany's – redeemer. But what should one do instead? If you were to address a progressive group in the United States or Europe about what *should* happen in such a reckoning, what would you propose?

Weizman

Rather than looking at the Holocaust in a Christological way – a second sacrifice – it's critical to look at historical continuities in all their dimensions. There is by now a growing scientific-historical consensus – however unrecognized in Germany itself – that elements of German and European colonialism more generally helped establish the ideological grounds for the racial politics and extermination of Jews in Europe. In addition to other historical forms of antisemitism, the Holocaust has an imperial-colonial ingredient to it. German memory politics, as it is presently configured, simply has no space for this connection to be drawn explicitly. The Holocaust remains historically atomized, and sacred.

Would it not be more productive to see the Palestinian Nakba as a continuation of the crime of the Holocaust, extending all the way to 1948 and 1949, and to understand that Europe and Germany bear some responsibility for the ethnic cleansing of Palestine? Instead there is an immaculate break after the end of the war in Europe, and the Palestinians are cast out of the narrative – just as the continuous repression of Algerians by the post-war French government has for years been eliminated from the official French narrative of its role in the European conflict.

All this shows how the German state bolsters its legitimacy by elevating a narrowly circumscribed slice of its past into an object lesson. Germany's political history is rife with examples of leaders and parties demonstrating their excellence at making distinctions, at circumscribing and selecting, lecturing everyone else about what the right path is, what the right memory is, what counts as being civilized. In this way, Germany universalizes its provinciality. It analyzes the world through the filter of its own history and makes its very particular trajectory into a general law that enables it to discipline

others. Germany is very invested in the idea of being the best at being the worst. Being an antisemitic perpetrator is thus projected as a form of moral expertise to be shared with the world.

Prochnik

You've spoken about the notion that there is an official, state-engineered project of building a post-Holocaust Jewish community in Germany, along with a separate, organic process whereby a Jewish community has begun taking root there on its own terms. What do you mean by this?

Weizman

There are multiple Jewish groups and communities inside Germany today. In the 1990s, after reunification, Germany encouraged Jewish peoples to migrate from the former Soviet Union and settled them in different cities. In its attempts to revive Jewish life, it sponsored the construction of synagogues, community centers and schools, despite many of the former Soviet Jews not having had an experience of Jewish communal life or strong national or religious inclinations. These state-organized communities became aligned with Israel through the consulates and the embassy. Israel's national holidays were prominently celebrated as a matter of course. But early in the 2000s, another type of migration became manifest: Palestinians and Israelis, including many artists and writers, migrated to Germany, and especially to Berlin, independently. Israeli Jews who moved to Berlin may have valued or rediscovered facets of their Jewish identity, but they were not being organized or represented by official Jewish communities. They were certainly not aligned with Israel. Many of

these individuals were non- or anti-Zionists. Some discovered that in Germany they could build more equal relations with Palestinians, unmediated by the skewed platform of contemporary Israeli Apartheid.

Prochnik

Isn't one of the challenges, however, that along with the manipulation of the concept of antisemitism you've both been elucidating, there are also instances of genuine antisemitism arising from the ostensibly progressive side of this conflict?

Weizman

There certainly are occasional disturbing, very real antisemitic tendencies that exist in some parts of the anti-colonial Left. These were on display at Documenta last year. At the exhibition in question, two antisemitic figures appeared on a banner. The most incendiary was an Orthodox Jew with bloodshot eyes and an 'SS' insignia on his hat. He was nefariously plotting in the background of an otherwise anti-Suharto montage of imagery.

We were all offended alongside the Jewish community in Kassel. We all wanted this picture taken down. The curators of this exhibition, an Indonesian collective named ruangrupa, which had not taken proper account of the banner's contents beforehand, concurred with this judgment. They removed the picture. But on the back of that outrage, a sweeping project of closure and repression was launched, led primarily by opinion writers in the media along with certain German politicians. It was as if the banner validated what the state

had been saying all along about left-wing antisemitism: that post-colonial thinking as such is, by definition, antisemitic. (In Germany, the term post-colonialism applies to both anti- and decolonial work.) In this charged atmosphere, there was a sense that physical violence would invariably ensue. The exhibition spaces of our Palestinian friends at Documenta were in fact raided and defaced with graffiti that contained death threats.

Ultimately, the Documenta episode has proven instrumental in enabling the Right to claim that there's a slippery slope between speaking about colonization and apartheid even in places outside of Palestine – in South Africa or Namibia for example – and making a critique of Israel that invariably breeds antisemitic tropes.

Dische-Becker

Documenta represented a new turning point, after which antisemitism became de facto categorized as a kind of 'permanent emergency', like the 'war on terror', requiring not just the cancellation of plays, prizes and exhibitions at an alarming rate, but also the amending of citizenship laws to exclude people from Germany altogether if they had ever participated in antisemitic demonstrations – a category that encompasses any Palestine solidarity event. German state authorities now ban such gatherings preemptively on the grounds that antisemitic utterances have been made at such events in the past. This year, for example, Berlin authorities outlawed all Palestinian demonstrations to mark the seventy-fifth anniversary of the Nakba. They cited, among other things, their concern that protesters might describe Israel as committing the crime of 'apartheid'. Such comprehensive silencing is a perversion of Germany's self-image as a liberal democracy.

One last point regarding the cultural memory project of so-called anti-antisemitism: It grants to the heirs of perpetrators of the Holocaust and of colonial massacres, as well as contemporary perpetrators of racist exclusion, the sole moral authority to enforce the lessons they choose to draw from their own history of violence. On the basis of what we're seeing today, this translates into the effort to ensure that certain continuities of dehumanization, mobilization of popular resentment and German self-victimization aren't acknowledged, even as solidarity among different racialized communities is disrupted. The lessons of German history have to remain static. They are reduced to the negative exceptionalism of 'Never Again Auschwitz', lest they offer us any guidance to fighting injustice in the present, or elicit further demand for reparations in the case of a place such as Namibia.

Prochnik

You've identified a panorama of instances in which the instrumentalization of antisemitism and Zionism for select political aims poses a danger to Germany's vulnerable populations, including migrants, Palestinians and Jews. These miscarriages of justice are becoming more blatant and contentious. Do you feel that the attention this problem has begun generating is going to trigger any significant pushback?

Dische-Becker

It's now apparent that the issue of anti-antisemitism represents a laboratory for larger anti-democratic policies, functioning as a precedent for prohibiting other forms of protest as well. First they

canceled the Palestinian demonstrations, now they prevent other demonstrations mounted by the Left. For example, the government has begun cracking down on environmental activists with measures such as preventative imprisonment. The German police also recently declared *Letzte Generation* ('Last Generation') – an environmental protest group – to be an organized-crime syndicate. The police have behaved atrociously and illegally – banning, for instance, anti-fascist demonstrations in Leipzig after the sentencing of Antifa militants in May 2023. We've unsurprisingly also witnessed an increase in police violence – of racialized people being murdered by police in Germany, something that had formerly been considered inconceivable in unified Germany.

All of this brazen, wide-ranging repressive activity means that there is an opening for people to connect the dots. The people who have a firsthand understanding of authoritarianism and the people who cherish democratic freedoms most are people who have a history of being on the receiving end of political violence. There are many people in Germany today with that background.

Weizman

Another area where opposition to these negative trends can be located is in the struggle for Jewish identity itself that is now taking place in Germany – that's to say the resistance to the Israeli state model of a national-ethnic state in favor of a diasporic one, which is non-nationalist and sometimes anti-Zionist.

It's not that similar struggles aren't being fought in Britain, in the US, and in other places, but it's inflected differently in Germany because of its history and because of the responsibility that Germans have toward Jews. We do not deny that special responsibility; we just do

not think that it's for the Germans to say to us what kind of Jews we should be, what kind of project we should be part of. Both Emily and I, as Jewish intellectuals in Germany, find ourselves occasionally being deplatformed, being publicly disciplined – being lectured by the children and grandchildren of the perpetrators who murdered our families and who now dare to tell us that we are antisemitic.

Dische-Becker

The Jewish identity question in Germany breaks down into two main factions: those who believe Jewish well-being and safety derives from appeals to the moral authority of the perpetrator-heirs, and Jews who see Jewish well-being and safety in solidarity with other minorities. That's the dividing line. You can call it Left or Right but that's the crux of it.

With respect to Germany as a whole, if the state takes a more right-ward turn, via its assumption of national singularity, that will be the worst outcome conceivable for vulnerable populations, even beyond Germany's borders. Germany is *the* arbiter in Europe when it comes to both antisemitism and migration. If Germany says it's fine to drown people in the Mediterranean, then it's fine to drown people in the Mediterranean because the people who are the most sorry for their past treatment of minorities and have learned the most from their abuse of racialized people say it's fine. If Germany says the people trying to get to Europe are a danger to Jews so it's fine to deny them entry, then it's fine to turn them away.

In its more extreme form, German overidentification with Jewish nationalism means that the Germans arrogate to themselves the right to project how they would feel if they were Jews. So for a particular kind of German who has strong feelings about Israel, the response to a Jew

who isn't gung-ho about Israeli militarism, is one of visceral disgust. The alternative Jewish responses to the contemporary landscape that Eyal and I have been advocating violate the Jewish identity that Germans have been imagining for themselves. Faced with this German exercise in inhabiting Jewish history and sensibility, I just feel like saying, *Go fuck yourself.* I have no gratitude. Not for Germany, and not for Israel.

Weizman

Once again, Germany defines who is a Jew, right? The irony that the German state would actually classify who is a Jew, and what's a legitimate Jewish position, and how Jews should react, is just beneath contempt. ■

FC ST PAULI

Ilyes Griyeb

Introduction by Imogen West-Knights

There's a pub around the corner from St Pauli's stadium, the Millerntor, called the Jolly Roger. It's named after the St Pauli logo: a skull and crossbones. Inside the bar there are thousands of stickers papered across every table and wall: hammers and sickles, pro-LGBT slogans and Che Guevara's face stared out at me from a hundred directions. I arrived at the pub at 1 p.m., in time for kick-off at 3 p.m. It was quiet, but outside the streets were busy. Little kids chased each other while ageing hard lads wearing jackets emblazoned with skulls and crossbones ate pizza on the kerb. There were black St Pauli hoodies, rainbow St Pauli T-shirts, anti-fascist sweaters, pins, badges, socks and caps.

Merchandising is a hot topic at St Pauli. The fans have long protested against money interfering with the club's spirit. Many of the old guard think that the availability of a St Pauli x *Rick and Morty* T-shirt is a sign that the club has become too commercialised, a brand rather than a cause. The stadium gift shop supported this complaint. There are tubes of St Pauli sun cream, St Pauli rubber ducks, bibs and dummies, caps retailing at €30, and even a St Pauli toaster.

Outside the stadium there were lots of women. Dads with daughters sat on their shoulders and groups of teenage girls. I asked Antonia and Kim, two eighteen-year-old Hamburgers, why they'd

come. 'We feel safe in the crowds,' Antonia said, taking a drag on her cigarette. 'And the community is the right side, politically.' As we spoke, the team arrived, but the reaction from the fans was surprisingly modest. No clamouring for attention from the players, just a few muted chants of 'St Pauli, St Pauli'.

I went upstairs to the press centre where I met Sven Brux, the head of security. He was jittery with pre-match nerves, clutching a coffee and currywurst. Brux has had a hand in shaping the last forty years of St Pauli. 'The politics kicked off with us,' he told me. 'We were punk rockers, I had green and grey spiky hair,' he said, splaying a hand in the shape of a mohawk above his bald head. 'Nowadays, it's more organised. We were just a bunch of drunken lads punching Nazis,' he said, smiling at the memory.

Brux acknowledged that St Pauli has changed since then. 'Before, it was a tough, working-class area with a lot of harbour workers and the red-light district. But as society around has changed, so have the people in the ground.'

I watched the game from the press stands. The crowd didn't seem rowdy. There were ultras for St Pauli at one end of the stadium and ultras for Karlsruher SC at the other. Even at this distance, the difference was visible. Most of the front three rows of Karlsruher fans were shirtless and while the Karlsruher flags were for their team, the St Pauli flags were a collage of left-leaning political slogans. There were more Che Guevaras, a picture of *The Simpsons's* Chief Wiggum on an 'ACAB' banner and a flag that read WOMEN, LIFE, FREEDOM.

St Pauli scored a 57th-minute equaliser and then not much happened before full time. The crowd filtered outside into the evening sunshine.

I met Julia, Martina and Paul. Paul told me he never really cared about football back home, in Liverpool. 'But this is more like a social thing.' Julia, who comes from a small town in southern Germany, has been attending St Pauli games for sixteen years. She remembers being at Millerntor-Stadion, watching a 2011 game against Bayern München, when she realised she wanted to marry her now-husband, who originally got her into St Pauli.

Julia and Martina were both disappointed in the Karlsruher ultras. 'I have a son who's fourteen years old,' Julia said, 'and we talked about this kind of behaviour. You don't take your shirt off. This is a safe space.'

I asked them what fans of other teams would say about St Pauli fans. They told me that the clichéd insult for a St Pauli supporter is a *Zecke*, a tick: an unwelcome species of football fandom.

They pointed me in the direction of Knust, a bar where St Pauli were throwing a free party for fans to celebrate the end of the season. On the way, I passed the Jolly Roger, and a woman placidly squatting down to pee by some shipping containers. Knust was busy. Supporters in their thousands thrummed around a stage in the venue's courtyard where indie rock bands played. Middle-aged punks with REFUGEES WELCOME drawstring bags had their kids slung round them as they queued up for bottles of Astra. A boy sitting on some pallets worked his way through a white sausage twice the length of his head.

I ordered myself a bratwurst and the nineteen-year-old serving them, wearing a 'Cops R Toys' T-shirt illustrated with a cartoon of a burning police car, noticed my notebook. I stood there holding a sausage for several minutes while he told me what the team meant to him. 'It's about politics,' he said. 'I grew up here. There's only one choice of team.' It turned out that you can't pay by card and so I handed my lukewarm, uneaten bratwurst back to him.

I joined a long queue for the Portakabins. The man in front turned to me and said, 'The toilets are too small for so many.' He told me his name was Bernd and that he played for St Pauli in 1978. He prodded the two guys who were queuing ahead of me and told them something. They turned to me and one of them said, 'If you want to go first it's okay.' I said no, thank you, and asked him why. Bernd gave me a significant look. 'It's St Pauli,' he said.

It was all a little self-congratulatory. But it was difficult to begrudge them, because the atmosphere was genuinely convivial. The team themselves rolled up at about 8 p.m. If I was in England, people would be roaring and puking by now. People were a little drunk, but the worst behaviour I witnessed was some dude going to town feeling

up his incredibly sunburnt girlfriend's arse while the team captain, Jackson Irvine, a long-haired Australian midfielder who joined St Pauli in 2021 after playing for Hull City and Hibernian, addressed the crowd. Most people around me couldn't hear what the footballers were saying, but they didn't seem to care. They weren't really there to see the players, they were there to see each other.

As the night progressed, the children were taken home and Irvine took to the decks inside Knust and played an endearingly shoddy DJ set featuring ABBA hits. From across the courtyard, someone brayed 'Phillip Schofield' to the tune of Big Ben's chimes. I found Joe, a QPR fan from Wandsworth, visiting Hamburg with his friends.

'I like the counterculture obviously, it's a good vibe,' he said. One of his friends turned to us.

'Nine out of ten women in Hamburg fancy Joe,' he told me. 'Is it hard to interview him because he's so good-looking?'

'Mate, shut up. The worst thing about it is that it's not even true, it's literally not true. Is it?' he asked me. Joe and his friend then got into an argument about whether or not Joe went to private school. I asked him what counterculture means to him.

'It's being able to go to the football and have a fucking thick old beard. English football is nasty, it's homophobic and racist. There're no clubs like this in England.'

I wandered over to ask a pair of girls for a lighter. Jana and Paulina, art students in their early twenties, were both from Hamburg.

They told me about how the team shapes their social life in the city. This party made more sense to me – socialising and nightlife are an intrinsic part of what St Pauli means in Hamburg. If a bar has a St Pauli flag, they know they will find reliably leftish people inside.

I asked them whether there is any truth to the idea that some supporters wear the merchandise and claim a passion for the club in order to steal left-wing valour. They laughed.

'Of course,' Jana said. 'We call them *Maca*. "Maca" is like . . . Left posers would be a rough translation. They have St Pauli on their shirts, but they don't live it.'

What doesn't impress her is St Pauli fans congratulating themselves when they march against fascism in Hamburg. The political composition of the city has changed a lot since Sven Brux's youth. There aren't really many neo-Nazis to punch any more.

'We have such big leftist demonstrations in Hamburg, and they're shouting "*Anti Fascista!*" but to who? There are no Nazis,' Jana said. 'Go to the east and experience ten people demonstrating against three hundred Nazis.'

Next I met a group of friends in their early thirties, several beers down, who were not so keen to talk politics. They were there to have a laugh. Henning, a teacher, opened our chat with a poor imitation of an English accent. 'I'm from London mate!' he said. They saw Irvine DJ. 'I think St Pauli are the only club whose players would DJ at the after-party,' said Henning's friend Lea. She gestured towards Irvine, who was dancing to Kylie Minogue.

When they discovered that I was at the party alone, they insisted I join them. The crowd on the dance floor lurched through the European canon – the Killers, Red Hot Chili Peppers – and at 4 a.m., Johnny Cash's version of 'Hurt' began to play.

'In Germany,' Henning shouted in my ear, 'this song means it's time to leave.'

We did, for a late-night snack at KFC on the Reeperbahn.

'All the clubs in eastern Germany hate St Pauli,' Lea said.

'We hate them too,' Annika replied, putting her middle fingers up in the air.

'Motherfucking Nazis,' added Henning.

Once we'd eaten, we went our separate ways. Henning clapped his hands on my shoulders. 'Welcome to St Pauli,' he said. The myth-making continued.

The next morning, as if summoned by the St Pauli PR department to drive home how different a team they are, Irvine was at the gate preparing to board my easyJet flight. A security guard asked for a picture for his brother. Irvine obliged, before heading onto the plane, where he sat down in a normal, cramped seat, just like the rest of us. ∎

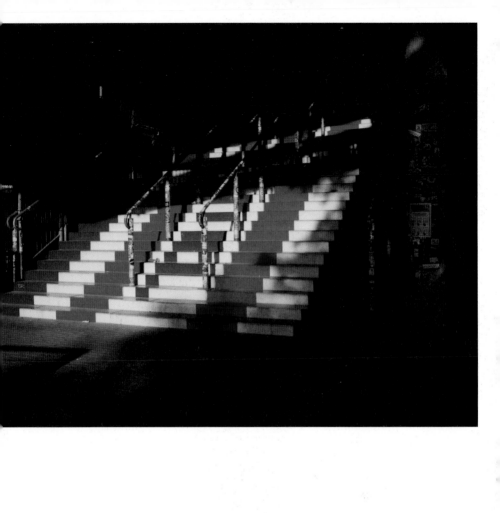

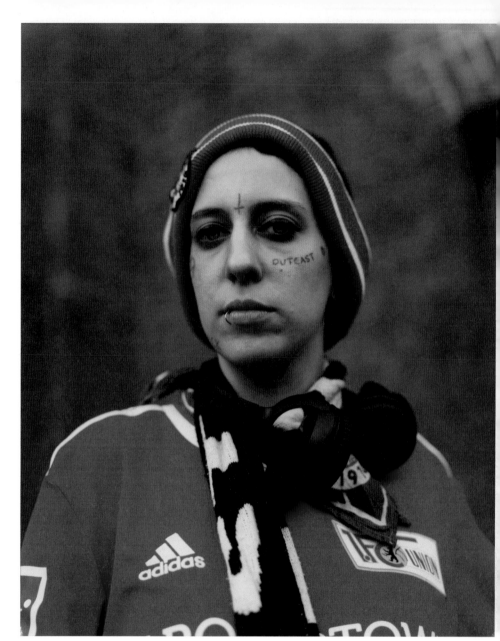

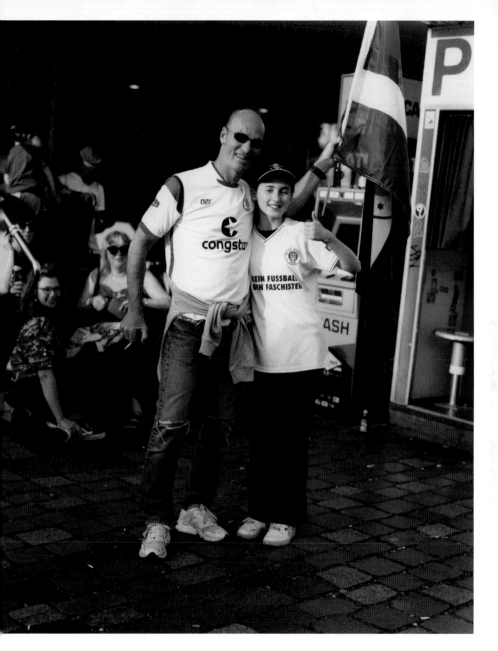

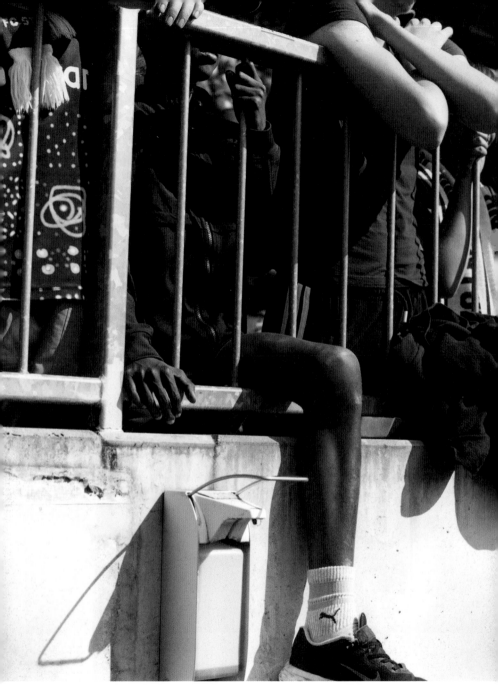

CBC
CURTIS BROWN CREATIVE

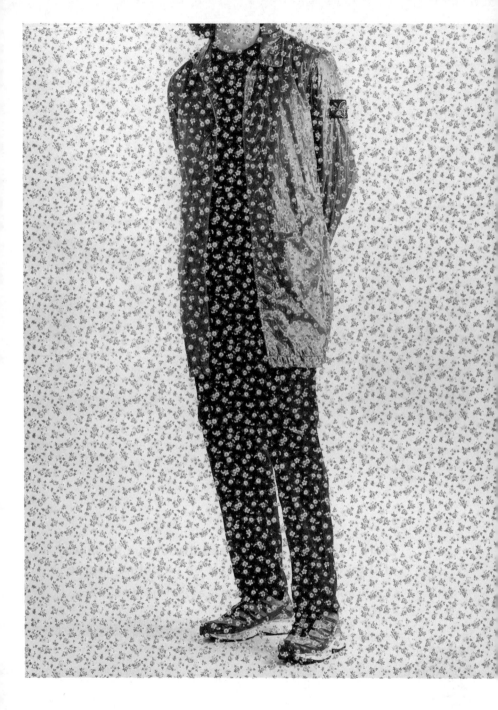

TOBIAS KASPAR
Personal Shopper (Mille Fleurs), 2022
Courtesy of Collection N Mirabaud & Cie, Geneva

ALLEGRO PASTELL

Leif Randt

TRANSLATED FROM THE GERMAN BY RUTH MARTIN

1

Maundy Thursday, 29 March 2018. The Frankfurt Hauptbahnhof was flooded with mild evening sunlight, and the passengers waiting on platform 9 cast long shadows. At 18.30, Tanja Arnheim arrived on the 375 express from Berlin, punctual to the minute. When Jerome Daimler, who was holding a paper bag of fresh pastries, saw her get off from somewhere near the restaurant car, he wondered for a moment whether he should walk up the platform to meet her, but then decided it looked more charming if he just stayed where he was. Tanja's straight hair was waxed flat against her head and tucked behind her ears. She was wearing headphones and wheeling her small suitcase straight towards Jerome without seeing him. Jerome couldn't help but smile, and when Tanja finally spotted him among the milling passengers, she beamed as well, which was always something of a revelation for Jerome; you might assume

Tanja Arnheim was someone whose expression never changed. And then, suddenly: lively, shining eyes; straight teeth. Tanja took off her headphones, and they kissed. '*How's it going – are you hungry?*' That was a question Jerome didn't really have to ask; Tanja was usually hungry, and after a four-hour train journey she was sure to be.

'*I ate in the restaurant car. The Maultaschen were actually okay.*'

They kissed again.

'*Do you want to go straight home? Or shall we get a drink somewhere around here?*' Jerome winked. And Tanja winked, too. '*Let's have a drink at home.*'

They walked hand in hand towards the U4. In the past, it had been a rare thing for Jerome to hold a girlfriend's hand as they walked through crowds. But with Tanja, he no longer thought twice about it. A small queue had formed in front of a stall selling freshly squeezed fruit juices, and there were still customers visiting the enormous newsagent next to Burger King to buy glossy magazines.

On her last visit, Tanja had told him that she thought it was much more fun to send short videos and photos from the periphery than from the capital city, which everyone had seen. She often took fast trains across Germany, Austria and Switzerland for work, and she tried to make at least one long-distance trip a year as well. She thought a lot of people wasted their potential by not leaving their own little worlds often enough. Jerome had agreed with her.

In the busy U-Bahn carriage they sat side by side and kissed with their eyes closed. Jerome was infatuated with the role of the blissfully happy heterosexual partner. One moment he was turning the eastbound U4 into his own personal movie set, and the next he forgot his surroundings completely. During a pause in the kissing, he placed his right arm around Tanja's comparatively broad shoulders with an extravagant gesture and gave her a tender smile. He realised that he didn't have full control over his facial expressions and took that as a good sign. Jerome liked the thought that if he could see himself from the outside, here on the U4, he might find himself insufferable. Liking a thought that would unsettle other people was typical of the new

Jerome, who now drew a playful line between an inner personality that only he himself could know, and an outer personality assembled from qualities that other people attributed to him. He could recognise his outer personality in photos and in the mirror, where he automatically saw himself through other people's eyes, through their assumptions and associations. His inner personality was something he felt most strongly when he closed his eyes once a day to pretend he was meditating. In the past eleven months, he hadn't once achieved a state he would have described as 'classically meditative' – he had no interest in emptying his mind – but he still found his attempts at meditation worthwhile. He believed that the voice that spoke within him then, which reminded him of his laptop's read-aloud function, was the voice of his inner personality. Since Jerome had come to know this voice, he'd almost stopped worrying about how other people saw him, and so there was nothing to stop him from occasionally sporting conspicuous accessories, like the orange vintage Oakleys he'd worn the Friday evening before last.

Jerome was surprised to see that comparatively few passengers in the U4 were looking at their phones. A teenage girl was staring at Tanja. She was noticeably well made up. '*Do you think she follows you on Insta?*' Jerome whispered. Tanja had developed a sure sense for the attention of strangers. '*She just likes my shoes,*' she said. Since Tanja's short novel *NovoPanopticon* had been published three and a half years ago, the occasional person with an interest in the arts had started to recognise her face. Her book was about four male friends who have a meaningful virtual-reality experience in the dormitory of a disused rural school – and so, among other things, she had been invited onto Markus Lanz's talk show as an expert in VR.

Tanja had accepted the misunderstanding with thanks, but once she was on the show, she'd pointed out that she only knew as much about VR as anyone else who had looked up the term. This was either coquettish and arrogant or refreshingly honest, depending on whom you asked. Liam, the main character in Tanja's miniature novel, creates a mindfulness VR, through which his friends increasingly

manage to control their addiction to sexual validation – at least until a jealous ex-boyfriend hacks the system and starts playing the protagonists off against one another. Jerome had laughed a great deal as he was reading it. He had only read the numerous critiques of the book once he'd got to know Tanja personally. It seemed that a lot of different people had found a lot of different things in *NovoPanopticon*. A few fans even went so far as to say that reading it had changed their lives. And those who didn't like the book seemed weirdly proud of not liking it; a distaste for something that had been meaningful to other people gave them an obscure sense of superiority. Two women had written essays criticising the fact that Tanja was a woman writing about men. And there was an article by a junior professor which said that Tanja Arnheim, whose facial features were repeatedly described as *striking*, was a kind of icon for gay academics between the ages of twenty and forty-five.

Jerome had parked his one-year-old rented Tesla at the Kruppstraße U-Bahn station, not far from the Hessen-Center – an indoor shopping mall on the outskirts of the city, which held countless, largely positive childhood memories for Jerome. He had often gone for Chinese food there with his mother at the start of the school holidays, though the Chinese restaurant was now a thing of the past. Jerome thought he'd last had lunch in the dimly lit restaurant with the aquarium in 2004. It was a place from another age and yet Jerome's memories of it were very much alive. During Tanja's last visit, they had wandered through the Hessen-Center together, and he'd talked to her about how much the mall had changed, and the extent to which these changes reflected a transformation of consumer behaviour in general. In the 1990s, a visit to an out-of-town shopping centre still had a certain attraction even for well-off city-dwellers, which meant that the Hessen-Center was able to house more upmarket boutiques, as well as restaurants you wanted to spend more than half an hour in. In the course of his monologue, Jerome had uttered the words *crispy sweet-and-sour duck* in a way that suggested a kind of burning nostalgia, and as he was speaking, it occurred to him that he

sometimes told Tanja things that weren't necessarily of any interest to her. Tanja had replied that this was precisely what she liked about him. So few people, she said, dared to talk about genuine memories, since by their nature those stories were short on punchlines – and she thought this was part of a structural problem that was closely tied to the global economy. '*But my boyfriend Jerome Daimler is evidently immune to problems of this sort,*' she said in the Hessen-Center, smiling at Jerome. Jerome felt a warm sensation in his belly and kissed Tanja on the lips.

Jerome had never felt immune at any point in his life. He had always been preoccupied with the world around him. But in the noughties, when he was in his early to mid-twenties, other people's concerns had begun to weigh more heavily on him. When he used to see a mother arguing with her child, he would first consider how he would react as a child, and shortly thereafter, what arguments he would make as a mother. He'd found considering both these things debilitating. But now Jerome didn't think about anything when he saw a mother and child arguing. He had the confidence to distance himself from these situations, though without sacrificing empathy – quite the reverse: he now found it easier to understand other people's troubles, he was fairer and kinder, but he no longer suffered along with them. Jerome always reminded himself of this improvement in his general attitude towards life when he was on the point of getting nostalgic. Nostalgia was just a sad reflex that sprang from a lack of ideas – his mother had told him something along these lines, in English, a little over ten years ago.

Jerome would have liked to know how many Teslas were on the roads in the Rhine-Main area, but he'd never attempted to research it – he wasn't quite that keen to know. He had already been given a customer loyalty discount at Jenny Köhler's Electric Rental, a new institution on the Hanauer Landstraße, although this was only the third time he'd rented a car there. Coloured pennants in the American style fluttered above its car park, and the company was staffed exclusively by young women in loose, sometimes oil-smeared uniforms. From

the Tesla's rear-view mirror hung a green air-freshener tree, printed with the loops and flourishes of Jenny Köhler's signature. Jerome didn't even consider moving the air freshener from his field of vision. He liked using things exactly as they were presented to him. In the same way, he'd always been a fan of subletting furnished rooms and of restaurants whose menus consisted of just a few regularly changing dishes. For a long time, he'd misconstrued this attitude as modesty, but it was rooted in a longing for order and structure, which to some degree had also sparked his interest in design. Jerome believed the drive to design was closely tied to the compulsion to tidy things up. And when everything was already specified and therefore couldn't be tidied, it came as a huge relief. Jerome was able to trace most of his characteristics back to his own biography – even as a child, he had liked to line his toys up on the rug – but he wasn't a fan of classic psychological approaches in general. The facts of his life were easy to state: Jerome Daimler, freelance web designer, born in November 1982 in the Holy Spirit Hospital, Frankfurt am Main, grew up a few kilometres away in Maintal, studied in Düsseldorf and The Hague, began his career in Offenbach, now once again resident in Maintal.

They didn't hit any traffic during the short journey along the A66. The Tesla's grey-and-white interior smelled the way new cars always used to. Tanja connected her phone to the stereo via Bluetooth, and played her Spotify playlist of the week, which, as so often, Jerome liked more than he thought he would. '*Good song*,' he said of one melancholy number. '*That's Bladee.*' Tanja checked. '*Yes. The track's called "Numb/Beverly Hills".*'

In the passenger seat, Tanja was now reading the Wikipedia entry on Bladee and looking at pictures of him. '*Swedish, born 1994. Most of the photos of him are well staged, and a few really aren't. Seems like a nice guy.*' Jerome had mentioned to Tanja before that music by younger artists generally did more for him than stuff by people who were his own age or older. '*I'm glad it's staying light so much later again now,*' said Tanja. Jerome knew that she didn't say this kind of thing just to

fill a gap in conversation, but because she was genuinely relieved. Her readiness to share the most ordinary thoughts was something that Jerome really liked about her.

Strangers sometimes assumed that she was under some kind of psychological strain, probably because she didn't smile very much. But Jerome knew that Tanja was usually able to find something to be happy about. He couldn't believe there were many people with a more positive outlook than Tanja. Her younger sister Sarah, by contrast, who was studying screenwriting in Potsdam, suffered from depression. Tanja had once told him that people born in 1988 were particularly susceptible to mental illnesses; apparently no cohort from any other year in the eighties and nineties was prescribed antidepressants more frequently. But in the Arnheim family it was Tanja, born in 1988, who was usually fine, while Sarah, born in 1992, would be at acute risk of suicide if she stopped taking her medication. Tanja once described this as a statistical curiosity, and at first Jerome didn't know what to say. Later, he said: '*You can't help the fact that Sarah is sad.*'

A lot of the buildings in Maintal looked like they had been designed by primary-school children: symmetrical triangles sitting on top of rendered facades, with married couples inside bringing up children. Most of the little town's houses, even those with weathered, brownish roof tiles, must have been built in the last four to six decades – this was a new world. All the same, nothing about it felt new and Jerome found this oppressive and charming at the same time. Maintal was not about emergence or regeneration; it seemed mostly to be about being left in peace, and this was a desire Jerome could understand, even if it wasn't right at the top of his list.

He parked the hire car in the driveway of his parents' house, a bungalow with a basement floor built in 1978, an unusual style in Maintal. The anthracite-coloured walls and the flat roof stood out from the crowd. From the age of twenty-nine, Jerome had begun to feel a kind of kinship with this building on the edge of the Hartig nature reserve. It suited him now. The fact that he still thought of it

as his parents' house he attributed above all to his essential modesty, though shame certainly also played a part in it. In purely formal terms, the bungalow was now his, though he had neither designed nor paid for it. Jerome's father had moved back to Frankfurt, to a small flat with a view of the Iron Bridge, and his mother, who had been born and grew up in Cambridge, had spent the past three years living in Lisbon, where Jerome had been to visit her five times. Originally, both parents had planned to sell the bungalow they had bought together, and which they now regarded as a sort of *midlife misunderstanding.* When Jerome's father asked him if he might like to move into it himself, it had been a kind of rhetorical question, but on Christmas Day 2016, Jerome had suddenly said: '*Actually, why not?*'

Tanja and Jerome liked to talk about the night they first met. Both thought it rather unusual to begin a relationship with a one-night stand, which is what the drunken episode at Flemings Hotel on Eschenheimer Tor had felt like at first. The first screening of the online series of *NovoPanopticon*, filmed on a Samsung Galaxy S7, had taken place in Frankfurt, in Bar AMP, opposite the big Euro symbol on Willy-Brandt-Platz. There were more men than women in the audience, and in late-summer 2017 a few of those men were still sporting meticulously groomed full beards and wearing dark clothes. Jerome, who had never had a beard, was sitting in the back row, and took an immediate liking to Tanja, though he didn't raise his hand during the Q&A. It was only after the screening, when Tanja was standing by the DJ booth drinking a mineral water with the evening's moderator – a lecturer at HfG Offenbach whom Jerome knew through friends – that he went and spoke to her. He said he'd liked the presentation of the four-part miniseries, without being too effusive.

The two of them had stayed in AMP until the bar closed, and then went on to Terminus Klause, where they started kissing, and after two large glasses of Apfelwein with sparkling water, they decided not

to avoid this awkward first night, but to see it through with a degree of coolness. They hailed a taxi and went to Tanja's hotel. The sex in the incredibly stuffy room was not particularly good, but there was a sense that it might become good eventually; it had promise, Jerome thought, and so ultimately it was good sex.

Tanja washed her hair the following morning after just four hours' sleep, in a glass shower cubicle that (true to the Flemings' quirky style) was situated in the middle of the room and printed with a translucent Flemings logo. Jerome stayed sitting respectfully on the edge of the bed with his back to her the whole time, looking at his phone. That evening she texted him from Munich: *Seems like there's no one in the whole of Bavaria to get wasted with.* And Jerome wrote that dinner with his father had been surprisingly harmonious. His lack of sleep had ensured that he was more patient than usual. Jerome didn't have to think too hard about what he was writing to Tanja; it felt normal to send her several messages one after another, and yet it was still exciting, which made him suspect that this was the start of something new.

The last time Tanja visited Maintal, they had slept together the minute they got back to the house. As darkness fell, they'd driven to Tegut, and then fried some soy steaks. Secretly, Tanja might have been assuming that this sequence of events would be repeated and become a kind of tradition, but this time Jerome had already done the shopping. *'Espresso or something alcoholic?'* he asked, and then they had an espresso followed by several glasses of the second-cheapest sparkling wine on offer in Tegut. They sat arm in arm on Jerome's anthracite-coloured sofa in south Hesse.

At no point did Jerome feel that this image was very 'them', and nor did he feel like he was sitting on his own sofa in his own house, but he still felt good. *'It's supposed to rain tomorrow,'* Tanja said, looking at her phone. She sounded surprised. Jerome, too, had automatically assumed that they were expecting an unusually warm and sunny Good Friday. Generally speaking, the weather was bombastically fine when he spent time with Tanja. She asked if they could do a bit

of work on her website at some point during the day. The second time they met – a date that began outside the Wurst-Basar concession in Hamburg's main station and continued in a pub at the station's southern entrance, where they both subsequently missed their last train home – they had agreed that Jerome would build her a website (tanja-arnheim.space) and that from now on they would officially be a couple. Tanja's home page, designed and built by Jerome Daimler, had inevitably become a symbol of commitment. '*Maybe instead of working on the page tomorrow, we could go to the Schirn gallery and then to the cinema,*' Jerome suggested. Tanja agreed at once. '*Yes, that's a better idea.*' Jerome knew that she was secretly scared of her website. Which colours, shapes and flourishes could express who she was in spring 2018 – these basic questions made her feel quite stressed. Jerome had therefore long since decided to build the website on his own and present Tanja with the finished design on 30 April, the day of her thirtieth birthday. A labour of love, as in ages past, he thought: a first home page of her own. Jerome was working flat out on it.

'*A*re any of the characters from NovoPanopticon *going to feature in your new book? Have you posed a question for it to answer? Is there something like a central theme?*' When the first bottle of cava was empty, Jerome felt a little like he was interviewing his girlfriend and he suspected that she liked it: his interest was genuine, he was asking both as a partner and a fan. As he went into the kitchen and took some clean glasses out of the cupboard, which he filled with ice cubes, cranberry juice and Skyy vodka, he could hear Tanja saying: '*I don't think you should ever define your theme too precisely.*' And after a little pause: '*The characters are similar, but they're still new. They seem more religious to me.*'

In *NovoPanopticon* the all-male characters were emotionally unstable, their behaviour was occasionally obsessive and there were few hints about their parents. The change of focus from psychology to religion seemed like a sensible move to Jerome. It struck him as somehow freer. Because while people often seemed entirely at the

mercy of their own psyche, religiousness was something you might be able to design. Jerome had chosen not to participate in confirmation classes at the age of thirteen, but to this day he still paid his Church taxes. On Christmas Eve 2017, when his mother came to visit him in Maintal, the two of them had gone to the Christmas service. It had been a spur-of-the-moment decision to attend, simply because it was something Jerome and his mother had never done before at Christmas. When they walked into the church, the only seats left were up on the balcony, on the left-hand side. From there they could look out over the packed nave. Jerome sent Tanja a short video, and Tanja, who was at her parents' in Kiel, replied immediately: '*Pretty church.*' Jerome was surprised by how relaxed the congregation seemed at this service – the reason being that, until then, he had only ever set foot in a church for funerals. Five of them in total: his two grandmothers, Greta and Mary; the father of his friend Mark from primary school; Judith, a fellow student in Düsseldorf; and his godfather, Falk. After attending three of these five funerals, Jerome had decided to leave the Church: the Christian ritual hadn't comforted him, but made him feel alienated every time. Ultimately, it must have been his father's comment that the Church also did a lot for society more generally that stopped him from actually leaving.

And now, with a cranberry-coloured glass in his hand, Jerome said: '*During the service, a young girl did a flute solo, and she played one wrong note after another. It was laughable, really. But instead of laughing, the entire congregation was embarrassed for her. Everyone was sympathetic. I think that was when I understood the Protestant religion: listening attentively to a mediocre piece of flute music, hoping no one messes up, and then being sympathetic when the schoolgirl hasn't practised enough, because you suspect the failure will stay with her a long time. That's Protestantism.*'

Tanja grinned. '*You've been taking aim at your own background a lot recently.*' She was just making a statement, but all the same Jerome felt attacked.

'*Yes, sorry … you're right. I talk about it too much.*'

'*Jerome, baby.*' Tanja reached for the loose sleeve of his shirt. '*I didn't mean it as a criticism. It's cute when you tell me things more than once.*'

When Jerome closed his eyes to kiss Tanja, he felt dizzy. '*Are you feeling dizzy too?*' he asked.

'*Totally,*' Tanja laughed.

'*What about nauseous?*'

'*No.*'

'*Me neither.*'

After that they had rather solemn sex on the sofa, spurred on by the conviction that they were now doing something unquestionably good for their bodies and souls. At one moment Jerome even believed that their act was helping to improve the energy of the whole planet. He moved with unusual awkwardness, and Tanja pushed herself against him in a rhythm that seemed new. Once he had come and then, shortly afterwards, she had, his thoughts about energy made him laugh. Jerome's first impulse was to tell Tanja about his energy theory straight away, but then he thought that you didn't have to talk everything to death immediately. He would simply continue to observe their sex and planet Earth. Tanja kissed his left temple, then she laughed, too. They got up from the sofa together and, seven paces away, lay down feeling slightly dazed on Jerome's 140 cm wide mattress. They slept back to back.

2

The week after Easter was warm and sunny. It was Tuesday evening when Tanja got back to her two-room apartment, from the balcony of which she could look out at the Hasenheide park. If she'd had the same depressive tendencies as her sister Sarah, Tanja might have found the mood on the street oppressive. In big cities, the first warm days of the year had such potential for social anxiety; in Berlin, it was all about having a good time in the most performative

way possible. Tanja thought that, even when they'd been in the city for years, a lot of people who'd moved here found it hard to accept that, despite the warmth of the sun, they would rather be working in the shade than sitting outside a corner shop drinking Sekt, which seemed to be the new thing. Tanja, too, had taken a while to recognise that in the long term, it wasn't enough for her to hang around outside and be liked. What she really wanted was to produce work that even the harshest audience would enjoy. The fact that this work was writing wasn't so important; it might just as well have been fashion or video art, Tanja sometimes thought. But in truth, all she had ever done was write, it came easily to her, and it went better when she was doing it regularly.

In retrospect, Tanja thought it was good that she and Jerome had argued late on Good Friday about *Call Me by Your Name*. The argument showed that they were both still developing their own thoughts and perspectives and didn't depend on each other for their opinions. They had sat in a couple's seat, the ones without a central armrest, at the Metropolis cinema on Eschenheimer Tor, sometimes arm in arm, and yet they had seen very different things in *Call Me by Your Name*. Jerome had let himself get caught up in the obvious beauty of the on-screen world – like most of the other people who had told Tanja about the film, which told the story of a homoerotic summer romance between a teenager and a doctoral student in 1980s Italy. But Tanja felt repelled by it. She found *Call Me by Your Name* horribly vain. The chemistry between the two main characters hadn't left her completely cold, but the film's implicit message seemed to be that you could only build happiness, tolerance and humanity on a foundation of wealth and elite education – and that bothered her. On the way back in the Tesla, Jerome said that perhaps it was all just too painfully close to home for her, as the pretty daughter of well-to-do academic parents, and that she at least had to acknowledge the film's stylistic perfection, and Tanja raised her voice. Please could Jerome just accept that the film hadn't really done anything for her. And when Jerome started to respond, Tanja said: '*Shut up now, Jerome.*' They didn't speak again the rest of the way home.

Tanja could be sharp-tongued on occasion. Her mother and sister knew that best of all. But apart from her ex-boyfriend Max, very few people outside her family would have imagined she had a choleric side. Tanja Arnheim was sometimes regarded as other-worldly, lethargic or arrogant, but never aggressive.

Not bearing grudges was an important part of Jerome's self-image and so they made up quickly. As Jerome was unlocking the door to the bungalow, Tanja broke the silence – '*Jerome, I'm sorry*' – and he paused for a moment, looked her in the eye, and then submitted himself to a fierce hug.

On 5 April, it almost smelled like summer. After eight and a half hours' sleep, Tanja was sitting in the Hasenheide drinking a sugar-free Red Bull, not far from the still-unfinished Hindu temple, which had been covered in scaffolding for months. The spire was the only part of the temple that had so far been painted in bright colours. Tanja liked the idea that her neighbourhood might one day contain buildings that stood for all the different religions. Everything she knew about Hinduism she had learned in the ninth grade of her selective school in Kiel: that from reincarnation to reincarnation you could rise and fall through the various castes and life forms, and that a lot of gods were represented as human–animal hybrids. It seemed like quite a nice religion. Maybe one day Hinduism would become an option, not necessarily for Tanja, who didn't even like yoga, but possibly for someone she knew.

Amelie had texted to say that she was hungover and wanted to go for food at City Chicken on Sonnenallee, but Tanja had only just had breakfast at home. There was no question of just offering to go with her: Amelie, who was over 180 cm tall and not exactly skeletal, wouldn't countenance eating in the presence of another person if that person wasn't also eating. Over time, Tanja and Amelie had learned even to like each other's more annoying qualities. There was always the possibility of friction between them, but it never escalated. Amelie frequently used the term *therapied out* when she was talking

about herself: in the space of eight years, three different therapists had attested that she'd made progress. Tanja knew that Amelie was still under some psychological strain, but at least she now seemed to know what was causing the strain, and maybe that in itself was a big thing. Tanja and Amelie met up every two or three weeks at around one o'clock on a Sunday, drank negronis and then went to a daytime disco. When they went out, they talked a lot, and their attention was fully focused on each other, so other clubbers hardly ever approached them. A kind of protective space formed around them and in this space Tanja and Amelie often had a really good time.

Amelie stopped off at the Hasenheide on her way to City Chicken. She was wearing a dark-coloured dress; it suited her, it looked timeless and laid-back. She wasn't one to follow the latest fashions, and her trainers were the only things that usually looked brand new. Amelie had been out to Heiners Bar the night before, and then to the newly renovated Bäreneck. To Tanja's ears, that just sounded like banging headaches and unnecessarily existential conversations. It wasn't like Amelie to be out late drinking on a weeknight; Tanja asked what the occasion had been, and Amelie said: '*Oh, you know, just Janis.*' Amelie had introduced Tanja to Janis, who had a striking tattoo on his forearm, in January at a party put on by Trade. Tanja found tattoos on women even more unbearable than they were on men, unless they covered the whole body. Tanja approved of someone deciding to become a *fully tattooed person* like Justin Bieber, but not someone just wanting a tattoo. On matters of style, Tanja would have liked to be more tolerant, but she couldn't help how she felt.

Amelie told her that she'd slept with Janis twice in the week before Easter. She couldn't completely deny she had a crush on him. But last night in Bäreneck, Janis had confessed that he'd fancied Tanja for a long time. Amelie quoted Janis, making her voice slightly lower: '*I thought I would keep it to myself, but it's on my mind all the time now ... and if I didn't say it, then eventually it might go nuclear.*' Amelie emphasised that he really had used the word nuclear, at 4.30 a.m. in Bäreneck. She had been shocked and angry and, for a minute,

speechless. '*Then I told him you can't stand tattoos and you're in a committed relationship. I think he quite quickly regretted having said anything. He apologised, but I was already out of there.*' As she spoke, her eyes filled with tears. Tanja was sitting beside her on the grass, the empty can of sugar-free Red Bull in her hand, trying to think of something to say that wasn't either meaningless or hurtful. Tanja knew that Janis took a woman home practically every time he went clubbing, he was wiry and reasonably tall, he had a pleasant voice, straight teeth and, Tanja thought, he was writing a doctoral thesis on a feminist topic. She also wouldn't be surprised if, beneath his understated clothes, he was a *fully tattooed person*. He was probably also a fan of *NovoPanopticon*. Tanja really wanted to change the subject, but then she said: '*Give him a few days. I mean, it's easy for you. He needs to behave. He's the one with the problem. Try to relax.*' Amelie nodded, looking very sad. '*I'm going to go and get some food,*' she said. '*You do that,*' said Tanja. They stood up and hugged. Tanja wanted to ask if they were still going to the Cocktail d'Amore party at the weekend as planned, but it didn't seem like the right moment. Amelie had already walked a few steps when she turned round. '*I'll be in touch about Cocktail d'Amore.*' And Tanja said: '*Cool.*'

Tanja and Jerome hadn't agreed any policies on information. They told each other whatever they felt like saying, mostly in long instant messages and less frequently over email. The personal, loosely written email that you fired off without having read it back was perhaps Tanja's favourite form of writing. But since 2015, when the last of her friends had finally switched to smartphones, email had been increasingly pushed out by less carefully formulated speech bubbles on various messaging services. That made Tanja value the fact that she had found a worthy email correspondent in Jerome all the more.

His longer missives, which he wrote about once a week, felt like an attempt to compensate for the diary that he'd never kept, and they were always entertaining. He often told her stories about friends

she had never met – so in theory he could simply have made these characters up, but she trusted him, and she was sure he trusted her, too. In their emails they told each other the truth, though they didn't tell each other everything. For the time being, Tanja would keep quiet about the reasons for Amelie's man trouble.

At the weekend, Jerome sent her a selfie he'd taken while he was out for a run. It showed him in a white headband, with a backdrop of windmills and a cloudless sky. Below the image, he wrote: *300% joy.* Tanja liked the message. The photo was vain and not vain at the same time, since Jerome's sweating, slightly red face looked older than usual, but he'd also chosen a flattering angle – offset low down to the left, emphasising his strong jaw – and his expression was goofy in a good way. You could see that running gave Jerome pleasure, and even people much older than he was could look attractive when they were radiating joy.

Sitting at her desk, Tanja looked at Jerome for a second not as the man she slept with and talked with about almost everything, but as a man from Hesse in his mid-thirties, who took cheerful selfies while exercising. She then thought, for comparison, about the men she'd encountered during her trial membership of the Holmes Place gym on Hermannplatz. A lot of them had been attractive, with an aristocratic look about them, which had something to do with the high monthly fees charged by Holmes Place. Jerome would have stood out there in a positive way, as a man whose vanity was refreshingly different. He liked his own appearance, that was true, but he wasn't trying to fulfil some fitness norm. Tanja had ultimately decided not to become a member of Holmes Place. Instead, in May 2017, she had rediscovered badminton, a game she'd played at school in Kiel, and in which she was able to exercise a degree of aggression without the sport becoming at all dangerous.

Hi Tanja, has Amelie spoken to you? Could you please tell her I'm sorry? And ask her to call me? She's blocked my number. Janis.

Tanja wasn't sure how he'd got her number. It very likely wasn't from Amelie, but possibly from her ex-boyfriend Max; Max was

always happy to pass on her details, to prove that Tanja's privacy no longer meant anything to him. Tanja had never blocked a number in her life, nor had she deleted emails or texts that said hurtful things and she had never sought ways to get her own back either; she'd never felt the need to draw a pathetic line under anything. She was proud of that. Instead of responding to Janis straight away, she wrote a message to Amelie, which in retrospect was not a clever thing to do. Amelie claimed she hadn't blocked Janis's number at all. There followed a call from Amelie that Tanja termed hysterical, although she had firmly resolved to stop talking about 'hysteria' in relation to women, because it always felt a bit cheap. Her success as an author, however, made her think the words that came to her spontaneously were usually the right ones. Tanja believed her choice of words was sound in this case, too. Amelie was very hurt by the accusation of hysteria.

In the queue for the Cocktail d'Amore party, Tanja was wearing badminton shoes made by Artengo, Decathlon's own brand. She was 100 per cent sure she was the only person in the queue – which on this early Sunday afternoon was made up of around 400 people – who was wearing badminton shoes. They were a luminous reddish-orange, and it looked like you would sweat more in them than in comparable trainers from more well-known brands, but in fact the opposite was true. Tanja was also wearing grey linen trousers and a grey men's shirt, with a sports bra underneath in case she wanted to take off the shirt on the dance floor. The fully-bare-torso look that was popular at this kind of Berlin rave, even among women, was something she would have found out of character. But a sports bra and badminton shoes suited her down to the ground. The majority of people in the queue were men with dark, buzz-cut hair; not many were wearing make-up. Tanja had worked gel into her own hair until it lay flat against her head and had a slick sheen. She had been standing there for forty minutes when the doorman asked her if she'd been here before, by which he meant Cocktail d'Amore and not the Griessmühle club. Tanja replied: '*Yes, three or four months ago*' – though she knew very well it had been three months – and looked the man in the eye with a

neutral expression. He hesitated for a moment, then let her go through to be patted down and pay the €15 entry fee. She bought a Diet Coke at the first bar she came to, so that she could take the rest of the pill she had been keeping in a transparent baggie in her sports sock. The piece of pill, which had been nibbled on six weeks previously and kept in the fridge ever since, was burgundy, with the logo of the clothing firm North Face printed on it. According to the saferparty.ch website, the whole pill had contained a total of 155 mg of MDMA, so the remaining half should be precisely enough for Tanja's afternoon high. There were good reasons for not taking Ecstasy very often. Tanja liked the effect more than that of any other drug, but since she turned twenty-seven, she had become more sensitive to the after-effects, and now chose to deal with these only four to six times a year. This frequency would probably have to be reduced even further in future. She had told Jerome – who was planning a similar experiment with Ketamine in Offenbach today – that they should take notes on their trips. Since they had been together, they had shared most of their drug experiences, at least on a message level. Tanja didn't even go into the toilets to take it, and afterwards she texted: *Taken at the bar at 14.14. Pleasantly numb. Long-range heating soon.*

Outside, unlike the Cocktail d'Amore parties that took place in high summer, there was no music playing, but men in varying states of undress had gone out to sit in the sun and have sex with varying degrees of obviousness. Tanja's theory was that the second half of the 2010s in Berlin could be remembered as the period when sex parties made the leap into the mainstream. The number of people who went to parties where blow jobs were given in plain sight wasn't exactly small. There were thousands of them at these events every weekend. Tanja couldn't claim to be a fan of this development, but in general she thought it was a good thing that there was an increasing number of places where people could act on their desire for public sex, though she did also assume that a high percentage of clubbers had absolutely no wish to strip naked in front of countless strangers.

O n the way to the toilet, she bumped into her sister. Sarah's pupils were dilated and her forehead was damp with sweat; she approached Tanja accompanied by two guys wearing black vests with silver chains around their necks, probably fellow students at the film school. A hug and a kiss on the cheek was nothing unusual between the sisters, Tanja knew that, but she also felt a special surge of affection from Sarah. Sarah hastily introduced the guys – Tim and Jakob – and from the way they greeted Tanja, with a strangely formal handshake, she surmised that these boys already knew she was Sarah's successful elder sister. Tanja and Sarah agreed to meet up at the outdoor bar at 3 p.m. at the latest, to drink still mineral water together. In the toilet queue, Tanja wondered whether she was seriously worried that her depressive sister was taking drugs, and if so, then what kind of a double standard that was. The interaction between antidepressants and Molly was not ideal, as far as Tanja knew, but on the other hand she was no neurologist. When it came down to it, her unease was really just based on the term 'reuptake inhibitor', which she associated with antidepressants. Tanja looked at her phone. Jerome had sent only the sunglasses emoji, which she found a little disappointing. She considered using her time in the queue to find out more about drug interactions, but she was nearly at her data limit and there wasn't much signal in Griessmühle. They certainly didn't yet live in the age that many people claimed they were already living in. Tanja read some of the texts she'd received in the past few days. Most of them pleased her. Actually, all the people she communicated with had developed a confident tone in their messages. Even her mother was now able to text with some degree of detail, and increasingly managed to skip the formal address – *Dear Daughter*. Tanja was proud of her mum, who worked as a therapist in Kiel, just as her mum was proud of her. Tanja's father, a Hanseatic internist, was also proud of her – according to her mother – but entirely incapable of showing it. Tanja was moved by the thought of her father. He couldn't help it; he was just less articulate than the other Arnheims. That didn't make him a lesser person, though. Tanja decided to give her dad a

call in the next few days, and now she was really looking forward to the faltering start of that conversation. In *NovoPanopticon*, Tanja had her central character Liam say: '*You can either become very like your parents, or get mentally ill. And only if your parents are mentally ill might you manage to do both.*' Although Tanja had already defended this statement in three separate interviews, the insight now felt fresh again. Maybe Sarah had always fought too hard against her role models, maybe that was where the whole problem lay. But was it a problem at all? It was quite warm in the corridor outside the toilets. By the time the door in front of Tanja opened and a mixed group of five emerged – two women, three men – she was feeling really good. She nodded broad-mindedly to all five of them and then turned back to look at the men and women who were lining up behind her. For a moment Tanja contemplated asking whether anyone wanted to go ahead of her – she wasn't desperate – but then it occurred to her firstly that this question would be entirely bizarre when she'd just spent ten minutes waiting and secondly that she was already pretty high. Not having eaten much for breakfast was paying off; the half a North Face was taking effect quicker than she'd anticipated. Tanja entered the toilet cubicle as if being washed in by a wave of bubble bath, and closed the door. She carefully laid tissues all around the toilet seat and sat down. She took her time, she couldn't help but smile, she closed her eyes as she urinated; it was lovely.

Text to Jerome: *Just saw Sarah, she's high. Pleasantly cotton-woolish walking around in the toilet fumes. Far too many men. Miss you.* And just a few minutes later: *Miss U* 👻 *Miss U* 👻 *Miss U* 👻.

Jerome wrote back that his plan to meet up with Bruno and Julian had not come off because Julian's daughter was ill, so instead of walking along the riverside in Offenbach on Ketamine, he was sitting at home with the sun coming through the windows, programming. He still wanted to read the updates on her trip, though, even if they did make him a little envious. Tanja wrote that he should at least have a cider while he was working: *in solidarity with your drugged-up girlfriend not far from the Sonnenallee S-Bahn station.*

Jerome responded: *You only use the word solidarity when you're on xtc. But when you are, you use it every time* 😄.

Tanja stood sweating on the dance floor; looking at her phone, she saw the word *solidarity* in front of her and knew that Jerome was right. She loved him, yes, she really loved him, and she wanted to text that to him now, but then she decided to save it. Their situations were too different. She was feeling the bass; he was looking out at the nature reserve. And for Jerome, Ecstasy was a nostalgic thing. He'd often told Tanja about his 'E-phase' between 2009 and 2012 – a period he'd left behind but would always remember, like the summer of 2001, when he'd just got his driving licence and drove to France for a camping trip on the Atlantic coast with his best friends.

In Griessmühle, things went the way they usually did when Tanja was staring at her phone on the dance floor: people told her with looks and gestures that she should be living in the moment, and put her phone away – but these people didn't understand. They had no idea that for Tanja, this was the most beautiful moment: high, and looking at the gateway to the world in her hand, communicating with the people she liked best in the way she was best at. It was fantastic to own a phone, it was fantastic to have people you loved in your life. Tanja was wearing her shirt tied round her waist, and dancing in her sports bra. She put her arms in the air, closed her eyes. She kept a tight grip on her phone the whole time.

'*Sarah, I'm high!*' This simple statement brought a beaming smile to her sister's face. '*How are you doing? Want to do a shot with me?*' Sarah didn't reply, seemed a little hesitant, but Tanja had already ordered vodka shots for them both. She had been intending not to drink during the party, but the idea of the vodka's slightly burning aftertaste filled her with such a pleasant anticipation that it would simply have been wrong to deny herself the experience. Sarah was only 169 cm, 4 cm shorter than Tanja, but that afternoon you could hardly tell: Sarah was wearing heels, and Tanja had her flat Artengo badminton shoes on. And so the sisters stood facing one another and

clinked their vodka glasses, flooded with a warmth that reminded Tanja of the magical moment when she had tried Ecstasy for the first time. She was even tempted to believe that the trip she was currently on felt just as good as that first one, but that probably wasn't true.

'*I've got a new therapist now,*' Sarah said. '*He's my own age, and half Indian. He's quite nice.*'

'*How often do you meet?*'

'*Twice a week. It's a lot cooler than group therapy.*'

'*Definitely!*' said Tanja loudly. At that moment, she was a 1,000 per cent convinced that group therapy was nonsense. Sarah already knew her elder sister's opinion on this and said that, actually, this wasn't the time to talk about the progress she was making in therapy, while Tanja thought that in the medium term, it would never again be so easy to discuss this kind of thing. Their last mutual high had been four years previously, just before *NovoPanopticon* had come out, and before Sarah had started her screenwriting degree at the Babelsberg film school. That evening, at Club Golem in Hamburg, off their heads on Molly, they'd talked about their parents and both agreed they should have divorced fifteen years ago, and probably hadn't because of Tanja and Sarah – and then, before they went back to the dance floor, the sisters said they hoped their parents had at least been happy to some degree. This time, a comparable moment of truth and intimacy eluded them. Sarah had been at Griessmühle since five in the morning and was starting to get tired, while Tanja was just peaking and might even consider buying another pill from someone. Sarah left the club at half past four. After that, someone came up to Tanja every twenty minutes and asked how long she'd been there or whether she wanted to snort something, to which Tanja answered truthfully, and declined. Despite being in the best of moods, her responses were mostly monosyllabic, and then she went back to dancing with her eyes closed or writing messages to Jerome. When Janis suddenly appeared in front of her at around 10 p.m., wearing a white T-shirt with a Vetements logo on the chest (which Tanja disapproved of), she was less monosyllabic. She could remember

having a really interesting conversation with Janis in OHM once about *Good Time* by the Safdie Brothers, a film that Tanja thought was the best of 2017. Janis had liked it as well, and recommended the directors' previous film, though when Tanja watched it, she liked this one much less. At Cocktail d'Amore, Janis seemed shy and very concerned about Amelie. '*It's funny, of course, seeing you here. I really messed things up with Amelie . . .*' His hair was longer than it had been in January, and he'd combed it into a centre parting, which looked at once absurd and attractive. Tanja tried not to let on that she knew he had a crush on her. She was standing in front of Janis, high and wearing a sports bra and quite enjoying the whole situation. '*Amelie is really into you,*' she said. '*Just be careful with her – I don't think all is lost yet.*' Janis looked more alert and more sober than most people in the club. '*I hope you're right,*' he said, looking Tanja in the eye. When she glanced at his shirt again, he said: '*Don't worry, it cost €10. It's a silk-screen fake from Brandenburg.*' He didn't smile as he said it. Tanja felt she'd been caught out. '*What have you taken?*' Janis asked. '*E,*' said Tanja. Janis smiled. '*It suits you. You're more open than usual. Almost warm.*' The comment clearly overstepped the mark. '*So what have you taken?*' Tanja asked.

'*Nothing. You want a top-up?*' Tanja did, but she shook her head. '*I'm going to let this one wear off and then go home.*' Janis nodded. '*Sounds good. Have a nice evening.*' Then he disappeared towards the toilets.

Tanja got the final message from Jerome at 1.14. As he was going to bed, he texted her: *Enjoy, baby. I'm off to dream about you now.* In the taxi at 2.15, Tanja still felt blissful. She studied her face in the rear-view mirror and saw that she looked better than her sister did under the influence of drugs. Maybe she was more careful about the dose, or she simply benefited from not having a metabolic disorder or depression like Sarah did. In the back seat of the taxi, Tanja was sure that she was lucky in a lot of ways. At home she would have no trouble falling asleep from honest physical exhaustion; she wouldn't dream about anything, and when she woke up she would launch herself into

a pleasant, unplanned Monday. She would probably go for some fast food, make some phone calls, send some texts. '*Good night?*' the taxi driver asked her. '*Yeah, really good,*' said Tanja, and gave him a €2 tip as she got out. She would feel weary and demotivated on Tuesday at the earliest, and probably again on Wednesday. Tanja decided to take a positive attitude towards this state as well. ■

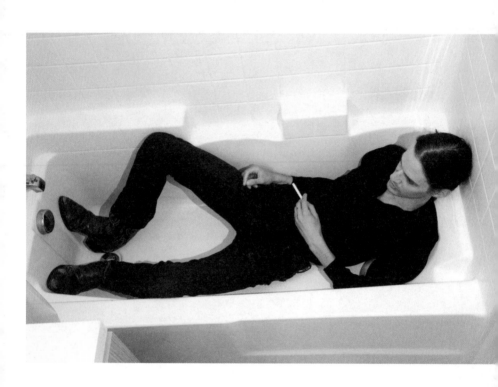

SIRI KAUR

LAST WEEK AT MARIENBAD

Lauren Oyler

W e went because we thought it would be funny; we came to realize the movie isn't even really set there. It takes place, if not in the mind, then in a composite setting of several nineteenth-century Central European spa towns, in a sense of vague possibility and in danger of being lost. The misunderstanding was Thom's fault. He had seen the movie once before, a long time ago; I had not, but I knew I would have to eventually, because it's one of those movies you have to see. 'It's a trip,' he told me.

Our relationship had recently undergone a series of unlikely transformations, and it was vital to the development of its narrative that we go on a trip. A trip would confirm that we were in a relationship, and that this relationship was not going to remain forever stuck in the past, in a phase of remembering and fighting over what we remembered – over things that had happened, seriously, the previous year. According to the couple clichés, a trip is a new memory you make together. It's also a test: how moody one of you might become at a setback; how neurotic the other might be about the schedule; how fundamentally incompatible you are suddenly revealed, in an unfamiliar setting, to be. Kafka knew this. When he and his on-again, off-again fiancée Felice Bauer met at Marienbad for ten days in July 1916, they fought the entire time, unable to overcome

the ceaseless rain and 'the hardships of living together. Forced upon us by strangeness, pity, lust, cowardice, vanity, and only deep down, perhaps, a thin little stream worthy of the name of love, impossible to seek out, flashing once in the moment of a moment.'

Neither I nor Thom is anything like Kafka. I would prefer to stay in bed all the time, but I don't have tuberculosis, or any serious physical ailment, just melancholy and probably a few minor vitamin deficiencies. Thom thinks this is cute and integral to my artistic process. The problem we had was that we both had a lot of work, meaning I would want, or need, to lie down even more than usual, and I didn't want to go on any more trips. 'You've become one of those people who lives in Berlin and is never there,' a friend said when I found myself in Italy for the fourth time in a year. I don't even like Italy. I love Berlin. You can bring golden handcuffs in your carry-on if you upgrade to easyJet Flexi. After what I vowed would be my last distressing international vacation for at least three months, yet another unlikely event required me to go on a cocaine bender across Europe. 'That's *horrible*,' people would say when I told the story. Truly, it was, and maybe still is.

The idea to visit a fading grand Central European spa town was Thom's; I suggested Marienbad because its literary reputation for an atmosphere of romantic melancholy and attractiveness to great neurasthenic historical figures appealed. Though others, like Karlsbad or Baden-Baden, are reachable by train from Berlin – a key element of the semi-ironic Central European nostalgia tourist experience – Marienbad overpowers, significance-wise. If I'd known anything about the film, I might have thought the trip too on the nose. But it's hard to make decisions, and if there's some arbitrary theme or parameter you can set, it's easier. We would go to Marienbad and watch the movie, which, as it turns out, is kind of about how it's hard to make decisions.

On the train from Berlin we had the strange and ultimately prescient feeling that we were too young to be doing this. How was it possible that we had purchased tickets, booked hotel rooms, packed bags? It was as if we were embarking on a mission that we did not fully understand, and perhaps by the end we would only understand that this was precisely why we had been given this mission. We stopped for a night in Pilsen to see where the beer comes from, and the beautiful hotel we stayed in was furnished in comically gigantic proportions. The hallways empty, the grand staircase dark, the functioning of the front desk dependent on a spooky little bell. We felt like naughty orphans or the kids who slept in the Met. We loved all this, of course, in the innocently condescending way of the sophisticated intellectual tourist who, in an era of mass awareness and ease of travel, rarely gets to see something so relatively undiscovered without raising ethical questions. The next morning we departed for the spa.

The word *Marienbad* is German for 'Mary's Bath'. Given that it is located in contemporary western Czechia – which I am still used to calling the Czech Republic, though that also sounds awkward in English – but also in the former Sudetenland, which had a majority German-speaking population until they were expelled and the area repopulated after World War II, Marienbad is not really the town's name, but it also kind of is. The local thermal spring has been called Marienbad since the Thirty Years War when, legendarily, a soldier healed his wounds there, next to a tree where he'd hung a picture of the Virgin. 'The implication was that Mary herself took ablutions there,' David Clay Large writes in *The Grand Spas of Central Europe*, 'though doubtlessly not in tandem with the troops.' The town itself is relatively young, as far as historical European spa towns go, and it has always been primarily a tourist destination, and thus always a bit otherworldly in the sense that it does not give a visitor a sense, however illusory, of the country where it's located, or of the people who live there. There were no buildings in the area until the late eighteenth century, and the place name was officially recognized in 1810. Then a Czech gardener named Václav Skalník had his way

with the landscape, transforming it into what he bragged 'could have been confused with the Garden of Eden.' When discussing the trip elsewhere I referred to the town as Marienbad, because pretty much everyone I talk to in my pretentious Berlin expat circle knows the film as well as the desire to make a kind of kitschy train trip to a bygone Central European spa, but when we arrived I called it Mariánské Lázně in what I thought might be a respectful counterbalance to the German visitors. As a practiced sophisticated intellectual tourist, I feared offending the local population by using the German name, but given the entangled history, I haven't encountered anyone who seems to care. As a *Kurort* Marienbad is German in nature, and remains popular among German tourists. It was until recently also popular with Russians, but after the outbreak of the war in Ukraine, the Czech government barred Russians from visiting the country as tourists, which generated mixed reactions among hoteliers and tour operators who were interviewed for a February 2023 *New York Times* article about the absence of the ruble in Karlsbad/Karlovy Vary and, by implication, the entire West Bohemian Spa Triangle, of which Marienbad is a part.

I didn't know much about how the history of tourism created linguistic trends in Marienbad before I visited, so I was mostly excited to hear Thom, who is Polish-American, speak Czech, because the languages are similar enough that you can, as he says, 'speak Polish in a Czech way' and get by, and vice versa. If you know Polish, he claims, Czech is 'cute'; I asked another Polish speaker if this is true and she said, 'Yes, definitely cute.' I expected that this would be a key facet of the couple-development project. What I did not expect was that we would have to speak German. German is Thom's fourth language, which means he has some fun with it; he speaks it with what I refer to as a Habsburg accent – though it's not quite Austrian or southern German, he rolls the r's exaggeratedly, ups the cadence and often deepens it ironically. I am more demure. No one knows how good I am at German, including me. While I have taken many classes and sound pretty good, I have never 'used' my German, by which I mean

I have never truly needed to speak German to communicate. This is because I live in Berlin, which is 'not really Germany'. It's of course more complicated, but it is also true that most Germans who live in Berlin speak English better than the many, many people who speak German badly. There is just no reason to seek out a German-speaking experience if your reason for living in Germany is not Germanophilia, which is a strange syndrome most people would not admit to having even if they did. But the working languages in Mariánské Lázně are Czech, Russian and German, so if you enjoy little ironies of life in twenty-first-century Europe such as 'I spoke more German in the Czech Republic – uh, Czechia – than I ever speak in Germany', it's a good place to visit.

It was raining when we arrived, and it didn't stop, except when it kind of snowed. This was fine; we picked the hotel where we were staying, the Ensana Nové Lázně, in large part because it is connected to two other hotels in the Ensana group by a long underground passageway where we assumed we could get our steps while pretending, again, to be insomniac orphans. Our taxi driver from the train station assured us it was the best hotel in Marienbad, and while we were not undertaking the rapacious kind of travel experience whereby you trek to an 'exotic' suffering region where your presence is questionably ethical in order to torture the local population with your unbelievably valuable currency, the best hotel in Marienbad is affordable 'for what it is', as the saying goes for us members of the easyJet Flexi class. Two meals at the buffet and unlimited access to the marble Roman baths in the basement are included in the daily rate. I also suspected I might be able to write it all off as a business expense. When the driver, who was already delighted by Thom's Czech Polish, learned we were from the United States, he was downright thrilled: his cousin plays hockey in the NHL. I'd noticed hockey games on televisions at the train station in Prague. 'Do Czechs like hockey?' I asked the driver. I can't get a handle on them except that they seem fun to drink with. 'Oh yes,' he said, 'but we have no NHL.'

I know only one Czech person, Roman, so I asked him for tips for a short trip to Marienbad. 'That is only like small Karlovy Vary,' he replied. 'I have no tips.' An American friend added, 'Mostly do not under any circumstances eat at Churchill's.' Roman's American wife, Laurel, recommended we go to Jáchymov, a small, disturbing spa town near Karlovy Vary where you can take a radon bath. Marie Curie studied the wastewater from the town's paint factory to eventually isolate polonium and radium; the discovery that radiation killed cancer cells soon followed, and led to a craze for radioactive treatments at the beginning of the twentieth century. The grand hotel in the center of this radiation village is called the Hotel Radium Palace. 'Did you know about this?' I asked Thom. 'No,' he replied, 'but I would happily undergo radioactive therapy.' He loves Marie Skłodowska-Curie because she was Polish. Thankfully the radiation village is only really accessible by car.

Tips are unnecessary in Marienbad anyway. 'There really is nothing to do here,' one character writes to another in Sholem Aleichem's 1911 epistolary novel *Marienbad*. 'One can go crazy from boredom.' If the idea of Marienbad is nostalgic, or if Marienbad represents 'one of those places (rather like Venice) whose future was in its past', according to Large, being in Marienbad is, for rootlessly aware people like us, a distinct break from any kind of yearning for a historical moment we didn't experience. In Marienbad we were relieved from the feeling that we'd missed a heyday – we did, but it doesn't matter. The heydays I wish I could have experienced are characterized by a desire to destroy rather than dubiously regenerate the physical body. I can enjoy and pity the German spa town's gestures to its past resplendence; I can smile at how badly it has adapted to competitors in the 'wellness' space. There is no pressure to have an 'authentic' historical German spa town experience or to wish I had been alive to see it decades earlier. I've lived in Berlin for several years, sort of, and the pressure to resurrect the city as it exists impossibly in the collective expatriate mind, prone to romance and nostalgia for eras it didn't experience, is exhausting; living there can

feel, at times, like the kind of vacation I hate, full of stuff I'm afraid I'll regret not having done.

As soon as we arrived, I realized I just wasn't excited about being in the town where old Goethe fell in love with a seventeen-year-old girl. The only thing on the schedule was spa. Given the amount of work I had to do, it wouldn't be full spa, but it might help. Everyone I know fantasizes about taking a one-to-six-month *Kur* in a calming natural setting. No one that I'm aware of wants to take the waters – they are stinky and one suspects similar results could be achieved through supplements and regular hydration – but we all believe that a luxurious convalescence, consisting only of massages, slow shuffling walks around the grounds in a bathrobe, and the making of intergenerational friends would cure us. In Germany, the concept of 'burnout' is widespread and much discussed; to an American this is precious, bordering on cultural appropriation. I took an online quiz to assess my burnout levels and it told me to 'seek help urgently'. What might that mean, realistically? You can purchase long-term packages at the best hotel in Mariánské Lázně; we stayed for four days.

The hotel was indeed very nice, opulent, decorated in deep green and ivory and gold, with endless treatment rooms labeled with *fin-de-siècle* fonts. We immediately wanted to walk the underground passageway, which takes about fifteen minutes one way and involves occasionally passing through soothingly soundtracked hallways as well as the creepy medi-spa. At intervals appear fountains of flowing, dribbling or, at that time, out-of-order mineral water, each sourced from different springs and so of different compositions, with different bad smells and alleged benefits. The water tastes of nothing, but just to reiterate, it stinks. All the hotels, as well as the souvenir shops in town, sell special ceramic sippy cups; they're designed so you don't have to put your nose near the water to drink from it. The juxtaposition of nineteenth-century splendor and doctor's office decor is disorienting, as are the elevation changes throughout the passage. One elevator has you exiting on the fourth floor; you arrive at the next elevator to find you are two levels below ground.

'*Zwei große Menschen*,' I heard an elderly German voice say at one such juncture. Standing in the elevator with her husband, she gestured to us. '*Zwei große Menschen*,' she said again, looking at us expectantly, like a grandmother awaiting acknowledgment for her cookie recipe. Thom and I are both very tall. In boots, we are taller. Despite the benders, we radiate an image of what is theoretically sought at Marienbad: clear skin, shiny hair, bright eyes, athletic builds. We look like we could save someone's life, and in fact we have. We quickly realized that despite the relative obviousness of Marienbad as a weekend getaway, two beautiful giants in their early thirties are still a sight to behold there. Except the boring blond couple who showed up in the sauna area on our last night, whom we despised and sought to destroy, the only other young person I saw the entire time was an approximately ten-year-old girl skipping alone down an empty sulfur-smelling hallway. I smiled at the German couple standing in the elevator with my mouth closed, like an American.

The word *tourist* has negative connotations. The phrase *German tourist* has many negative connotations. It is an exciting time to be an American tourist in Europe: we are much less hated than we have been in the recent past. Meanwhile, visitors from other countries are becoming very annoying, and at least we still have the glamour of the previous century and, despite the odds, our willingness to spend money. Plus, we're really *friendly*, you know? Occasionally a European in my midst will attempt a feeble complaint about a loud American woman TikToking about the absence of tap water on the Continent, but today there are a couple of varieties of tourist reviled more than we. The British, who can't be helped; the Australians, who, because they're good-looking, have no idea that they're just like the British, and so are, on top of the drunken doofishness, cocky; and the Germans.

Contemporary hatred of German tourists focuses on debauchery in the areas known as Schinkenstrasse (Ham Street) and Bierstrasse (Beer Street) in Mallorca – in 2023, one Spanish expat newspaper claimed residents now find them 'as boozy and awful as the Brits'

because they 'throw themselves from balconies, they keep mixing their drinks all day . . . they fall asleep in people's gardens, and they are being robbed.' But for much of the twentieth century their particularities while traveling abroad were interpreted as evidence for Nazism's success. 'All Central Europe seems to me to be enacting a fantasy which I cannot interpret,' Rebecca West writes at the beginning of *Black Lamb and Grey Falcon*, her magisterial Balkan travelogue written in the 1930s and published in 1941. On her way to Croatia, she shares a train car with two German couples who reveal themselves to be 'unhappy muddlers, who were so nice and so incomprehensible, and so apparently doomed to disaster of a kind so special that it was impossible for anybody not of their blood to imagine how it could be averted. It added to their eerie quality that on paper these people would seem the most practical and sensible people.' One of the men was, according to his wife, 'very ill with a nervous disorder affecting the stomach which made him unable to make decisions'; they were on their way to a Dalmatian island in the hope that the sun and air would solve it. None of these Germans is in the Nazi Party – indeed, they resent and fear the Nazis, and the men are both especially daunted by the capriciousness of the Nazi tax system – but they are to West clearly representative of how and why the Nazis came to power: they are simultaneously entitled and desperate for guidance. They lament the absence of German food on the train car and dread the weeks they'll spend without it, despite West's extolling of then-Yugoslavia's 'romantic soups'; they kick a young 'Latin' traveler with a second-class ticket out of their first-class carriage to make room for West and her husband, who impresses them with his perfect 'real German German'. When a conductor comes around, the Germans reveal that they have second-class tickets, too.

When one has very little to do, the schedule fills up rapidly. It somehow became difficult, if not impossible, to visit the sauna twice a day, though that had been our intention. My inexpert

opinion is that most of the benefits of spa treatments come down to two things: increased circulation and enforced relaxation. They are not magical, or so scientific that you need a doctor to explain them. What we are used to from living in Germany is a very hot sauna – 90 degrees Celsius – undertaken nude. You see what you can stand until you can't stand it anymore. With practice you can stand more. A normally punishing icy shower transforms into relief. It shocks me when people fear or doubt the efficacy of the very hot sauna; it's almost too obviously a spiritually educational experience.

Still, we are not immune to the exhilarations of modernity. When we arrived in our room, we were greeted with a long printout of available spa treatments. This was overwhelmingly exciting until we realized many of the treatments required a doctor's consultation before and after, both of which cost money, and might kill or permanently injure you. A shorter list of normal spa treatments was more manageable. Beyond the hotel, you could also purchase a session at the local 'beer spa,' stylized variously as BEER SPA BEERLAND and SPA BEERLAND, which involves renting a private room where you can drink and bathe in actual beer, 'beer extracts' and 'beer herbal mixture'. They actually have these all over the world. There is at least one article online called 'Why Bathing in Beer Could Be the Healthiest Thing You Do All Summer.' It has many alleged benefits; all the treatments do.

'The idea of the beer spa is, basically, what if I could be just like a cow but have all the desires of a man?' Thom said as we photographed the BEER SPA BEERLAND sign.

'What do you mean?'

'Sleeping in a bed of hay' – this is one of the things you get at the beer spa – 'drinking so much I can only roll around,' he said. 'Masturbating, presumably.'

'I don't think cows masturbate?' I said.

'What do you mean?' he replied.

'I think dolphins are the only animals that masturbate,' I replied.

'What do you mean?' he replied again. I was actually wrong about that, but it's a non sequitur.

We took mineral baths instead. This is the marquee treatment at the Nové Lázně. Germans love carbonated water, so it follows that they also like to bathe in it. After you soak in the tub for twenty minutes or so, an employee comes in and wraps you up in towels and sheets. 'Like baby,' she says approvingly. The thing about anecdotes like this is that they can seem stereotypical, and thus offensive. But of course if you don't speak much English, 'like baby' is going to be one of the phrases you can produce, especially if your job is swaddling adults like babies. After the baths, Thom and I reconvened in the hallway, whose horrible smell, always stronger in the morning, we could now fully appreciate. We were euphoric. Our skin was soft. We felt productive.

As mentioned, Thom is a large man. His caloric needs are significant. The daily buffet, with its geriatric hours and gestures toward what is healthy and easy to digest, could not sustain him. I am sympathetic to this problem but not the type to bring protein bars for my boyfriend everywhere I go, though as many girlfriends will know, sometimes it is better to maternally fill your purse with snacks than to suffer the consequences of their absence. On the second day of the trip, we planned to have a couple of treatments and work. I did this shockingly diligently. The trip was working, for me, but at times it seemed we were on parallel journeys. 'Are you hungry?' Thom would ask hopefully at 11 a.m., 4 p.m. – not at all the buffet hours. No, I would say. We weren't doing anything. I had a massage appointment. How could I be hungry?

By 4.30 p.m., the situation had worsened. Thom needed to visit, he said, the Wiener Café, the Viennese café in the basement decorated as such. I was about to finish editing an essay. I asked if it would bother him if I met him in the Wiener Café when I was done. He said no, he didn't mind, but he had to go right then. He was starving. I said the gap between men and women is wide and maybe even unbridgeable. He left.

Fifteen minutes later I found the Wiener Café dark and empty. The significance of this development was grave. It must have closed at 5 p.m. Maybe even 4 p.m. The hotel had taken up the German custom of not keeping businesses open at times when they are likely to do business. It is normal in Berlin to encounter coffee shops that don't open until 10 or 11 a.m. on weekdays. I imagined Thom, hungry, forlorn, roaming the labyrinthine passages of the hotel, having lost the ability to speak. I found him sitting in the bar, despondent. His face looked like it was melting. He was hamming it up, but he needed ham. I looked to the bartender, who was uninterested in us. Dinner was in half an hour. 'Tell her, "Don't worry, he is a vulnerable man and I am his girlfriend,"' he said. 'But say it in Czech.'

Weakly, he typed this message into Google Translate on his phone. He began to giggle. 'The word for "girlfriend" means "the one I cuddle with",' he said.

The next day we adopted a new strategy: constant treats. We ate breakfast followed by Viennese coffees – coffee with whipped cream – and a slice of Viennese cake. This was luxurious and I enjoyed it. Thom ordered a second Viennese coffee, about which I said nothing. I had an appointment to get dry-brushed and I believe in personal agency.

When I returned from the dry-brushing – they let you keep the brushes! – I saw in front of Thom not only a third Viennese coffee but also another cake. Again I said nothing. He was exuberant.

'I was just standing at the window and that man said to me, "*Eh* [German way], *du bist ein Sportler!*"' Thom said. 'Even though my belly is full of cake.'

As the day wore on, my mood remained steady; I was actually working for once in my life. Thom, however, was becoming dark and concerning.

'I think it's the barometric pressure,' he said wearily. 'It's just not a good day.'

In the afternoon I suggested we take a walk, which we had not really been doing, and visit a little food market on the square. We got beer, sausage and a traditional fried cheese whose mountain origins Thom eagerly explained to me. But even this did not boost his mood.

'Do you think maybe,' I proposed at 5 p.m., the worst hour of the day, 'you have eaten too much dairy?'

'Sheep's milk barely has lactose,' he replied sharply. 'And I'm not lactose-intolerant! My ancestors brought dairy to the world!' He was referring to the Tatars.

I listed what he had consumed that day. When I got to the second slice of cake I began to laugh. He was having a sugar crash, aggravated surely by his caffeine addiction. 'I think you are having a dairy crisis,' I said mischievously. Days of working in bed had made me happy enough to make jokes.

'I'm not!' he cried. 'It's not a dairy crisis!'

Marienbad has long inspired emotional volatility in its visitors. 'These people are the most miserable on earth,' Aleichem writes. 'They crave food and aren't allowed to eat. They yearn to travel and can't. They desire nothing better than to lie down and aren't permitted.' In the United States, the wellness industry has responded to the commodification of the self by coming up with evermore specific pseudoscientific syndromes and accompanying solutions, the pursuit

of which can distract you from your real problem, life; in Central European spa towns they're still hawking the benefits of the periodic table. When there is nothing to see or do, tiny vacillations in mood are the only thing to pay attention to. When you're not a true believer in the possibility of a cure, your mind has space to wander to dark places. Nietzsche, another famous weakling, sought relief from migraines in Marienbad and found only bitterness and resentment. 'The people are so ugly here, and a steak costs 80 kreuzer,' he wrote to his mother in 1880. 'It is like being in an evil world.' Though he planned to leave after a month, he was too sick to make the journey home, so he had to stay another four weeks, beset not only by the headaches but also by his memories of his former friend Richard Wagner, with whom he'd had a falling-out after Nietzsche wrote 'Richard Wagner in Bayreuth' in 1876. After years of idolizing obsession followed by mutual adoration, Nietzsche had become ambivalent about the much older man, not so much as a composer – he praised him in the text – but as a person and foreboding representative of Germany's past. Famously, Wagner sucked, and Nietzsche had all sorts of other philosophical complaints about how Wagner's particular brand of decadence was of the decaying kind, spiritually weak, the latter's antisemitism and alleged Christianity being only two of several examples. If you have a lot in common otherwise, if you love each other, sometimes differences in perspective and temperament don't really matter, until they do. Disappointment follows, and a sense of betrayal: how could you stray from the path? I thought we were taking it together.

Wagner and his wife Cosima blamed Nietzsche's turn on masturbation and his Jewish friends. They all cared too much about Germany, but in critically diverging ways. 'It's for the best,' absolutely everyone will tell you. Neither rest cures nor reasonable advice helps. 'How often I dream about [Wagner], and always in the spirit of our former intimacy,' Nietzsche wrote to a friend. 'All that is now over, and what use is it to know that in many respects he was in the wrong?' Time is what heals, unless you go insane before it can.

The sauna is exhausting, even when you can only manage once a day. On our last night, we hit play on the movie while lying in bed after dinner. When it became clear that the stark shadowy lawns and elaborate interiors were not the same shadowy lawns and elaborate interiors we had been traversing ourselves, that the delight of recognition would not be ours, it became even harder to stay awake. What's more, the film is incredibly boring, and should not be watched on a computer. I am not against boring movies; I am merely, sadly, a realist. Its themes might have made me sad if Marienbad still carried its associations with loss and memory, but the place has become a straightforward representation of a very specific idea of the past, no longer a site of vague, moody possibility. Is it all in her mind? In his? Might the man pushing the woman to remember him represent a psychoanalyst, a drill sergeant of the unconscious, holding place for some other man she might actually remember, if pressed long and hard enough? Might they all be dead, or in limbo, or in a dream? It will never be certain, but that uncertainty has become certain, obvious, possibly even boring. We never finished the movie, but the trip was great. ∎

LAUREN BAMFORD

THE TEXTURE OF
ANGEL MATTER

Yoko Tawada

TRANSLATED FROM THE GERMAN BY SUSAN BERNOFSKY

The man standing in front of Patrik looks very *Trans-Tibetan*. This is the first time Patrik has ever used this Celan word, which he's been warming beneath his feathers for a long time now, without knowing what group of people or languages would hatch from it. The man really does look Trans-Tibetan; this is a subjective impression, and the purpose of adjectives is to support subjectivity.

The man asks permission to join Patrik at his table. The language he speaks is no *rara avis* requiring a recherché description like Trans-Himalayan or Sino-Tibetan. He speaks a straightforward German with a faint accent. Other tables are occupied, and it's only logical, it seems to Patrik, for two men to share a table in solidarity.

'My name is Leo-Eric Fu,' the man says, elegantly extending his hand and then quickly withdrawing it before Patrik can respond. Patrik understands that a greeting need not be physically consummated. There's a question buzzing circles in his head. Should a person reveal their full name right at the outset when making a fleeting cafe acquaintance, or are all three components – Leo, Eric and Fu – his first names? Patrik is cautious and offers only the first of his given names.

'My name is Patrik.'

'I know,' Leo-Eric answers with an understanding nod. Patrik is

unnerved, uncertain how to interpret this reply. Leo-Eric then says he's often observed Patrik sitting in this cafe – the last time, in fact, reading the book of poems *Fadensonnen* (*Threadsuns*). Patrik has no memory of this, but it's certainly possible he was reading poetry at the cafe, especially since he was planning to give a paper at a Paul Celan conference in Paris. At the moment, he isn't sure if he'll be cleared to participate or if he'll be struck from the list of speakers as an oversensitive crackpot.

'You intend to give a talk on the book *Threadsuns*?'

'It's possible I intended to a few weeks ago. But now, no.'

'Why not?'

Patrik can't find an answer to this question, so he quickly invents a reason, looking down.

'I don't like conferences.'

'Why not?'

'I find it a stressful situation, being observed from all sides. Everyone suddenly wearing devils' masks.'

'What do you mean? I don't follow.'

'First the talk, then questions, answers, discussion: it's like a play at the theater.'

'Society *is* a theater, it seems to me. Democracy requires a backstory, a narrative structure and well-rehearsed variations. You can't build a democracy on authentic feelings alone.'

Patrik looks up again, wondering if this Leo-Eric isn't a freedom fighter from Hong Kong. A moment later he erases this spontaneous conjecture from his brain-page. Someone from Beijing could be a freedom fighter too. Patrik himself is the one least likely to be democracy-minded.

'I don't like questions, criticism or discussion,' Patrik responds. 'But you can't say that out loud, and when it comes right down to it, I don't think it's all right that I am the way I am.'

'What displeases you about discussion culture? Do explain, I'm genuinely curious.'

A storm of chaos swirls up inside Patrik's head; it's a torment to

be unable to sort out the multitude of multicolored thought-scraps. He invents a new theory, which at least gives him something to hold on to: Leo-Eric is collecting clips of people making anti-democratic statements. He's using a hidden microphone, recording the authentic voices of EU citizens and selling them to countries where they'll be used as teaching material in language classes. Patrik taps three fingertips against the forehead behind which this absurd theory is taking shape. He's like a woodpecker hunting nice fat thought-worms in the bark to gobble up.

'I usually construct a conference paper as lovingly as you would a sandcastle at the beach. I don't understand why most children are so cruel they want to destroy my sand art with their toy shovels.'

Whenever Patrik hears the word *shovel*, he gets goosebumps. Now that he himself has uttered the word he feels all crumpled up inside, but it consoles him when a smile appears at the corners of Leo-Eric's mouth and he says:

'Oh, the children don't mean anything by it. You shouldn't take their game so personally.'

'If I don't take anything personally, what becomes of my person?'

'A toy shovel is as harmless as the little wooden spoon we eat ice cream with.'

'Even a tiny medical spoon can grate on my nerves so brutally that I can't stand it for a second.'

'An ice-cream sundae with strawberries, please!'

This sentence isn't meant for Patrik. The waitress nods and places a cup of milk in front of Patrik.

'Excuse me, I didn't order any milk.'

'You left the decision to me. I think milk is the most suitable thing for you.'

Patrik actually remembers what he said to her – at this moment he feels something like a continuity, which is rarely the case with him.

'Yes, that's right. I wanted to know what you think of me. I guess you think I still have my milk teeth?'

Ha ha, hilarious. Ignoring his words, the waitress turns to the next

guest who has just lifted one hand in the air. Leo-Eric considers the Tipp-Ex-white milk and says:

'You own a first edition of Paul Celan's *Threadsuns*, is that correct?'

The man appears to know even unimportant details about Patrik's life.

'I have the 1968 edition, but that's nothing special.'

'Why not?'

'There are five thousand copies of it. I'm one of five thousand readers. A surprisingly large edition for a book that's so hard to understand. Even the Deutsche Oper only seats two thousand.'

Leo-Eric emits a bright peal of laughter.

'Well, that doesn't mean five thousand people have actually read the book. Possibly you're one of only a very few still reading and thinking about the book today.'

'I'm actually too tired to think about such a complicated book. My girlfriend got it for me at a used bookstore as a birthday present. When she gave it to me I was furious. I almost threw it in the garbage. But I found its snowy-white dust jacket and slender body appealing, so I put it on the shelf anyway. A thicker book would have ended up in the fire.'

'What did your girlfriend do wrong?'

'The absence of premeditation is paramount for me. Obviously, she wants to force me to write a lecture. Every sort of well-meaning female manipulation is like snake venom.'

Leo-Eric nods impassively and says: 'A career can never be as radiant as a flame scallop.'

Someone who isn't career-oriented can't possibly come from China, Patrik thinks. Maybe he's from Tibet. He's probably one of those monks that meditate day and night high up in the mountains without giving a thought to money or worldly careers. Patrik laughs inwardly and interrupts this clichéd thought by providing a response: a Tibetan can also be a successful businessman with an account at a Swiss bank. Patrik doesn't want to go on speculating about where Leo-Eric comes from, instead he'd rather listen. He just said a career

isn't radiant like a flame scallop. This is a crystal-clear statement and worthy of a reply.

'If a career can't be a scallop, what can?'

Patrik has succeeded in asking a question that moves the conversation along. After asking it, he goes on savoring the word 'scallop' in his mouth like a sip of red wine. He uses dead words far too often to be understood, or else he reverts to the state of a patient remaining stubbornly silent in a therapy session. But now he feels able to utter freshly squeezed words without being accused of sickness. Leo-Eric inclines his head gently to the left, searching for a response. He takes his time.

When human beings fall silent, a music can be heard. A singer sings impatiently in a tree. She places her first note high, then lets her voice fall step by step before quickly ascending once again. A blackbird. You don't see her form until she comes down from her tree. Can so shy a singer sing at the top of her lungs? Oh yes, she's just the one to manage this. Exaggerated shyness is a sort of traffic jam. Behind the dam, the pressure builds until it creates enough electricity to power all the chandeliers in the concert hall. Patrik loses track of the blackbird and finds himself looking at Leo-Eric, who has something birdlike about him. Perhaps it's his slender neck, or his eyes like black glass beads. Who's to say Leo-Eric isn't a blackbird? He watches people from high up in a tree, he collects facts, builds a nest of them, and, when he finds it useful, he appears in human form. There are people like Patrik who wait to receive help from winged beings. Finally Leo-Eric opens his mouth again.

'Do you know the No Tree? It stands in the middle of an open field. You can ask it the same question from all eight points on the compass. The answer will be different every time, though it's always No.'

To Patrik this sounds like a koan from the tradition of Zen Buddhism. Perhaps Leo-Eric comes from the country in which most Zen Buddhists live today: France. This supposition is half confirmed when Leo-Eric says:

'The word *career* comes from the French *carrière*, which also

means quarry. Perhaps this is why for some people a career seems as impenetrable as granite.'

Patrik replies, 'Everything about a career strikes me as highly disagreeable. I don't want to be trapped on a career path, I want to be free. No highway, no train tracks. I much prefer open fields without footpaths or trails. A free, modern human being must be able to walk in all directions. I don't just mean the four or eight points of the compass. There are more than eight directions.'

'But the place you grew up wasn't a Central Asian steppe, it was a city full of high-rises.'

'Yes, that's true.'

'In a city, pedestrians and cars, for the most part, can only move in four directions: backward, forward, left and right. That's it. But four directions are already too much for you. To avoid the necessity of making a new decision at every moment, you've found a single answer that you apply to each situation.'

'And what is this answer?'

'Turn left!'

Patrik swallows and blinks like a stroboscope. In the hectic alternation of light and shadow, his interlocutor vanishes. This makes it easier to speak.

'How do you know that?'

'As I said, I've been observing you.'

This beakless person cannot be a blackbird, Patrik thinks. Perhaps this intelligent-looking man comes from the northern half of the Korean peninsula, and is wearing special contact lenses connected to a giant databank. Patrik notices that his thinking has derailed again and considers how to get back to the main track of reality. Leo-Eric knits his brows and says:

'Please don't be alarmed. I'm not a stalker.'

A stalker! Patrik hadn't even thought of that. After all, the victim of a stalker is never a man in a wrinkled shirt with no color in his cheeks.

'No, I never suspected you of being a stalker, or more precisely: I can't imagine being the victim of such activity. I thought maybe

you were a spy. But since I'm not in possession of any important information, this too is unthinkable. Unless you are a Zen Buddhist spy who wants to steal the great Nothingness inside my head?'

Patrik has succeeded in joking his way out of an embarrassing situation. Leo-Eric laughs in relief, and begins the fluent narration he's prepared:

'I came to speak with you about the channels that run through the human body. There are twelve main channels, which are called meridians. The word "meridian" comes from the French translation of the Chinese term *jingmai*.'

Patrik responds reflexively:

'But there's only a single meridian. Why are you speaking of meridians in the plural?'

'Most people only consider a single meridian, the zero meridian, and suppress all others.'

'Well, there aren't many poetological texts by Paul Celan, so "The Meridian" is really quite important to me.'

'But can his poems be explained on the basis of just this one meridian?'

'Of course not. If a single meridian isn't enough for you, how many do you have to offer?'

'There are as many principal meridians as there are numbers on a clock: twelve.'

'What are you talking about?'

'For example, the liver meridian begins in the big toe under the nail, crosses over the top of the foot and then goes up through the knee and thigh. It passes through the liver, the back of the throat, the nose, eyes and forehead, until it reaches the crown of the head. If a person has a problem with their liver, you can use a needle to treat all points that lie along this meridian.'

'Aha, you're talking about acupuncture!'

Patrik feels infinitely relieved. Now he knows what's going on. But this breath-pause of relief doesn't last long. Leo-Eric draws him into a new vortex of confusion.

'No, I'm talking about a poem by Celan: "Detour- / maps, phosphorus . . ." Do you know the poem?'

'Of course I do. This poem contains the word "aorta", and as a child I had a dog named Aorta. In this respect, the poem also serves as a detour to my memory.'

'A detour? When the liver isn't working right, we don't treat the liver itself, we treat the liver meridian. That's not a detour.'

Patrik becomes aware of his big toes, which for some reason are having trouble sensing the ground beneath them.

'My feet have become strangely present. They can't find the ground.'

'My grandfather used to say: pay attention to your feet when you are speaking with someone! The foot is a nice thick book. Some people think only the eyes or heart are connected to the soul. That isn't true. The networks within the body are far more complex.'

'But Celan couldn't have been talking about this sort of meridian. For him, only a single meridian existed.'

'The meridian that passes through London? I don't believe that. For example, here's another very important meridian for Celan: the one connecting Paris with Stockholm.'

Patrik remembers in a flash that a meridian appears in Celan's correspondence with Nelly Sachs. 'Between Stockholm and Paris runs the meridian of pain and consolation,' he quotes from memory, and then says, 'A number of meridians exist – metaphorically speaking. But I don't put any stock in metaphors, they're too spongy for me. I prefer to rely on numbers and letters for orientation.'

Leo-Eric replies, gently, 'I'm speaking not metaphorically but geographically. Have you ever visited the historical observatory in Paris?'

'No.'

'The so-called Paris meridian is found there, inlaid in the floor in multicolored stones.'

'Didn't you say meridians are channels in the body?'

'What difference is there between the terrestrial sphere and the body? Place names and the names of organs were equally important

as points of reference for the poet. We must search for the lines that connect them to one another.'

'This is all very interesting,' Patrik says. 'Why don't you go to Paris for the conference yourself? You're the one who really should be giving a presentation on Celan and the meridian or, if you prefer, meridians.'

'Unfortunately I can't do that. It isn't my area of expertise. My grandfather practiced traditional Chinese medicine in Paris in the 1950s and 1960s – the period when Celan was living there too. My grandfather was a highly educated man who read Chinese, French, Hebrew and German. In his papers after he died I found the notes he'd made on Celan's poems.'

'Please go on.'

'I can tell you some things that probably only a very few other people know. What you do with this information is your business. It's all the same to me whether you have success in your profession or not. What I have to offer isn't a career, it's just a handful of meridians.' ∎

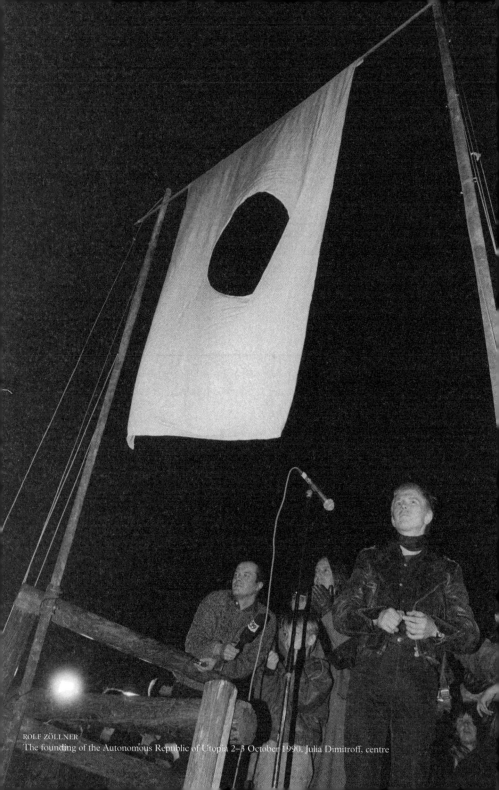

The founding of the Autonomous Republic of Utopia 2–3 October 1990, Julia Dimitroff, centre

FROM THE PLANETARIUM

Ryan Ruby

1

Nothing distinguishes ancient from modern experience so much as their respective attitudes toward the cosmos, writes Walter Benjamin in 'To the Planetarium', the concluding prose piece of his 1928 collection *One-Way Street*. Whereas, according to Benjamin, the ancients maintained close contact with the stars in a communal, ecstatic trance, since the days of Copernicus, Kepler and Tycho Brahe, we have instead approached it optically and individually. This did not obviate the *need* for cosmic experience, however. Moderns were to find it in warfare on a planetary scale, and in revolutions that promised new political constellations. Given these coordinates, the planetarium, which never actually appears in Benjamin's short essay, is an ambiguous figure. Is it an extension of the optical technologies of early modern astronomy and thus a further alienation of humanity from the cosmos? Or is it a technological balm for the problems created by technology, artificially returning to the dweller of the metropolis the possibility of cosmic ecstasy?

These tensions – between the cosmos and the machine, between space and time – were present in the building and the marketing of the first planetarium. Invented by Walther Bauersfeld, the chief engineer of the Carl Zeiss Optical Company in Jena, and Oskar von Miller, the director of the Deutsches Museum in Munich, the 'Wonder of Jena' opened in 1926. It was perhaps the quintessential technology of the Weimar Republic. Replicated in other cities, a new and improved version in dumbbell-shaped form was erected in Berlin on the grounds of the Zoologischer Garten in November 1926. Benjamin, who first experienced the garden with his nursemaids, his 'early guides' to the city, visited the Berlin planetarium in 1927 or 1928. Next door was the Ufa-Palast, then the largest movie theater in Germany in what was the most exciting period in its cinematic history; within six months on either end of the opening of the planetarium, viewers could have attended the premieres of F.W. Murnau's *Faust* and Fritz Lang's *Metropolis*.

The two most popular programs at the Berlin planetarium in its first year of operation were *The Skies of Home* and *The Year in a Matter of Minutes*. In the former, the rim of the dome was illuminated with a silhouette of the Berlin skyline to orient the viewer as the projector slowly spun in order to permit them, in the words of the script that would have been read by a lecturer, to see the planets and constellations in the night sky 'as it really appears, without any of the sight-obstructing influences around us'. Noting the irony that the sky 'as it really appears' could only be viewed in the form of a technological simulation, the historian Katherine Boyce-Jacino attributes the immense success of the program to viewers' nostalgic desire for the 'grounding effect' of seeing the sky as it might have looked one or two generations previously, in the countryside from which many of the viewers' families had migrated, or in the city before the advent of factory smoke and electric lighting and neon signage.

The Year in a Matter of Minutes, by contrast, appealed to those who embraced the jagged rhythms of industrial modernity. Here the script was upfront about the relationship between simulation and reality: the viewer was about to be shown something that could not be seen with the eye alone. 'We would like,' the lecturer would have intoned, 'in these artificial skies, to let time advance wildly.' The motor of the projector would be sped up to show how the planets and constellations would look over the course of a single year: first in seven minutes, then in four minutes, then in a minute and a half. The lecturer would bring the projection to a stop, exclaiming, 'We are making an intervention into the natural order! We are stopping the rotation of the earth, for just a moment.' Nothing, except perhaps the world viewed from the window of a railway car, would have prepared viewers for such a disorienting visual experience of acceleration and deceleration. 'We are bound to neither time nor space,' one viewer said. 'It looks as if in a jazz age even the heavens were moving in jazz time.'

The Berlin planetarium was destroyed, along with the zoo and the Ufa-Palast, in an Allied bombing raid in 1943, three years after Benjamin's death, by suicide, during a frantic attempt to flee occupied France. For the 750th anniversary of the city of Berlin, the government of East Germany (GDR) commissioned the building of the Zeiss-Großplanetarium, with a state-of-the-art Cosmorama star projector, on the site, rather fittingly, of the decommissioned gasworks that had polluted the sky over Prenzlauer Allee since the first years of the *Kaiserreich.* The entire leadership of the Sozialistische Einheitspartei, including General Secretary Erich Honecker – who was responsible for the GDR's most notorious piece of architecture, the Berlin Wall – attended the opening on 9 October 1987. What was initially conceived of as a public educational center and tourist attraction was now regarded as an important accoutrement of state power. It signaled that East Germany and its government were technologically advanced, future-oriented. But the future had something different

in mind. One of the largest and most modern of its kind, the Zeiss-Großplanetarium, whose rooftop is visible from my balcony, was to be the last major construction project undertaken in the GDR. Three years later, the country would no longer exist.

<p style="text-align:center">2</p>

One S-Bahn station away from the planetarium is a building that presupposes a different idea about the relationship between collective humanity and the cosmos. Built on a plot of land between Stargarder Straße and the railroad tracks to serve the rapidly expanding population of the city's northeastern districts in 1891–3, Kaiser Wilhelm II named the Gethsemanekirche after the garden in Jerusalem where Jesus prays before his betrayal and arrest. With its pointed, copper-topped steeple, its buttresses and pinnacles, architect August Orth's large red-bricked structure synthesizes Gothic and neo-Romanesque elements – an unusual design for a Protestant house of worship, but fashionable during the confident period after the unification of Germany, engineered by Bismarck.

The church was to have its brush with history just under a century later, when it joined with others, including the Nikolaikirche in Leipzig, where Bach had premiered the *Johannes-Passion*, and the Zionskirche in Mitte, where Dietrich Bonhoeffer had once been an assistant pastor, to form a constellation of meeting places and protest sites for the group of dissident musicians and writers, environmental and anti-nuclear activists, church leaders and ordinary citizens who made up the opposition movement that peacefully ended Honecker's government and then the GDR during the years following the construction of the Großplanetarium. Along its south aisle, the church maintains an exhibition called *Wachet und Betet* – 'Watch and Pray', Jesus's admonition to his disciples in the garden – devoted

to its role in *Die Wende*, the 'turn' or 'turning point'. Lancet window-shaped panels show photographs of, for example, the demonstration on the anniversary of the deaths of Karl Liebknecht and Rosa Luxemburg, the all-night vigil, and the founding of the New Forum, the first opposition movement in the GDR outside the Protestant church itself.

The crossing of thousands of East Germans, my parents-in-law among them, through the Bornholmer Straße checkpoint between Prenzlauer Berg and Wedding on 9 November 1989 – the event we call the fall of the Berlin Wall – was triggered by a misstatement at a press conference. Günter Schabowski, appointed press secretary following Honecker's ousting, accidentally read out a draft of new regulations, which permitted East Germans to travel to the West. When asked when these were to go into effect, Schabowski, who had missed the meeting in which the regulations had been discussed, mistakenly announced to the international press corps covering the unrest in the GDR: 'Immediately.'

The event was a fluke, a classic instance of Benjamin's observation that 'all the decisive blows are struck left-handed'. It was not the first physical breach of the Iron Curtain (the border between Hungary and Austria had opened in May) nor was it the first of the many, largely peaceful revolutions that toppled Communist governments in Central and Eastern Europe (Poland and Hungary preceded it). Yet its symbolic significance, then as now, can hardly be doubted, nor can it be separated from the particular place where it occurred. The fall of the Wall has been taken not merely as a metonym for the victory of the United States and its allies in the Cold War, but as the hinge moment between two epochs: modernity, the 200-year-long period stretching back to the storming of the Bastille, and our own, for which we have yet to land on a consensus term. For some it is an endpoint, for others a tear in the very fabric of time. If we find ourselves returning to this particular moment over and over again,

perhaps it is because, as with every repetition compulsion, it contains something we have forgotten or repressed.

<div align="center">3</div>

Few traces remain of a tear in the fabric of time that occurred a few minutes' walk from the Gethsemanekirche during the 'Summer of Anarchy' that took place in the neighborhoods of Mitte and Prenzlauer Berg in 1990. The Summer of Anarchy was a perfect example of the sort of spontaneous social self-organization that can occur in hyperlocal spaces in the absence of states and property regimes. In the wake of the fall of the Wall, people flocked to the tenements of these and other neighborhoods of East Berlin from other parts of the city, all over the two Germanys, and as far away as London, in order to secure and occupy the hundreds of apartment buildings that had been abandoned by residents who had fled to the West or moved to the countryside. This could be done with a quick consultation of the local property registry, a piece of string across the door frame establishing interest, and a crowbar. From this foundation an entire culture sprang up. There were experiments in communal living, some of which included the collective raising and schooling of children.

The bottom floors of these squats were often converted into art spaces – including galleries and puppet theaters – and entertainment spaces such as movie theaters, dance clubs and bars. The overall aesthetic of the time was post-apocalyptic utopia. After the currency union, which pegged the East German Mark to the Deutsche Mark, went into effect in July, many older residents saw the opportunity to use their new (and as it happens, short-lived) buying power to refurnish their houses with supposedly higher-quality Western goods, and threw their unwanted Biedermeier tables, sofas, chairs and other household

items on the street. This created a salvage economy in East Berlin, which is still visible today in the numerous flea markets in that part of the city and in the eclectic interior design of the bars founded in that period, which have survived into the present. Information about available houses, upcoming shows and events, and demonstrations against reunification were broadcast from a pirate radio channel, Radio P, set up on the rooftop of a building on Schönhauser Allee occupied by a squatter group called the Wydoks collective.

All autonomous zones are necessarily temporary and all summers come to an end. The culture and institutions created in Prenzlauer Berg in the eleven months after the fall of the Wall suffered, over the course of the next few years, a by now familiar and international pattern of slow devolution, from radical political movement to urban arts scene to gentrified neighborhood, aided, in all cases, by the police, who slowly and sometimes violently evicted the squatters, and real-estate development firms, who bought up the housing stock and raised prices. Any visitor to the neighborhoods between Prenzlauer and Schönhauser Allee today, with their sumptuously restored late-nineteenth-century apartment buildings, their upscale international dining options, their twice-weekly ecologically friendly farmers' markets, and their stroller-led squadrons of young families, including my own, would be hard-pressed to guess that they were walking over the invisible ruins of one of the more audacious and colorful utopian experiments ever conducted in urban space.

If one had to point to a culminating moment of the Summer of Anarchy, one could do worse than the last one, the founding of the Autonomous Republic of Utopia, the 24-hour micronation that was declared on Kollwitzplatz a few minutes before midnight on 2 October 1990. Part anti-reunification protest, part outdoor party, part communal ecstatic trance, the Autonomous Republic of Utopia, or ARU, was the brainchild of Julia Dimitroff, then a resident in the Wydoks squat, today a luthier in Pankow.

A black-and-white photograph taken that evening by the electrician turned journalist Rolf Zöllner – held in the archive of the Museum Pankow across from the water tower a few blocks away – shows Dimitroff standing behind a child on top of a wooden climbing frame, flanked by two men with microphones, one hand-held, one free standing. It must have been a cold evening: the man to Dimitroff's left is wearing a leather jacket and a scarf; she is wearing gloves. The man is about to read a collectively prepared statement: *Declaration of Independence, Autonomous Republic of Utopia. All people are born free and equal. Since the beginning of humanity much energy has been spent trying to make people forget this.* Standing with her back to the statue of the artist and sculptor Käthe Kollwitz, which gives the square its name, Dimitroff is looking onto a crowd that numbered in the hundreds, if not the thousands; she recalls that many of them were holding the lit candles that just a year before had been used to signal solidarity with the opposition to the GDR. Many were also holding the ersatz 'identity cards' distributed by the micronation. *We declare ourselves independent from anything that would separate us from ourselves. We are independent from states and citizenship, independent from parliamentary politics and parties.*

The focal point of Zöllner's photograph, which is shot from the base of the climbing frame, is the flag of the ARU, made out of a bed sheet with a circle cut out of the center, hanging from the makeshift crossbeam under which Dimitroff is standing. Silhouetted against the night sky, the flag looks like Kazimir Malevich's 1915 painting *Black Circle. Independence, freedom and resistance begin in the soul of every child, every woman, every man.* With elegant simplicity, the flag corresponds to the ARU, which for a day had cut out this small territory of Berlin from the reunified nation that would be born when the clock struck twelve. But it was equally a cut-out from the historical order that reunification would inaugurate, a moment in which time was brought to an ecstatic standstill, before being ground down into the dialectic of bad infinity and eternal recurrence of the

same that has characterized the last thirty-three years. *In every heart is a revolutionary cell.* The flag now exists only in a photograph, but as Benjamin knew, images of the past are meant to be seized, and empty spaces are meant to be leapt through. Every second, he says in the concluding line of 'On the Concept of History', which was written in the months before his death, is a small portal through which the Messiah might enter. *It depends on everyone to remember this in order to survive.* ∎

KATHARINA SATTLER
Habermas House

EUROPE'S MISTAKE

Interview with Jürgen Habermas

TRANSLATED FROM THE GERMAN BY MAX PENSKY

The following interview with Jürgen Habermas was conducted by the editor of *Granta* on 23 July 2023.

EDITOR: You've never shied away from taking positions on the political issues of the day. The Russian attack on Ukraine and the question of how and on what scale the EU states and the United States should support Ukraine is no exception. Last year, you defended Chancellor Olaf Scholz's position – viewed by many as hesitant and evasive – and explained how complicated the constellation really was. Germans, you argued, could not simply admire and envy the national patriotism of Ukrainians. For post-war Germans pride themselves on having built a society for which the values of national patriotism are already a matter of history.

JÜRGEN HABERMAS: Two months after the outbreak of the war, when I wrote the article for *Süddeutsche Zeitung* that you refer to, what surprised me – and what I still cannot understand – had nothing to do with the West's politically required partisanship for Ukraine's struggle against a murderous aggressor. There was never any doubt about how the Russian invasion should be evaluated in normative terms, and I consider the military and logistical aid to Ukraine to be right.

What startled me in those first days and weeks of the war was the thoughtlessness and shortsightedness of the uninhibited emotional identification with the event of war as such. I've never been a pacifist. But I experienced the attack on Ukraine as a fateful violation of an inhibition concerning the archaic violence of war, an inhibition that had become uncontroversial in Europe. Yet the outbreak of this war with a nuclear power did not trigger any anguished reflection, but instead immediately prompted a highly emotionalized war mentality, as if the enemy were standing outside our own door. These bellicose reflexes – as though we had not learned in the meantime to see *war in Europe* as a superseded stage of civilization – really irked me.

However, your question refers to a particular aspect – not the entirely understandable solidarity with Ukraine under invasion, but the lack of psychological distance from the Ukrainians' inflamed national consciousness. It is not as if the process unfolding before our eyes – that of a far from linguistically, culturally and historically homogeneous population coalescing into a nation, as it were under the pressure of this brutal war of aggression – provides even the slightest ground for criticism. But we should understand it as a historical process. In the Federal Republic of Germany, we needed half a century to achieve the necessary critical distance from our own nationalistic past, extremely burdened as it is by crimes against humanity. I was astounded by the lack of any inkling of recognition of this historically understandable difference in mentalities in the rush to identify with the events of the war.

Quite apart from German sensitivities, I find the historically shaped differences in political mentalities among the three parties involved in the war revealing. After the fall of the Ottoman and Austro-Hungarian empires during the First World War, Russia is perhaps arguably the last empire in which the fossilized remnants of an imperial mentality have survived. This mentality is now running up against the nationalism of the Ukrainians inflamed by the war, while in the

West, there had been at least the hope, perhaps strongest in Germany and faintest in the United Kingdom, that the post-national spirit that gave rise to the United Nations human-rights order after the Second World War would continue to spread. This political mentality has been of major importance for long-term cooperation and mutual understanding across national borders, at any rate within the EU and especially in the Schengen Area. Having a clear perception of these mentalities is simply a matter of useful information: quite apart from the unambiguous assessment of the war in terms of international law, they give rise to different perspectives on the nature, cause and progress of the conflict.

EDITOR: Do you think that by admitting Ukraine, the European Union would risk promoting the return of older-style nationalism that could marginalize, or at least challenge, the constitutional patriotism to which you have devoted so much of your thought and action?

HABERMAS: No, it would not make any difference. On the EU's eastern flank, we've long had member states that insist on upholding the sovereignty they only regained after 1990 more forcefully against Brussels than is sometimes conducive to joint action or even to upholding constitutional principles. A historically informed view of the development of the different mentalities and of the interest positions within Europe and the Western alliance might help to explain the actual reason for my political unease. Under US leadership, the West is in a certain sense keeping the war going – while making no discernible efforts to rein it in. The danger of escalation alone means that Western governments are certainly no longer 'sleepwalking', but, quite apart from the danger of escalation, I fear that the conflict is increasingly slipping out of their hands. In any case, as it progresses, it is unfolding a divisive dynamic at the global level that is completely derailing a world society which until now has been at least halfway economically integrated, albeit in an asymmetrical way.

Western governments want to avoid formal participation in the war. What I've found disturbing from the very beginning, however, is the lack of perspective; they are providing Ukraine with endless reassurances of unlimited military assistance up to that threshold, but without declaring their own political goals. Officially, they are leaving everything else up to the Ukrainian government and its fortune in the arms of the Ukrainian soldiers. This failure to publicly articulate political goals is all the more incomprehensible the more the course of the war reveals how the geopolitical constellations are changing to the disadvantage of the United States, a superpower in decline, and of the EU, which is incapable of acting internationally. That is why, in the run-up to the Munich Security Conference, I recalled in another article in the *Süddeutsche Zeitung* – 'A Plea for Negotiations' – that, by providing the military aid that ultimately makes the prolongation of the war possible, the West has assumed a shared moral responsibility. Quite apart from the Ukrainians' determination to resist the invasion, the West's logistical support and weapons systems mean that it shares moral responsibility for the daily casualties of the war – for all the additional deaths and injuries and all the additional destruction of hospitals and critical infrastructure. It would not be a betrayal of Ukraine, therefore, but a clear normative requirement, if the United States and Europe were to insist on exploring all avenues for a ceasefire and a face-saving compromise for both sides.

EDITOR: In the 1990s, you defended the NATO intervention in the Balkans. Yet now you may be the most prominent German expressing skepticism concerning the nature of the support for Ukraine that is being organized in particular through NATO.

HABERMAS: I just explained why this allegation is mistaken: I've not spoken out against effective support for Ukraine. What I criticize is the failure of the West to develop its own perspectives and to reflect on its own goals in providing military assistance, as well as its failure to accept shared moral responsibility for the victims of the war.

EDITOR: Then have you changed in the meantime, or has the context changed? Did your support for the intervention in the Balkans have anything to do with your having seen it as a solidarity-building exercise for Europe, whereas you now fear that the Ukraine policy could have the opposite effect? In short: why were you on the side of the liberal humanitarian interventionists in the 1990s? And why are you now taking a position that is otherwise more closely associated with the Left, but also with American realists such as John Mearsheimer and the experts at the Rand Corporation?

HABERMAS: I've never accepted the conception of political realism, which can be traced back to Carl Schmitt and Hans Morgenthau, that justice between nations is impossible. This doesn't rule out coincidental agreement with some conclusions we draw from different premises. I considered the Kosovo war, which was waged by NATO in 1999 without a Security Council resolution under pressure from the Clinton administration, to be legitimate at the time on humanitarian grounds, even though it was dubious from the point of view of international law. That judgment weighed heavily on me, because it was the first military deployment of the Bundeswehr since the founding of the Federal Republic. Nevertheless, I considered this intervention to be justified at the time as a humanitarian intervention, with similar qualifications to those expressed by a leading expert in international law such as Christian Tomuschat.

This had nothing whatsoever to do with political hopes concerning Europe. It was rather that the end of the Cold War had raised hopes that a durable, peaceful world society might be possible. At that time, humanitarian interventions were a major issue – even if they did not always prove to be successful later on. In 1998, the Rome Statute establishing the International Criminal Court in The Hague was adopted, and it entered into force in 2002. The war in Kosovo spurred the discussions that then led to the recognition of the 'responsibility to protect'. At the beginning of the 1990s, the

foreign policy of the administration of the elder George Bush was in place: under the leadership of the United States, then still the sole undisputed superpower, the human-rights regime that had long been established in the medium of international law was to be politically enforced. There was ample evidence at the time of the willingness and the ability of the United States to pursue a different policy from the one we have come to expect – after George W. Bush's military adventure in Iraq, Obama's political half-heartedness, and four years of Trumpian irrationality – from a declining superpower that has become less predictable. We are all relieved over the Biden administration – but it is not set in stone.

At the end of the 1990s, the United States was still a superpower which had acquired an undisputed authority in the post-war period in Europe and beyond. At the same time, we could look back on a wave of new foundations of democratic regimes. In academia, disciplines such as peace studies, international relations and international law had experienced enormous growth. The drafts for a constitutionalization of international law initiated by German jurists were still being seriously debated. Many legal experts at the time thought that the prospects for the success of a global implementation of human rights were good. It's too easy in hindsight to make fun of such idealism. No contemporary historian worth their salt would write history exclusively from the cynical perspective of the disappointing outcomes, as if hard-nosed realism always knows better. Aware of the contingencies of historical events, historians must also acknowledge the disappointed – but at the time not unfounded – intentions and hopes that guided the actions of the protagonists, even if their plans ended in failure. It's often only in hindsight that we can understand why they failed.

So, if you bear in mind the historical context of those years, the contrast with the current situation is obvious. A declining superpower riven by domestic political divisions is now focused primarily

on competition with China, the rising major power, while the EU remains fragmented and weakened from within by right-wing populist movements. The vociferous appeals to the unity and strength of NATO are already reactions to the drastic geopolitical changes that have occurred in the meantime to the disadvantage of the West. From an enlightened post-colonial perspective, the West is no longer in a position to make loudmouthed normative appeals to a human-rights order that it has violated itself to persuade neutral powers like India, Brazil and South Africa to take sides in support of Ukraine, although such partisanship would undoubtedly be justified. With the weakening of its own geopolitical influence, as recently described in a self-critical online essay by Fiona Hill, 'Ukraine in the New World Disorder', the West has, empirically speaking, forfeited the global credibility and authority required to make the normative arguments for itself as the champion of the political implementation of the peace and human-rights order, as it was still able to do in the 1990s. It is not as if our normative arguments are any less valid today than they were then, but today we must be more concerned that an *impotent* political rhetoric might rob the principles of the UN of whatever remains of their international recognition. The talk of 'our values' that has now become commonplace contributes to the devaluation of *rationally justified principles*.

EDITOR: Your articles and interviews in the German newspapers sometimes make you appear like a counselor to the Social Democrats.

HABERMAS: Political consulting was never my thing. Without being a card-carrying member of the party, I do see myself as a left social democrat; but as a public intellectual, I've criticized the SPD all my life.

EDITOR: What do you make of the German Greens? How has a party that was once built on fear and rejection of nuclear power (and nuclear weapons) gone on to become the one most willing to risk

nuclear war? How do you account for this trajectory? Did some kind of anti-totalitarian bacillus take hold of the party after 1989?

HABERMAS: The Greens have the historical distinction of having put the issue of climate change on the political agenda. In Germany, however, they have now more or less lost their former social-political wing; their young voters mostly come from similar milieus to the economic-liberal Free Democrats. And as far as their 'anti-totalitarian' stance goes, I'm undecided. In Germany, this expression is rarely used symmetrically in political disputes, but almost always against the Left.

EDITOR: You've long been skeptical of NATO and had very harsh words for the organization in the 1980s. Together with Macron, you call for Europe to develop its own self-defense capabilities. Would that also mean Europe freeing itself from something like American tutelage? And isn't NATO itself perhaps the main hindrance to any independent European defense initiative? Some observers believe that this has always been an important function of NATO from the US perspective. But even if you don't want to go that far, wasn't and isn't NATO a useful tool for Washington to wring concessions from Europe in other areas (trade, monetary policy, etc.)?

HABERMAS: So we're working our way through one misunderstanding after another. But first things first: I enjoy an unblemished reputation among the German public for my pro-American stance. There's no special merit in that for someone of my generation. However, I do take credit for consistently advocating the necessity of a *normative* identification with the political tradition and culture of the West in the old Federal Republic. NATO may have played a role when I insisted that it was not enough to adopt an *instrumental* orientation to the West on the grounds that the United States was providing military protection during the Cold War. For if that was *all* that was involved, Adenauer's Germany, with its unbroken continuity of former Nazis occupying key positions in almost all functional areas, would never

have become a reliable democratic partner. You have no idea how often I've declared and written since my critique of Heidegger in 1953 that anti-Americanism has always been associated with the most questionable German traditions.

EDITOR: But if NATO also prevents the possibility of anything approaching European autonomy in world affairs, would it not be worth adopting a more Gaullist position, and entertaining the possibility of a withdrawal from NATO?

HABERMAS: I can't remember ever having called for Germany to withdraw from NATO. And I've never had any truck with Gaullism. That's probably also the wrong term for Macron's European policy. His ambitious initiatives in support of a Europe capable of acting politically at the global level failed due to the resistance of the German government, especially of Chancellor Angela Merkel and her finance ministers Wolfgang Schäuble and Olaf Scholz. But that's all yesterday's news. Today, I no longer believe that the EU will play a globally influential role in the future. When Macron offers us intelligent reminders that the interests of the United States and the Western Europeans are also different with regard to the war in Ukraine, he's merely following a perfectly normal precept of political prudence. Aren't Europeans instead making a mistake by ignoring the deterioration of the geopolitical situation for the West as a whole? And isn't it rather dangerous for the longer-term support of Ukraine when we turn a blind eye to the unpredictability of a partner we still depend on completely for our own security? The political and cultural divisions have become apparent in American society at the very latest since Trump, and the collapse of the American party system or even the convulsion of important political institutions such as a politically neutral Supreme Court are developments that have been in the offing since the late 1990s, if you cast your mind back to the role played by Newt Gingrich. And I fear that they may have even deeper roots. ∎

HARF ZIMMERMANN
Grand Hotel Friedrichstraße, 1994

THE KILLING OF A BERLIN POWER BROKER

Peter Richter

TRANSLATED FROM THE GERMAN BY SHAUN WHITESIDE

These sad encounters happen all the time in Berlin: first-time visitors make the mistake of booking their hotel at what appeared on the map like downtown. Culture buffs drawn to the city by films, books, art and music – one of the world's greatest orchestras, some of the world's best techno clubs – expect some kind of volcano, only to find themselves in an extinct crater.

Why does the centre of Berlin look like an abandoned shopping mall on the edge of Omaha? Empty pavements, vacant stores, unoccupied office buildings: high-end blight. Why is Potsdamer Platz so bleak, so ugly, so dead? How did Friedrichstraße, Berlin's most fabled thoroughfare, become so lifeless?

The historic centre of Berlin was in East Berlin. It was walled off – quite literally – from the ambitions of Western investors, contractors and real-estate developers for decades. When the Wall came down in 1989, the two acres became a site of frenzy. Nowhere was this more palpable than on Friedrichstraße. The street was already legendary long before its glamourous rival Kurfürstendamm was anything more than a riding trail through the swamps far outside the city. The Elector of Brandenburg, Friedrich III, named the street after himself to celebrate becoming the King of Prussia in 1701. Over

the course of the next three centuries, Friedrichstraße became home to Berlin's *haute bourgeoisie*, as well as craftsmen and workers from Berlin's budding entertainment industry.

One hundred years ago, passers-by jostled together along the whole 3.3 km length of Friedrichstraße. The street ran through Berlin's newspaper district, the business district, the banking district, the night-life district with restaurants, theatres and cabarets, and, finally, at the northern end of the street, the red-light district. Even someone as professionally jaded as the critic Siegfried Kracauer delighted in the 'glitter and excitement' along the narrow piece of land that must have seemed, to a train driver looking down from the railway bridge, 'like the world's axis'.

Shortly after writing this, Kracauer, a Marxist Jew, had to flee Berlin for his life. Twelve years later, the Nazis were defeated. Most of Berlin-Mitte lay in ruins. For the next half-century, Friedrichstraße was cut in two by the checkpoints between the Soviet and the American sectors. It became a border crossing for foreigners, a mainstay in spy thrillers and in the real spy business too. The Americans called it Checkpoint Charlie. The rest of the world would learn this nickname when American and Soviet tanks rolled up on both sides for a sixteen-hour staring competition in October 1961 in what appeared to be the beginning of World War III.

During the Cold War, life went on in Berlin – but elsewhere, not in the old centre. Even after the Wall was brought down in 1989, an astonishing number of Berliners, especially in the west part, wanted little to do with a city centre that was not the centre of *their* city any more. On the brink of the country's unification, West Berlin's then Green Party environmental minister wanted to create a park on the grounds of Potsdamer Platz, which had once been Europe's busiest traffic joint. The minister proposed that with this new park – right next to the already existing Tiergarten – Berlin should host the Federal Garden Exhibition in 1995.

Hanno Klein was not prepared to tolerate such naiveté. As Berlin's chief bureaucrat responsible for channelling foreign investment into the infrastructure of the soon-to-be capital, he had grand plans to Manhattanise Berlin. Klein was a Social Democrat who, like many Social Democrats, was reputed to be dialectically inclined towards the upper-middle class. In 1990, he coordinated a competition for a dense cluster of new high-rise buildings by world-famous designers for Berlin's new downtown. He was dealing with designs from celebrated international architects such as Renzo Piano and Helmut Jahn. A gardening zone was out of the question. As he made painfully clear to journalists, Klein couldn't believe how Berliners were simply unable to grasp the potential of their city. Foreign capital, in all its abundance, was ready to be sown in Berlin-Mitte. It wanted to grow and, of course, become *more* money. The sheer numbers were evidence enough. East Berlin and West Berlin put together had around 3.5 million inhabitants, and their count was expected to rise fast. Soon it could be 5, 7, 11 million. Berlin lay halfway between London and Moscow, a natural hub between the West and the East. Phenomenal growth seemed inevitable. And if some Berliners didn't like it, it didn't matter. Investors were coming in from America, from France, from Scandinavia – from everywhere – and they didn't care. In a feature film made by local TV station Sender Freies Berlin (SFB) in the spring of 1991, Klein sits in his office, conveying the enormousness of this change, seemingly incredulous himself, but careful to convey that he is only the messenger, that he did not call for all these investments: his job is merely to funnel them. But in spite of this, Klein became a symbol of the new hot-money Berlin – an association that may have cost him his life.

At around 10 p.m. on 12 June 1991, Klein opened the explosive package that had been propped against the door of his apartment in the genteel neighborhood of Wilmersdorf. The apartment was so spacious that his partner didn't hear the detonation in his study from her bedroom. She didn't find the body until the next morning.

The police first suspected this partner, and then the wife whom

Klein had in the meantime abandoned with four children, the last of whom was the offspring of a third woman who had briefly joined their ménage. Most murders, statistically speaking, take place in the private sphere. But sending letter-bombs is generally considered unusual in family conflicts. For the police – who have never solved the crime, which remains one of the great unsolved murders in Berlin – the clues seemed to lead toward Klein's professional world, towards the district that bears the official name 'Mitte', middle.

'You will only be able to solve the puzzle if you look into the investment structure of open-end and closed-end property funds, as well as the share of Russian investments in these funds,' a former member of Berlin's financial administration told me recently over the phone.

The former Berlin official, who wanted to remain anonymous, suggested money-laundering investors from the Soviet Union could have been behind Klein's death. He spoke vividly about the men who used to get off the night train from Moscow with very young girlfriends at Berlin's Lichtenberg station in the early 1990s. They were given suitcases full of cash by local lackeys and were then driven to Friedrichstraße. In the former 'House of Soviet Culture', the Berlin office of Mercedes-Benz had quickly set up a branch where luxury limousines were available for cash customers, complete with registration and screwed-on license plates, ready to be driven off the lot.

Now, more than thirty years after Hanno Klein's murder, the official doesn't have any particularly nice words for the deceased, whom he thinks was a bit too smitten with the sudden influx of capital into the part of the city that had just stopped being under Communist rule, while evincing a rather socialist nonchalance towards the original owners of the plots.

This official, who himself was from a modest West Berlin background, resented the mixture of Klein's bourgeois tastes with an absolutist will for influence. The picture he drew of Klein resembled an early-career Robert Moses, the mighty planning administrator

who shaped New York City like no one else in the twentieth century. It is not clear, however, whether Klein knew of Moses or saw himself growing into a Berlin version of the 'power broker'. What is clear is that Klein believed that Berlin's city centre could be the next Manhattan.

Hanno Klein was born during the Second World War in the small Hanseatic city of Stade. From an early age, he wanted to be an architect. After starting a family and completing his training in Karlsruhe, he moved in 1972 to West Berlin, where he worked as an assistant at several architecture firms and eventually got a job as a clerk in West Berlin's building authority in the mid-1970s. He worked his way up from the district office in northern Berlin-Reinickendorf to the actual building administration of West Berlin. By the 1980s he was coordinating architecture competitions for public buildings before he became the person in charge of dealing with investors who wanted to build in the historic centre of an only-just unified Berlin. Shortly after the fall of the Wall but before the reunification of the state, Klein, still a clerk, had been dispatched to East Berlin by West Berlin's building minister to help the Eastern authorities with plans for marketing and building in the central districts of the city. Such people were known as *Leihbeamte* (advisors on loan). East Germans griped about the increased pay – known as 'jungle money'– that they received for going to the East. These advisors earned the reputation of fashioning themselves as modern colonial lords. The term *Besserwessi* crept into the discourse, a portmanteau of *Besserwisser* (know-it-all) and *Wessi* – all the more barbed for West Berliners since *Wessi* was originally a derogatory term *they* applied to everyone living over in West Germany, far from their island within the East.

Both meanings of *Wessi* applied to Hanno Klein. He was from northwest Germany, and spoke the 'pure' German of the region. As a result, he not only stood out like a sore thumb in East Berlin, where dialects abounded (working-class Berlin dialect among the locals, intellectuals included, and the Saxon dialect among the political elite),

but also in West Berlin, where a residual grouchy tone typical of the officers' mess of the Prussian Army still lingers on today (and which many of the squatters in Kreuzberg cannily adopted to conceal their origins in bourgeois Baden-Württemberg). Since the fall of the Wall, Berlin has resembled one of those vertiginous M.C. Escher drawings with steps that ceaselessly rise in a circle: everybody looks down with utter contempt on everybody else, all at once – West Berliners on East Berliners, East Berliners on West Berliners, West Germans on West Berliners and vice versa, East Berliners on the rest of East Germany, the rest of East Germany on East Berlin, and everybody, all together, on the clueless tourists on Friedrichstraße.

Many people considered Hanno Klein arrogant because he didn't say hello to them. But his former press spokesperson, Petra Nelken, a woman from East Berlin, told me she didn't agree. She knew that Klein was simply very short-sighted – and too vain to wear glasses. When someone proactively called out 'Have a very good morning, Herr Klein', he was visibly grateful for this acoustic information, and would be receptive and even charming.

Klein's poor eyesight supports the thesis that he died because he must have held the letter-bomb up close to his face, just like everything else that he couldn't otherwise decipher. The not especially large explosive charge sent splinters straight into his brain. Perhaps the detonation wasn't supposed to kill him but only give him a scare, or a warning. It could mean that he was only meant to be pushed into a particular course of action, or inaction, in the reorganisation and redesign of the centre of Berlin. And Klein would have needed to be violently pushed because he wasn't viewed as corruptible.

Dorothee Dubrau, the then councillor for building in Berlin-Mitte – herself another East Berliner, who took up office after the fall of the Wall, after having been involved in local citizens' action groups – described Klein to me as upright and charming. But she did often feel dismissed by him as a 'naive little Easterner' at crucial committee meetings, when in actual fact she was making much more important decisions than he was. Klein only *prepared* the decisions. But that was

precisely the source of his power: everything went through him. He decided which building projects by which investors and with which architects ended up on the decision-makers' table. It was a position in which a lot of people wanted something from you.

Klein drove a pre-owned red Porsche 924. The 924 was not considered to be a 'real Porsche' by certain aficionados because it consisted mainly of parts from Audi and Volkswagen. The engine wasn't even in the back but in the front to make room for a spacious trunk, almost like in a family car. To make matters worse, it came at a relatively affordable price. The model was known derisively as an 'Aldi-Porsche'. Klein's opponents at West Berlin's biggest contractor, Klingbeil, were meanwhile collecting Ferraris and turning up in Rolls-Royces for meetings. Yet these men were duly informed by Klein that they were 'too small' to be allowed a share of Friedrichstraße. This was perhaps Klein's way of broadcasting that he could do without the corruption and vulgarity of the self-complacent sharks in the pond of old West Berlin.

When I spoke to people from East Berlin who remembered the Hanno Klein case, they were generally inclined towards the view that the letter-bomb must have been sent by men involved with West Berlin's construction companies: businessmen who were keen to be seen as dominant figures and now found themselves dismissed by Klein. People who would have liked a piece of the action but kept finding Klein standing in their way. People driven by greed for profits and fear of losses.

Roland Ernst, a leading construction magnate from Heidelberg, said at the time that the bomb must have come from his own area of business. Ernst himself was one of the contenders very keen to build on Friedrichstraße. But Klein blocked him (probably for being too small). Ernst fought back – but only after Klein had been killed – by locating the precise point at which Klein's big plan was most vulnerable: the heirs to the old owners of the many different pre-war plots, which either the Nazis or the GDR administration

had long ago expropriated. In the centre of Berlin many of these plots had been Jewish-owned. The Claims Conference, the body that pressed for compensation and restitution to the descendants of the previous owners, was arguing for their return. The days of lump-sum compensation, common in the West immediately after the war, were long gone, and now the principle 'restitution before compensation' applied. No one would have expected the former owners or their heirs to rebuild their bombed pre-war houses on their jigsaw-piece parcels of land on Friedrichstraße. But as long as they could still lay claim to them, they threatened to block any large-scale projects. Roland Ernst would be one of the first to buy up these claims en masse: it was a win-win for buyer and seller. That was how Ernst acquired his block on Friedrichstraße. (It happened to be the one that under Klein had been allocated to French department store company Galeries Lafayette – which had already swept away one of the last signature projects of the late German Democratic Republic.)

If Klein was a resentment magnet for West Berlin construction men, he faced as much opposition from old East Berlin bureaucrats. Back in the 1980s, the East Berlin building authority had made big plans for Friedrichstraße. The Communist government wanted to make it into an entertainment and shopping district, complete with covered passages to be christened the Friedrichstadt-Passage. At some point in the 1980s, politicians and city planners in the GDR had rediscovered the myth of 1920s Friedrichstraße and wanted to relive it. East Germany's leader Erich Honecker wanted Friedrichstraße to become the 'most attractive shopping street in the capital', not least as a way of enticing flâneurs with hard Western cash across the border in pursuit of amusement. The urban phenomenon of the 'passage' was also designed with the flâneur in mind; that was one of the great subjects of the Marxist prophet Walter Benjamin, who had recently come back into fashion.

The GDR's biggest state construction company – Baudirektion der DDR – had historically understood the land it was building on

as its own property. Under the prevailing logic of state socialism that question was irrelevant. But as the process of re-privatisation got under way after the fall of the Wall, the question of who actually owned the land became more than interesting. Land prices in Berlin-Mitte, after all, had sky-rocketed.

But in 1990, East Berlin's half-finished project for Friedrichstadt-Passage was halted under Klein's aegis. His department filed an application for demolition, officially because there was no underground car park. In fact, Klein wanted everything reorganised, replanned and rebuilt, but according to Western guidelines. Western Germans ridiculed the whimsical art nouveau ornaments that GDR planners had wanted to use to spruce up their prefabricated building facades. The shell of the Friedrichstadt-Passage was mocked as an 'Uzbek railway station'. Naturally, this generated bitterness among the Easterners from the GDR's former building authority who had worked for years on the mammoth project.

Today if you talk to West Germans who remember Hanno Klein, many are convinced that former agents of the GDR's Ministry of State Security – the Stasi – were behind the assassination. The Stasi certainly knew how to carry out such an operation. Just a few days after the attack, an anonymous caller from Klein's office alleged to the police that two of his closest colleagues, both of them East Berliners, had previously been with the Stasi. Did Klein somehow threaten the Stasi's post-Wall retirement plan of enriching its former agents through real estate? Nothing was ever proved. Nevertheless, West Germans still like to point to manipulated entries in the Berlin land register which date back to the early days of reunification.

In the documentary that Berlin public television broadcast a few weeks before Klein's death in 1991, the old land registers of Berlin-Mitte are piled up in the basement of a court building like the lignite briquettes with which most of the houses in East Berlin were still heated in those days. Anyone who wanted to make something disappear, or wanted to add something, would have had quite an

easy job. 'The office was previously engaged in dispossession,' the sonorous voice-over in the documentary intones. 'Private property was transferred to public property. Now it's the other way round, and sometimes done by the same people.'

Hanno Klein makes a striking appearance in the documentary. In an elegant Italian double-breasted suit, he leans over a map of the city and counts off the pending investments with his index finger. For Friedrichstraße alone he lists figures of between 8 and 9 billion Marks. Smiling, he leans back into his chair, and his whole comportment seems to ask: do all those little naysayers who accuse me of megalomania have any idea what is actually *happening* here? How much pressure from foreign money is involved? 'At the bottom end you've got small investors, starting with 50 to 100 million,' he explains to the camera. 'But I'd also say that the investor who wants to make a billion relatively quickly in Berlin isn't that much of a rarity. Berlin is seen globally as the most fascinating city in this respect. I don't know. Perhaps because we're all caught up in it, suffering from tunnel vision – as Berliners.'

Klein had no compunction about telling Berliners that he thought they were hopelessly provincial. He believed that the time of the village-like idylls in the various neighbourhoods – Kreuzberg, Charlottenburg, Wilmersdorf – after the fall of the Wall was over. The wind of the big world was now blowing into the reunited city, which would presumably soon be the seat of government again, on top of everything else. Klein preached what came to be known as the 'St James's philosophy', a phrase that still makes former colleagues smile. He wanted the 600-metre stretch of Friedrichstraße between Unter den Linden and Leipziger Straße to be like the St James's area of London. For people who weren't familiar with the British capital – East Berliners, for example – he explained: 'There will be no cheap or medium-range shops there.' Investors had to be chosen on this basis. The major US developer Tishman Speyer was already building on the ruins of the GDR's Friedrichstadt-Passage. Bouygues Immobilier, the biggest construction company in France, would be

building next to it: an art deco orgy dreamed up by Henry Cobb of the star New York firm Pei Cobb Freed & Partners. And next to that: Galeries Lafayette from Paris!

Klein himself had explicitly specified that not even department stores would be tolerated on Friedrichstraße. Normal department stores, in his view, were far too mainstream, too cheap, for his St James's philosophy. But Galeries Lafayette had approached the government of the GDR early on. In the year or so between the fall of the Wall and unification, France had been remarkably committed to East Germany. It was widely rumoured that, on the last stretch of negotiations, President François Mitterrand still hoped to halt the unification of the two Germanys. Or at least profit in due course from it as an emerging market. Faced with this French persistence, Klein finally decided that 'a small fashion house with French flair' did indeed have his approval. What was more, it would be built by Jean Nouvel, his favourite Parisian architect. Nouvel had wanted to build a 'Tour Infini', an 'Endless Tower', 400 metres high, on the former slaughterhouse between the working-class districts of Prenzlauer Berg and Friedrichshain. But the prospects didn't look good (too many petty-minded naysayers). Nouvel instead would erect for Galeries Lafayette a spectacular building of curves and glass, with a funnel interior, on the corner of Friedrichstraße and Französische Straße. The funnel was supposed to be seen as an inverted version of the dome on the Galeries Lafayette building in Paris. Anyone who failed to recognise that would at least be astonished at the lavish waste of floor space.

Officials in the economic administration of the new Berlin raised their eyebrows at the unfolding plan for Friedrichstraße. Three different investors – Tischman Speyer, Bouygues Immobilier and Galeries Lafayette – each aimed to replicate the same blend of shopping, offices and gastronomy on the street. They would be connected by an underground passage which would run, as in the old GDR plan, parallel to the actual street – competing with it by adding even more shopping and gastronomy. The projects' rents and

returns surprised some city experts. But any scepticism was deafened by the roar of capitalist euphoria about the potential for growth in the city. Berlin was unified again! Berlin would soon be the capital once more! Berlin was applying for the Olympic Games! A gold rush was in the making, and anyone who wasn't there, anyone who failed to stake a claim, would go away empty-handed. Those were the noises that blocked out everything else.

As the frenzy on Friedrichstraße took off in 1990, Hanno Klein met with real-estate developers in double-breasted suits whose lapels pointed as jaggedly upwards as their soaring share prices. Men whose chauffeurs held the doors of their limousines open for them as they came eagerly springing along. Men like Mark Palmer, who had until recently been the US ambassador in Budapest. Palmer was now developing an American Business Centre at the famous Friedrichstraße border crossing known as Checkpoint Charlie. He aimed to enlist American starchitects of the calibre of Philip Johnson – the kind of men that Hanno Klein liked.

Alongside Western and Eastern business interests, one motive for Klein's murder stared the Berlin authorities in the face. After Klein's murder, the police had received a message claiming responsibility for the attack. They initially dismissed it as inauthentic, a bit of bandwagon-jumping: the letter was from hard-left opponents of gentrification. They didn't identify their faction or group. A few weeks before his death, Klein had prompted extreme displeasure with a few remarks that he had made in the national weekly, *Der Spiegel*. Berlin needed 'a new *Gründerzeit*' (the rampant period of German urban construction in the late nineteenth century) 'which would be striking and brutal', he said. Klein declared Berlin was under great pressure to grow and appreciate. Nothing could be done about it. Those who could no longer afford apartments in what was still the idyllically decaying bohemian neighbourhood of Prenzlauer Berg, when they were all renovated and whitewashed, would have to go live on the edge of the city – 'in the vacuum cleaners of Marzahn

and Hellersdorf'. 'Vacuum cleaners' was the term Klein used for the large pre-fabricated slab buildings in which half of all East Berliners still lived.

Police suspicion fell principally on the Revolutionäre Zellen (Revolutionary Cells, RZ), a loose association of outwardly respectable West Berlin terrorists from Kreuzberg, the traditionally left-wing area that begins where Friedrichstraße ends in the south between social housing blocks, which in Klein's terminology might also be vacuum cleaners. (Klein being Klein, he had plans to reopen the pedestrianised cul-de-sac to motor traffic and pep up the area with shopping and gastronomy.) The RZ sometimes carried out attacks, but hadn't gone underground like the terrorists of the Red Army Faction (RAF), who had a few weeks previously claimed responsibility for the assassination of Detlev Rohwedder, the director of the Treuhand Anstalt, the West German privatiser-in-chief of national property in the former GDR. It was after the murder of Rohwedder in April of 1991 that, according to police files, Hanno Klein was reported to have said: 'I'll be next.'

When I looked at the investigation files another fact struck me: at the time of his murder, Klein had already *resigned* from his job. Most likely Klein wanted to stand down because he had lost a power struggle against his old colleague Hans Stimmann. In their youth, they had both been members of the JuSos, the Young Social Democrats. In those days, Stimmann and Klein had campaigned together against the city autobahn that was supposed to lead across Potsdamer Platz, just where the Green Party later wanted to create yet another park instead. They used the informal *Du* with one another, as is traditional among Social Democrats. In matter-of-fact correspondence they passed on greetings to each other's wives. But in April 1991 Hans Stimmann had been appointed as Berlin's first Director of Building since the famous and influential Martin Wagner in the 1920s. That made him the superior of Klein, whose plans for the city he did not support. Klein wanted Manhattanisation; Stimmann wanted a return to the old Berlin. Within the Federal Republic of Germany,

Berlin is a federal state in its own right; it has ministers who are called senators. Klein was often addressed as Senator for Building by investors and, as his staff later told reporters, he often didn't bother to correct this mistake. It was widely assumed that the actual senator for building and city planning, Wolfgang Nagel, had installed Stimmann to put Klein back in his place. Stimmann and Klein were not only old acquaintances and members of the same party, but both were also equally ambitious and equipped with a pronounced 'will to power'. (Stimmann with his wrathful moustache even looked a bit like Friedrich Nietzsche.) Now Stimmann occupied the much more powerful position. Klein was furious. A friend who had seen Klein and his girlfriend drinking in an Italian restaurant on the evening he would be killed told the police that even then Klein – that very evening – was raging against the incompetence of his bosses.

After Klein's death, and even a bit before it, Stimmann had already eclipsed Klein's name and fame. By the mid-1990s, among the investors and builders flocking to Berlin, Stimmann was one of the most feared figures. He became the single most hated man in Berlin among architects and builders. Only the least imaginative investors were willing to sign on to Stimmann's fearlessly stubborn conservatism: a roof must be at 22 metres, facade must show more stone than glass (he would come with a gauge and a calculator to check), windows must, please, stand as upright as Prussian soldiers.

Klein had once studied with the famous German modernist Egon Eiermann, and he championed internationally acclaimed architects like the Frenchman Jean Nouvel and the Italian rationalist Aldo Rossi, whose approaches to building he considered to be an aesthetic and intellectual gain for the new Berlin. Stimmann, who had insisted on learning masonry and bricklaying from the bottom up before studying architecture, was less impressed by big names. On the contrary, he forced them to play by his strict rules when they proposed new work for Berlin, just like everyone else, or he simply scared them away. In any case, he seemed to favour buildings that came without the name tags of internationally famed designers.

Commitment to certain local traditions was more important. After all, the typical *Berliner Altbauten* – or pre-war tenements – that have become the most desirable buildings in the city are also rather anonymous architecturally. But the construction that happened in the 1990s in Berlin-Mitte turned out to be quite different, technically, from the construction around the 1900s. Stimmann's demand for stone facades was not met with artful masonry or bricklaying. Instead, thin stone slabs were glued to otherwise modern constructions like a veneer. When the slabs fell off, which happened occasionally, a face of coarse concrete was unveiled. Even when these slabs remained, their imitation of genuine stonework – by suggesting a balance of weight and buttress – was clearly perceptible as a simulation. Similar issues arose on the larger block constructions. These were sometimes meant to look like a cluster of independent houses by gluing slightly different facades to various portions of the building. To avoid the impression of Disneyland, ornamentations such as cornices and mouldings were mostly flattened and minimised, as if to indicate a contemporary detachment from the original style they were replicating. Facades that were meant to be modest and of noble, civic-minded decency, instead came out dull. The rigid height restriction of 22 metres incited building owners to hide as many stories as they could in slanted mansards. It was an attempt at mimicry that not only failed aesthetically, but was also a risk economically, since many investors were being lured in with guaranteed rent revenues – as if demand for office and retail space in these buildings would never be a question. Unfortunately, that would not be the case.

High hopes for rapid growth soured quickly in Berlin: in fact, the city even shrank for a while. More people were leaving than moving in. West Berliners lost the sumptuous subsidies that had been paid to everyone for holding out in the 'front town' of the West. East Berliners, previously privileged among East Germans, were hit with mass unemployment and poverty. The Olympic Games Berlin had applied for were lost to Sydney. If the nineties are remembered today as one of Berlin's most flourishing eras in terms of culture, that was

due to the low cost of living, the low rents, and the empty space in the inner city. It was a great time for artists and bohemia. For real estate developers – not so much. But most of the projects on Friedrichstraße were already under construction by then.

When I spoke with Stimmann on the phone in 2021, he was admirably combative in the defence of his record: he told me he wanted to ease the crushing pressure of the waves of capital breaking on Berlin; he wanted to 'break down' large-scale investments to get closer to the grid and plot structure of the pre-war city; and he wanted to correct the mistakes of his predecessors, who allowed wholesale developments in old building districts and green-lit inner-city autobahns running through anti-historical, late-modern 'urban landscapes'.

Hans Stimmann told me he particularly regretted how the area around the Tiergarten, once favoured by the Jewish *haute bourgeoisie*, was being razed and replaced with a free-form arrangement of modern buildings called the 'Kulturforum'. He now thought he might have been able to prevent similar destruction of the historic centre of Berlin by enlisting the descendants of the former owners of the buildings. He believed his mission was to keep the history of streets and plots from being swept away by developers.

Stimmann was responsible for the strict realignment of Friedrichstraße. Under his supervision, the street lost almost all the spatial extensions accrued during the war, some of which had been turned into green squares under Communist administration. Stimmann had always wanted the street to return to its pre-war glory. He has often been blamed for the fact that that's exactly what didn't happen.

Philip Johnson did eventually build something on Friedrichstraße. What became the Philip-Johnson-Haus was the worst design he ever did. His hatred for the building is on the record. In 1995, when a Berlin journalist asked Johnson how he envisioned Friedrichstraße in five years' time Johnson is famously reported to have replied: 'Empty.' When I scoured the issues of local daily *Der Tagesspiegel*,

THE KILLING OF A BERLIN POWER BROKER

I found a report of an uproarious meeting at the Akademie der Künste: intellectuals mainly from East Berlin protesting 'architectural banalities' in Berlin's centre. 'In Mitte, they are building bankruptcies,' one man shouted. It had become apparent that things were not working as planned.

Today Stimmann could argue that even Cobb's art deco follies didn't save his luxurious building from bankruptcy and vacant stores. There was a rumour that Nouvel's shiny Galeries Lafayette only survived on Friedrichstraße because the French state did not allow it to retreat from such a prestigious address. But, as announced this August, Galeries Lafayette will be gone by next year. The French department store chain is closing all of its branches abroad. Berlin's cultural minister, Joe Chialo, has suggested using the building for housing the city's central library. The local trade association immediately endorsed the idea. The future epigraph of Friedrichstraße may yet read: 'Silentium!'

Symbolism is all that Friedrichstraße has left to offer. It was once an emblem for the golden days of pre-war Berlin, until it became a symbol for Berlin's division in the Cold War. Today Friedrichstraße is the symbol of the New Berlin with a capital N. Or more precisely: it is the symbol of the New Berlin trying – and failing – to resemble Old Berlin with a capital O. Social Democrats like Stimmann and Klein shared a romantic love for the big city, the metropolis, even at the price of glorifying a social stratification that their Social Democratic forefathers once fought against. The German Greens, by contrast, the rebellious offspring of Social Democracy and German Romanticism, and the culturally dominant force in most parts of Berlin's inner city, often harbour a passion for the small town, the village, the countryside. Thirty years after the Berlin Greens had tried and failed to turn Potsdamer Platz into a landscaped garden park they tried to turn Friedrichstraße into a landscaped village square – a pedestrian zone with makeshift wooden patches and benches spread across the road. Not even enough of their own constituencies really wanted to stroll let alone sit down here and stare at empty shop windows

and grimly gridded facades. In the last elections the Greens were turfed out of office in Berlin. Even by their own account: because of Friedrichstraße.

It's difficult to say what Hanno Klein would make of this today. The area around Friedrichstraße is no London, no St James's. In the rest of the city, however, he was astonishingly prescient in the prognoses for which he may have been killed. Today, Berlin's population *is* growing drastically and at great speed. There are almost no more crumbling old buildings with low rents left for less affluent people in formerly bohemian neighbourhoods like Prenzlauer Berg. They are being renovated and painted white and have become dazzlingly expensive. Even in the 'vacuum cleaners on the edge of the city' things are getting tight now. Berlin is, once again, considering a bid for the Olympic Games.

Friedrichstraße might now offer a reason for hope, even excitement. To have a such a site of high-end decay in the very midst of an otherwise brutally booming town is astonishing. Dancing on the ruins was once seen as the new Berlin's recipe for success. It created much of the cultural capital on which the city still subsists. Who's to say that that wouldn't also be possible with the investment ruins of Friedrichstraße and Potsdamer Platz?

Investors will be able to write off their losses. (Much of the profit of Berlin's allegedly high-yield construction in the centre came from tax breaks anyway.) If the people of Berlin paid for outside investors' enrichment from ghost buildings, they should at least be permitted to dance in them, play music, open up artists' studios and rehearsal rooms. Everything that has no affordable room elsewhere in the city could find a new haven in the centre. There are hardly any residents to complain about the noise. The ghost of Hanno Klein probably wouldn't even raise objections, except to specify that, in this part of town at least, it would need to be top-notch noise. ∎

OUT OF THE WOODS

Elena Helfrecht

Introduction by Hanna Engelmeier

TRANSLATED FROM THE GERMAN BY PETER KURAS

If I'm unlucky on my way to work, I sometimes end up stranded at the central train station in Wanne-Eickel, a small town in the Rhineland. There's not much to do there. There's a DM, a Lidl, a Hornbach. So you can shop, at least there's that. The only thing I know about Wanne-Eickel is that Heinz Rühmann's parents once ran a pub in the train station, most likely serving hearty broths behind heavy curtains. Heinz Rühmann – the so-called actor of the twentieth century, Germany's cinematic everyman (starring in ninety films) – died in 1994 at the age of ninety-two. He was a little too old to be Elena Helfrecht's grandfather. Great-grandfather, that would be about right. The people's actor. Our grandpa, Germany's grandpa.

In the film *Die Feuerzangenbowle* (1944), Rühmann plays the mildly insolent middle-aged writer Johannes Pfeiffer. Sometime around 1900 (we never learn when, exactly), his friends convince him to pass himself off as a schoolboy at the local Gymnasium. Among the weird old hacks teaching alcoholic fermentation and other arts, the young and pithy Dr Brett stands out. A perfect nationalist pedagogue, he compares his students to saplings: young trees need to be bound to stakes in the ground so that they don't sprout in every direction. Discipline is the tie that binds them.

Despite the film's celebration of discipline, it wasn't enough for Nazi censors in 1944. The teachers in the film – apart from Dr Brett – were a bit too easily lampoonable as figures of authority. The film was not permitted to be shown publicly. Teachers couldn't be disparaged when they were in such short supply. On a January night in 1944, Heinz Rühmann boarded a south-bound sleeper train out of Berlin with a copy of the film. When he arrived at the Führerhauptquartier near Görlitz (present-day Gierłoż) in East Prussia, Rühmann hoped to convince Hermann Göring to allow the film's release. Göring's officers were given a private screening, which they greeted with cheerful enthusiasm. Cheerful enthusiasm being at least as rare as teachers at the time, Hitler green-lighted the film, which he had not seen; it opened in theatres the next day.

Some of the film's actors never lived to enjoy its lasting success. They were conscripted as soldiers in the Wehrmacht as soon as they finished their gigs as pupils in the fictitious Babenberg Gymnasium. Dr Brett's rendition of the film's core symbol for German discipline didn't include the purpose for which the young saplings were raised: to be cut down as needed. Elias Canetti in *Crowds and Power* (1960) refers to the forest as a potent symbol of the Germans:

> The mass symbol of the Germans was the army. But the army was more than an army. It was the marching forest. There's no other modern country in the world where feeling for the forest has remained as alive as in Germany. The rigidity and parallelism of the upright trees, their density and their number fill the heart of the German with a deep and mysterious pleasure. Even today, he seeks the forest where his ancestors lived and feels himself united with the trees.

That was how it was supposed to be. In 1936, the German forest made its star turn in the propaganda film *Ewiger Wald* (*Eternal Forest*), a moody black-and-white cinematic hymn to the German woods, with a voice-over to match it: 'The "Die and become" of the forest is

woven through history. The *Volk*, like the forest, stands in eternity. We come from the forest, we live like the forest. From the forest we craft *Heimat* and space.' The film is now only available in state archives. *Heimat, Volk*: ideology-laden words, which are today best avoided. Space. Forest. It's hard to find words in German to substitute for them. As phenomena, they persist. How can we do without them?

Elena Helfrecht's images don't depict horror, crimes or violence. And they don't contain any people. They present the forest as people left it. It's not a forest into which the sun shines brightly or where lilies extend heavenward. There is snow and it is night. These images don't know Christmas. Helfrecht's forest is a place where dead wood has taken on the form of a woman, where we stare wild animals in the eye, where we suspect body parts may be hidden under the snow. Icicles descend – but from where? From the roof of a barn where a cat seeks sanctuary? Maybe there was a hunt nearby. Two wings (from a swan?) hang from hooks in a tiled utility room. The stories that took place here might only have their full effect if they were intoned by Werner Herzog.

Helfrecht does not depict the orderly forest that Canetti describes as an effective German mass symbol. There's nothing rigid and parallel here. Not a single tree grows straight and tall, as Dr Brett would have insisted. In Fritz Lang's *Die Nibelungen* (1924), the young Siegfried rides to his fate between enormous, straight trees, grown parallel to one another. The most German of all German forests is a stage, a fantasy that promises death.

Helfrecht's alternative imagery of brush and undergrowth are fostered by the knowledge of this dreamworld. Time and again, crosses appear in her photographs – perhaps more than are strictly necessary to understand that, for Helfrecht, these are spaces of death and trauma.

The forests in these images are crime scenes. Helfrecht's subjects – the roots of a tree, a cat, the wings of a dead bird – all appear caught by the flash of her camera. The proverbial deer in the headlights is here, too, and apparently sees everything that the images only indirectly reveal to us. One of the signature features of Helfrecht's work is that it tracks a past that she herself did not have to experience. The sense of menace unfolds quietly, its effect only heightened by its invisibility. The images make viewers, however unwillingly, into hunters, following the traces that Helfrecht has set out for them in the thicket of the past. But she does not guide us; there is no sense that we will make our way out. ■

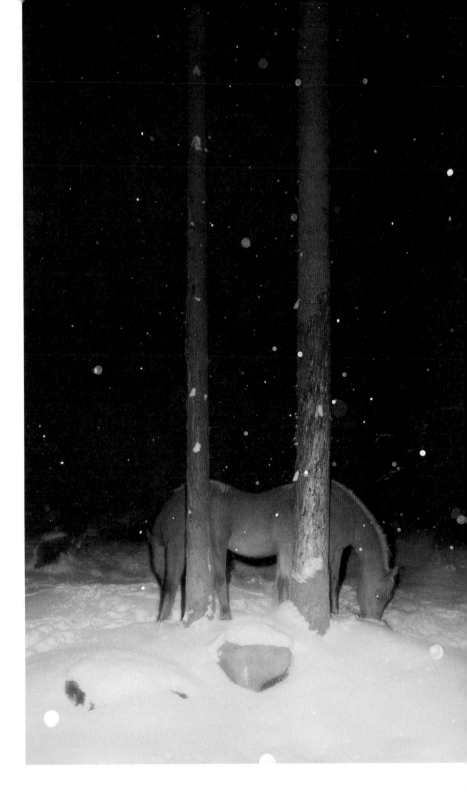

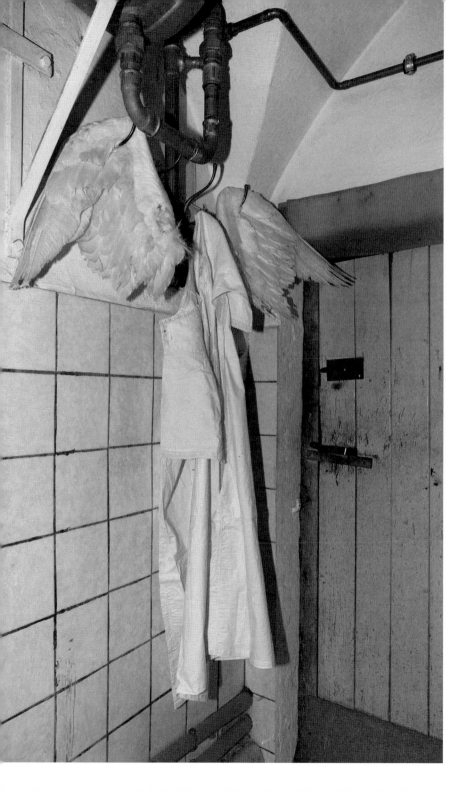

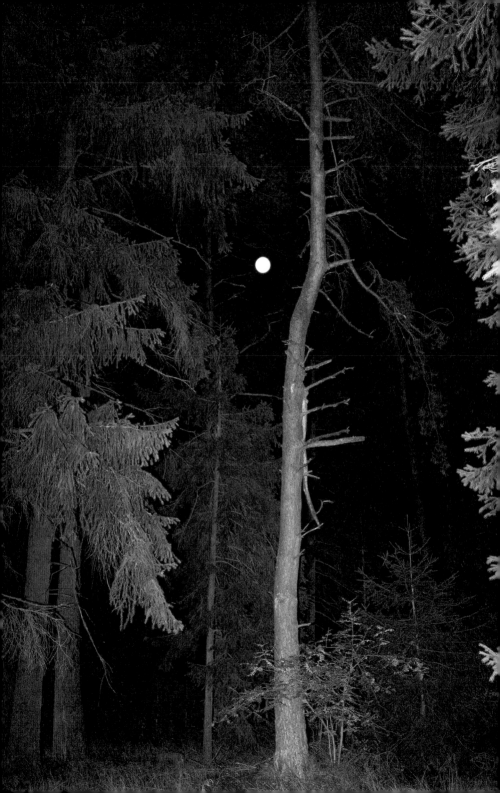

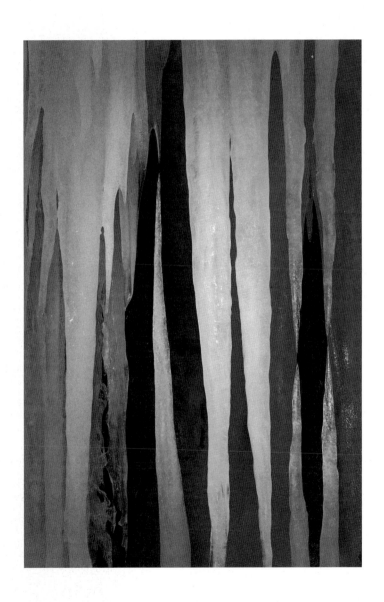

The Best Literary Series You Haven't Discovered Yet.

The Books of Furnass
by Richard Snodgrass

★★★★★

"Snodgrass artfully contrives an entire literary cosmos." – Kirkus Reviews

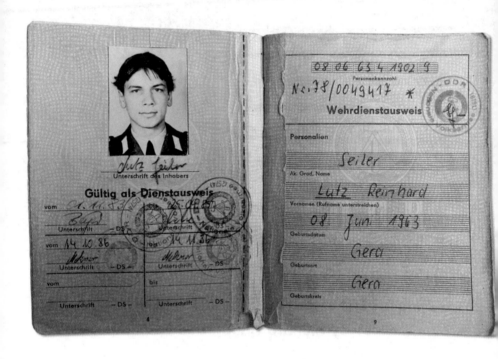

Lutz Seiler's health booklet from his time in the National People's Army of the German Democratic Republic
Courtesy of the author

IN THE MOVIE BUNKER

Lutz Seiler

TRANSLATED FROM THE GERMAN BY MARTYN CRUCEFIX

1

It started with the poster – the wording framed in black, not unlike an obituary. Year after year, it was displayed at railway stations, at bus stops and on trees along the streets. The headline read MUSTERUNG, followed in bold by the year of birth of those who were being summoned. As a child, I thought I knew well enough what the word *Musterung* meant – 'pattern'. For me, it was a word almost entirely associated with the plastic cloth on our kitchen table, with its dull sheen and pale blue check pattern that every morning took my tired eyes hostage. But for what or for whom was this 'pattern' being announced on the poster?

Then the posters would vanish; I forgot about them and, one year on, they would reappear, displayed on the churchyard wall beside the path I had to walk along at least once every day. There was some obligation here that no one was able to escape – that much I'd already understood: something was going to be unavoidable, but the years being referred to (the 1950s) were unimaginably distant in the past. It was only when the year 1960 showed up on one of these posters – and thus my own decade had been broached – that I persuaded myself to stop and stand in front of it. 'Attendance is due on . . .', 'You must bring with you . . .', 'In the event of failure to

attend . . .', and so on. The words had the kind of seriousness that frightened me: no chance of escape. From an early age, I was disposed to believe in such a possibility – a system of repression that made it possible for me to feel pretty much carefree for long periods of time. Because of this my mother often used to say I was 'happy-go-lucky', but that was not really true because, fundamentally, I sensed the threat perfectly clearly, yet my home-spun insouciance sought to draw an immediate veil over it. She was mistaken – but the unreasonable demands of the real world could actually be made to vanish for remarkably long periods of time with the help of this cloak of invisibility.

One of the phrases on the poster – the DISTRICT CONSCRIPTION OFFICE – impressed me (it still impresses me today). It had the ring of a genuine military operation. I was seventeen years old when the year of my birth, 1963, appeared on the posters. On 6 April 1981, I walked into the District Conscription Office, thereby obeying the very first command of my time as a soldier.

I can see the date in my health record. The health record book was begun on the day of recruitment and – this was the intention – it was updated throughout the remainder of my military career. Stages in your life were recorded there according to phases or categories of fitness. As a soldier in the National People's Army, you progressed through various kinds of deployment appropriate to your age and physical condition. On 4 April 1986, at the time of the final entry, twenty-seven of the thirty-eight possible service categories still remained available to me.

In some ways, the brown card-bound health record is my very first diary. Although strictly military and medical in character, some of the entries contain details that I find astonishing today. Entry for 7 February 1984: 'On 31.1 several slabs fell on the pat.'s lower back / lumbar x-ray / urinalysis.' What slabs? I remember none of it.

When soldiers were discharged from military service, the health record was entrusted to them 'for personal safekeeping' until the next call-up. To ensure nothing untoward occurred, there were

'Instructions for the Safekeeping of the Health Record' printed inside its card cover: three paragraphs in small font and three more on what you were expected to do, divided into further points and sub-points, including the proper treatment of what was referred to as 'medical resources', which included the gas-mask goggles that were supposed to be retained by their owner after active service and be appropriately maintained, protected and kept at the ready. According to Section 3, Sub-section 2, Paragraph a), the gas-mask goggles were to be 'brought with you to each new call-up to military service'. Otherwise, any use of them was prohibited, though some of my friends disregarded this because the little plastic frames with straps to go round the ears, reminiscent of rubber bands, would never slip off your head when you were playing football. When we caught sight of a striker wearing gas-mask goggles, it was impossible not to think of Wolfgang Borchert, who we read enthusiastically in our first year at university: 'You call those spectacles? I think you're being deliberately odd.'

I have mostly forgotten what else happened on that first day at the District Conscription Office. I do remember my readiness to comply with the almost cheerful tone of command that prevailed there. Perhaps I wanted to show that I was not stupid and that I already understood what all this was about. I was certainly hoping that, after the process was over, all this would disappear again as quickly as possible under the cover of my invisibility cloak.

I do still remember that the *Musterung*, the summoning to medical examination for military service, started with the presentation of the ID cards we had been told to bring with us. Then there was a long wait in the corridor, perhaps two, maybe three hours. A first brief interview was followed by a series of medical checks as we processed from room to room, at one point having to strip down to our underpants. I was pleased to have remembered to put on gym shorts that morning and looked on in silent triumph at the other hapless guys standing in their baggy fine-rib briefs.

I was measured and I was weighed. I had to hop on one leg across

the room, to stand up straight, to bend forwards, and so on. In the hearing test, I managed 'whispered speech at six metres', or so my health record tells me. And, although I knew what was coming (because of countless stories embellished with obscenities), I was still shocked at the end by the swift, firm grasp of my pants, a hand gripping my balls and toying with them, the testicles and epididymis, a practised hand that took four, maybe five seconds, foreskin back, no restrictions and, as for the rest, 'All there!' The uniformed doctor dictated something of the sort across the room and the nurse sitting behind him conscientiously wrote it down. She was at a school desk in the middle of the room and, without glancing up, she recorded everything in her small, careful hand in the health record. At first glance, I took her for a student.

But most of the doctor's speech remained incomprehensible. The tone in which it was spoken also deprived me of my last hope of a miracle. The night-time sleepwalking – which I had made report of because it was said to be on the legendary list of grounds that might prove sufficient to declare a conscript 'permanently unfit for service' – was received without so much as a flicker of interest from the senior physician, Dr Seyfarth (I can still read his name; I can see his rubber stamp).

In fact, it had taken some considerable effort for me to broach the issue because, there behind me, barefoot like me and well within earshot, a whole line of recruits was waiting for the conclusion of the examination. I felt immediately ashamed of something I had simply made up. As it turned out, no reference to it ever made its way into my health record.

At the time, I had no idea what it took to make a story credible. The story of the sleepwalker probably reached Dr Seyfarth's ears many times every day. It was precisely because 'The Sleepwalker' featured on the notional list of supposedly successful stories that I really ought to have tried to tell it differently. Thomas Mann's *Confessions of Felix Krull, Confidence Man* might have served as a guide, but then again not everybody is capable of faking an epileptic seizure. Anyway, I did

not know anything of this or of any other books – literature did not interest me. It was only in the army that I started to read.

So, while I tried to keep my voice steady and detailed my supposedly restless and risky sleepwalking tendencies, some of those in the queue behind me were trying to shake off their own nerves, or sense of shame, by chattering and sniggering, though they were immediately reprimanded by one of the officers who continually patrolled the rooms. With these fellow sufferers breathing down my neck, the bark of the officers and the blank face of Dr Seyfarth (I wonder whether he, the doctor, is still alive and, if so, whether he sometimes thinks of that age of the sleepwalkers), under the circumstances, it was not easy to tell any story. Sure, in the tales of the *Arabian Nights*, the danger is on a completely different scale, but then, the setting is ideal by comparison: a candlelit quiet room, curtains, quilts and cushions, silk or velvet covers, and finally, a very attentive listener . . .

By contrast, the rooms of the District Conscription Office were brightly lit, and the lino shone so much that it hurt your eyes. After a while, my feet grew cold on the floor which had evidently been recently polished or coated with a special wax. If you stood in one place for any length of time, the soles of your bare feet started to stick to the floor. Those waiting in line, as they spontaneously shifted from one leg to the other, made a soft, slight smacking sound. After a while, it began to sound as if paper or something was being continually torn up or, at least, something was once and for all, in the course of that day, losing its currency. In the end, confronting the recruitment panel of four officers and their questions, I found myself possessed of neither great courage nor a good story. What little courage I had was enough to refuse the longer period of service (three years or more, instead of eighteen months) and to decline service at the border: 'I just don't think I could shoot anyone' – that was enough, even in the absence of a story, everyone knew that.

2

My nervousness increased by stages. At one point, I could no longer cross the station square without thinking of 1 November, the day on which I was to be called up. Before I stepped onto the station concourse, my gaze was inexorably drawn off to the right, towards the sidings of the marshalling yard. There, on one of the tracks, was the ramp in front of which soldiers from Gera and its surroundings were required to assemble.

A few months earlier, at five in the morning, I had accompanied my friend S there. A large group of men with travelling bags had already gathered in front of the ramp. The whole scene was illuminated by the headlights of a couple of lorries whose engines were idling. Somewhere on the way across the station square, I had the sense of losing my friend. He said goodbye with a quick hug, stepped across an invisible line and was gone. Yet, all the while, I could see him perfectly well. But I noticed how his back stiffened, his stride shortened, his walk adapting itself to the different rules that applied on the other side. Just in front of the ramp, he turned round again: he waved at me, or rather, he thrust his left arm into the air. It looked awkward and, at the same time, as if he wanted to give me a show of defiance. Even as he was doing this, he was already being dazzled by the headlights. 'Cigarettes out!' was the last thing I heard, then I too gave a wave, turned round and drove home.

3

The leap down from the lorry: I tried hard not to betray any sense of clumsiness. Perhaps ten or fifteen officers stood at the entrance to a compound surrounded by barbed wire which had to be the barracks. So far, I had seen nothing more than a dismal display of wood and brick huts.

'Compan-eeee – close order!' A few of us knew what this meant,

but it took a while before we were all standing in rows of three. I noticed the officers' faces, some looking tense, some amused. Yet everything proceeded quietly enough. There was a short, rather slap-dash alcohol inspection for which we had to step forward with our luggage. For a few minutes, nothing could be heard but the passing of cars on the nearby road. A big chimney with the lettering VEB LEUNA rose from the factory premises on the other side of the road. 'Bags – pick hup!' The command had been shouted, perhaps inadvertently, by several officers at the same time, that is, not properly synchronously, so that to begin with I did not catch what had actually been said, though I noticed how everyone instantly shouldered their travelling bags. Some were even carrying suitcases, though these had been expressly forbidden in the conscription order. The next command was similarly incomprehensible. Straight away, that fear again: of not understanding quickly enough, or even not understanding at all what was going to be required in this strange place. An ear-splitting whistle cut through the air and a flame burst from the Leuna chimney across the way.

We passed through the gate – a framework of steel tubing over which some barbed wire had been draped crosswise and rather carelessly. The gate was freshly painted but still managed to look run-down and bodged together. Just a few metres along the road between the huts, one of the officers (Sergeant Bade, as we later learned) began giving us a marching rhythm: left, left, left-two-three-four. In Bade's muffled voice and with the way he tried to maintain a low register, the whole thing sounded more like 'let, let, let-hoo-hee-hoor', which is probably why two or three of the guys started laughing. A murmuring arose which was promptly yelled down by a second sergeant. As if none of this was out of the ordinary, this sergeant, in his impressively polished boots, strode on across the grassed areas running alongside the road to the barracks.

The effort to stay in step while also managing our bags and suitcases resulted in ludicrous hopping and shambling around. But the strangest thing was the steam: a soft, white vapour that welled

up out of the ground on all sides, from gaps in the concrete surface of the road, from cracks in the pavement between the huts and, in some places, this vapour also rose like a marvellous mist from patches of grass. The sergeant with his shiny boots marched through it, seemingly unconcerned. Black, polished leather, misted by water vapour – when I think back, that is my first impression of this time.

Introduction to Hut 6, Dormitory 10: seven iron double bunk beds, fourteen cupboards, one broom cupboard, fourteen stools, one table. It was the room at the far end of the corridor, facing the room occupied by Sergeant Zaika – an enemy, as it turned out. On the other hand, the other thirteen men in my quarters seemed like friends from the start.

In the hours that followed, we passed through the maze of clothing and equipment huts. By the afternoon, everyone was dressed in their basic uniform. We were given soup and tea in a low building close to the gate. From there, we marched back down the road to a large bunker-like building. It was a huge, semicircular structure with a distinct crack running across the top. To my surprise, there was a cinema inside the building, or at least there was a screen and several rows of folding chairs, and soon after I heard the term 'movie bunker' for the first time.

The movie bunker was surprisingly spacious. Just a few moments after we had taken our seats, the lights went down. I was thankful for the darkness. I can hardly remember anything about the film. There were tanks and other armaments; there was no end of talk about peace and the difficult, but necessary, task of fighting for it, which meant defending it (by whatever means necessary). I had begun to close my eyes when someone touched me on the shoulder. It was the sergeant with the misty boots. He did not say anything, but I understood I was to get up. As I did so, my shadow fell across the screen and got mixed up there with images of a prison camp. Then the film was showing a city completely destroyed by war. In among the ruins, on bended knee, a Red Army soldier was waving the flag of the Soviet Union, just as my shadow was slipping away beneath him.

The sergeant and I walked back towards a row of long, thin lights. For a moment, I glimpsed the soldier who was standing behind the film projector. He looked calm and I admired him for that – for his long-term familiarity with all this, for having, as it seemed to me, survived it. There were mirrors on the wall at the back of the bunker. In front of the mirrors stood large chairs with metal armrests, head-rests and height-adjustable seats. It was largely because of my state of mind, but what these objects suggested to me were electric chairs. In fact, they were nothing other than what you would find in a barber's shop: big, wide chairs, upholstered in army-green leather. The seats were cracked, and the backs shone greasily in the glare of the neon tube lighting that hung on long rails from the ceiling of the bunker.

Behind the big chairs there were wooden benches for waiting. They were already taken, so I had to stand. The lockers between the washbasins, as well as the tiles above them, were painted green. An older, more thickset officer moved between the hairdressing chairs and was gesticulating. He seemed very annoyed, obviously wondering why the barbers had not yet begun their work. This was Captain Buddrus, head of the so-called Technology Park, which is where I came across him later, on my countless days spent there, and also while I was training as a driver of a W50 Ballon, a truck with unusually wide tyres.

The barbers' clippers in action made a kind of chattering noise that drowned out the film. It was nice when they eased up the back of your neck, but more nerve-racking round the ears. The barbers all wore white rubber aprons over their uniforms as if they had just popped in from the kitchen or the canteen. It was clear they were not trained barbers, but they were proficient with the little trimmers and, like the soldier behind the projector, they were at least half a year, some an unbelievable whole year, of army camp experience ahead of us. The evening before my call-up, my mother cut my hair. Squeezed in the aisle between the built-in cupboards in our new kitchen: first I had to swivel to the left for the right side, then right for the left side. With a hand mirror held up in front of me, I had agonised over every

millimetre cut off – completely pointlessly, as it now turned out.

The barber bent my ear forwards and said something I did not hear. The noise of the clippers was too loud. I smelled his breath and, for the first time, caught a whiff of the disinfectant used to wash soldiers' clothes at the military laundry in Merseburg. Once a fortnight, laundry was delivered and, sooner or later, the disinfectant triggered a fierce red, horribly itchy rash between the legs – then you needed ointment. The ointment was dispensed at the infirmary; it was cortisone, which we applied in great quantities over the following months. There was never any consideration of possible side effects, nor did we much care as long as there was something to soothe the burning on the insides of our thighs.

I said 'Uh-huh' or 'Oh yeah' while the barber used my uniform jacket collar to steady the clippers, running them round my neck as if on a rail. Under the gown, between my knees, I had hold of my uniform cap; it felt odd to be wearing headgear again. The cap made my head feel as it used to when I was a child: winter holidays, ski trips, marks on my forehead and ears, or the hat pulled right down over my face, the way it gradually frosted up with my breath freezing in the wool . . . Cut hair was piling up all round the chairs and the barbers waded through it in their boots.

The roar of artillery fire rose behind me. Staring into the mirror, I was part of the film: tanks trundled over a lumpy terrain and at the same time across my face, pale under the fluorescent lights. The barrels of guns swung left and right – as did my startled expression. 'The armed forces gearing up to advance . . .' For a moment, it seemed possible to bring the whole thing tumbling down with hardly more than a twitching of the corner of my mouth. From his place on the sofa, a big heavy, crocheted blanket across his knees, my grandfather would shout, 'Tanks, my boy, nothing but mobile coffins!' – and he was one who ought to know. In the mirror, I stared at my own face. Under the chattering of the clippers, for the first time, I found a few moments' peace. But I could not wholly abandon the effort to follow something of the plot or the commentary of the film being shown. I

thought there was perhaps something in it that we would be quizzed on later, something that might prove important in some way to my survival in this new environment. 'Our air force, equipped with the most advanced technology . . .'

'Stop, now stop! On to the picture!' At the captain's command, the clippers fell silent. Off to one side, to the left of the barbers' waiting area, another queue had started to form, stretching into a barely lit part of the bunker. The line of recruits ended in front of a wooden cubicle, the narrow door of which opened and shut at regular intervals.

It was only when I was sitting on the stool in the glare of the lamp that shone warmly on my face that I noticed the photographer was a woman. Instantly, I felt embarrassed at the sight I presented: the stiff, new uniform, the newly cropped skull. And I felt a dislike of the sergeant who was assisting her, even though he had spoken to me with some friendliness, or, at least, in a rather different tone from Bade or Buddrus. But that had more to do with her than with me – that much I understood immediately.

The photographer said something to me. I think she said, 'Look this way, please!' In her right hand, she had raised a pen in the air. Before she vanished completely again behind her camera, I noticed she had dark hair and was still quite young. She was not wearing a uniform and yet, here she was, in the movie bunker. I gazed up at her small pale hand holding the pen. It was a ballpoint pen.

Today, when I look at my military service ID card with its laminated dog tag, I see that glance up towards the pen and the hand that remained perfectly still in the air, the slim pale hand of the photographer with her baton as she conducted the moment. 'Thank you!' – perhaps she said thank you, perhaps not. The hand was then lowered, and for a moment I was left staring into a void. Out of that void, there emerged the uniform of the sergeant who was already ushering me out and calling the next person in to face the camera. For the first time since arriving at the camp, I felt exhausted and depressed.

The photograph on my ID card ('Photograph in Uniform') which, to this day, I keep in a kind of 'life-box' along with my health record and other bits and pieces from the past, in fact tells a rather different story. There, I am smiling a little and my head is inclined to the right as if quietly questioning. The arches of the eyebrows and the heart-shaped line of the upper lip, if you look closely, are softly delineated and everything seems peaceable enough. On the other hand: the smile sits as if tied to the corners of the mouth. And the eyelids are lowered a little, giving the face an expression of detachment and distrust. What you see are two quite different expressions on the same face in the same instant. It is impossible to tell who I was at that moment. The only thing that is easy to see is that the person in the photo is trying, as best he can, to hide his distress.

The longer I go on gazing at the picture, the more unclear things become. In the end, all I am feeling is sadness, regret – and self-pity. And then, finally, I am angry at everything that led to my ending up in that bunker, my bare face before the flash of the camera, completely at its mercy and struggling to maintain my composure with a strange and, it now strikes me, quite useless pride.

When I look at my ID card again a few days later, the sense of perspective in relation to the whole situation seems, for a moment, to have changed: suddenly, there is the twenty-year-old soldier staring back at me. There is some irritation and yet the impression is strong, undeniable, and I give in, I go along with it, and immediately the question arises as to whether, back then, thirty-five years ago, he could have seen me with those slightly narrowed eyes, while his gaze was fixed on the lifted hand holding the writing implement: a glimpse into the future – and hence his smile? The thought instantly yields a sense of parity between him and me and my anger begins to subside. Wasn't that expression on his face one of solidarity and understanding? I – from then – was encouraging me – from now – to peer all the way back into that wooden cubicle with the photographer and the sergeant, back to the barber's in the movie bunker, back to the day of conscription, the day of recruitment, back to the poster announcing

the year 1963 in its funereal lettering, back to the embarrassment felt in the instant of the photograph. Fleetingly, I recognise the outline of a truth composed entirely of the soft, unyielding stuff of patience: life is about patience. It is about the meaning, for which everything that has happened to us, at one time or another, is patiently waiting. ∎

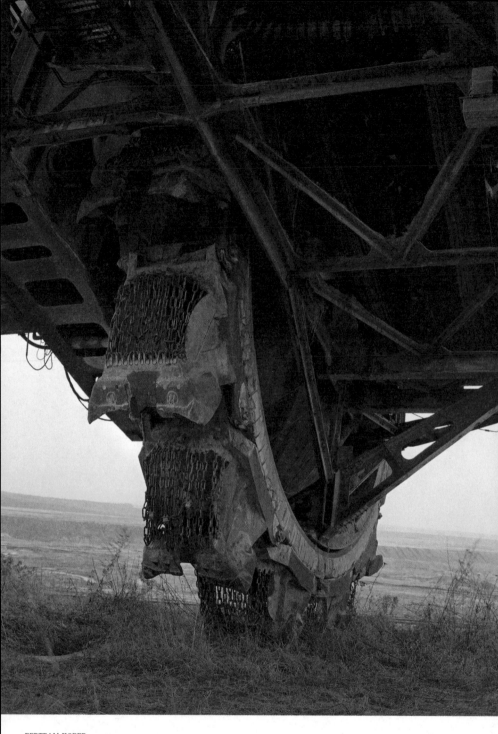

BERTRAM KOBER
Gremminer See, 1998

WHERE THE DRAGONS LIVE

Clemens Meyer

TRANSLATED FROM THE GERMAN BY KATY DERBYSHIRE

S ometimes I miss the dragons.

Then I ask Valon, the boy with the funny name. He's got a moped and he drives me to the village where I come from, where the dragons live.

The others mustn't find out I get lifts from Valon on his moped, 'cause they don't like him.

When we go to see the dragons I hold on tight to Valon, sitting behind him. I can feel his muscles. Valon is strong 'cause he works on building sites, even though he's only seventeen. I tell him he's stronger than anyone else I know, even though some of the others have big brothers who lift weights and do sport and look like warriors from the films. Valon laughs and calls me 'little sister' and the others mustn't find out I've got a crush on him. I'm not in love, I'm too young for that.

Sometimes I think he likes me and I . . . and us getting on so well is 'cause we're both not from here. His village is further away than mine, somewhere in the south or the south-east . . . 'Used to be called Yugoslavia,' my dad says, 'socialist brothers, long time ago.' Both villages have vanished now, or almost, and now we're here.

On the weekends we hang out at the station, me and the others – I mean, the others and me.

Valon's at work on his building site, he earns more on Saturdays, and on Sundays he has to rest or spend time with his family. 'They have a lot of tradition,' he says. But he only meets me when the others aren't around anyway.

The station's on the edge of town. We don't live near the station, none of us do. We meet up by the river, behind the tower blocks. When there's a lot of us we'll march from the river right through the town centre, right down the shopping streets, past the fountain, past the town hall, past the dark warriors' church, when there's lots of us we're loud, we yell and scream, and when we see kids from the villages on our way to the station we yell even louder, spit and yell and scream.

We sit in the station, the big hall in the station, on steps and benches, we stand around in the dark corners watching the travellers, the people coming, the people going, we roam around the station shop, flick through comics and sex mags in the newsagent's, search the men's toilets; sometimes drunks have a rest in the cubicles and we nick their beer cans and hand them in at the shop, twenty-five cents deposit per can, and sometimes we take a couple of euros out of their pockets, they never have much, and we run down the tunnel to the platforms, when there's lots of us we shout out loud in there, it booms back off the walls and the words come from all over, like echoes. 'Germany!' the others shout, and then in rhythm, 'East Ger-ma-ny, East Ger-ma-ny!' Sometimes I join in, and the words come from all over, freight trains pass over our heads and our shouts disappear in the rattle of the wheels, the tunnel seems to quake and tremble, we stand on one of the platforms and count the freight-train wagons, we're almost children still, and when there's only a few of us, 'cause some of the others get to hang out on the weekends with their brothers in the park and have a barbecue and drink beer, we sit outside the station and wait for the tourists.

My favourite place to sit is on the stairs in the big station hall, the ones going up to the old Mitropa restaurant that's been closed for years now, and I sit between the two men.

One of them's wearing a helmet with a miner's lamp, the other one holds an abacus in his hands. I like touching them 'cause they feel cool and smooth. They're facing the big door with the station forecourt outside it, they look like they're thinking hard, their foreheads all wrinkled up, sometimes they even look a bit sad, their dark bronze eyes, but I think they're only sad when I am too.

I'm sitting between the two men kneeling on pedestals on either side of the stairs, I'm resting my elbows on my thighs, my head on my hands, my palms on my cheeks. I can feel myself pouting and I wish Valon was here to see me pouting.

The others are sitting around outside the station waiting for the tourists; the trains from the big cities will be arriving soon. But I want to be on my own. I always want to be alone.

I look over at the station shop. Right next to the big door, Valon and me are standing at a table eating currywurst, he's got a beer on the table, I've got a Coke, we're leaning against the wall, we've moved the table into the niche between the wall and the pillar, the woman in the shop gave us a funny look but Valon paid and gave her a good tip, and now we're standing in the niche and eating and drinking.

'I bet you want to go and see the dragons again, huh, little sister?' He drinks from his beer and then leans over the cardboard plate of currywurst.

'If you'll drive me.' I look up and I can feel the curry-ketchup moustache on my upper lip before he laughs.

'Grubby little sister!' He wipes my mouth with a paper serviette, then his, and I get goosebumps.

'I'm not your sister.'

'No, you're not, little sister.'

'I can just hitchhike!'

'You shouldn't.'

'I'm not a kid any more.'

'Maybe, little sister, but it's better if I drive you.'

And then we drive. I lean against his back, feel his muscles and his breathing. Most of the time I close my eyes and don't see whether he

takes the fast road or the country road through all the villages; I feel safe against his back.

'You're such a grubby little sister!' He wipes my currywurst moustache with a tissue. A bang. The station hall booms. Another bang. The others are in the tunnel, lighting fireworks, New Year's Eve rockets bought in Poland or from the Czech Republic. Neither are far away. We squeeze back into the niche, watching the travellers glancing around in shock at every bang. Valon flinches next to me too, I can see his hands gripping the tabletop for a moment and the muscles on his arms hardening, and I put my hand on his, carefully.

'Tell me about your village, Valon.' Freight trains rattle along the tracks and make our voices small.

'Can't hardly remember. You tell me about yours.'

He drinks his beer and looks tired. I can see the dust from the building site in his hair, it shines grey even though he's only seventeen.

'If you need a pee, it's better if you go to the ladies,' I tell Valon, and he laughs at that.

When we're sad, the two men with their dark bronze eyes stare outside as well, towards the town. One of them grips an abacus, the other wears a miner's helmet.

When we're sad, we stand in the niche next to the station shop, lean against the wall and watch the travellers criss-crossing the hall.

'We've got tourists, let's go!'

The others call and wave from outside. There's not many of us this Saturday, the tables outside the shop are empty, Valon's on his building site, and I walk over to the exit, over to the big door.

We take a little tourist party to the building that blew up a few years ago, a long time before I moved here with my parents. They left the outside walls standing for a while, the others say, but then they pulled it down.

There was a lot of stuff on TV about the building and the woman who lived there with her two men, how they travelled up and down the country with their weapons, travelled to other towns, far away, taking death with them, but they always came back to our town and

the building that's vanished now. I didn't pick up on much of it, I was still little and the dragons were perched in the pit outside our village and coming closer and closer. Villages vanishing, buildings vanishing. Dust coming up out of the pits, dust settling on us when we played by the pits, thick dust with the dragons crawling behind it, inching closer, dust on houses, on the roofs where we sat to watch the dragons. 'If you need a pee you can use the chimney!' I laughed and coughed. 'Is that you, Valon, next to me . . . ?'

A lot of tourists think the building where the woman lived with the two men is still there, but we just take them to the gap between the houses, and sometimes they're disappointed and we have to tell them stories so they'll give us money anyway. It's usually me who tells the stories, even though I'm new in town, but I'm good at telling stories and the others know it's better if they don't say anything, 'cause otherwise the tourists go away again and we don't get anything at all.

The others think heroes lived in the vanished building. 'Like Bonnie and Clyde,' one of the others says, a boy only a bit older than me. None of us knows what that means, no one knows who Bonnie and Clyde are. And when we ask he starts stuttering and says something about gangsters and films and resistance and 'against the system', 'cause the people in the vanished building were against the system as well, but for Germany.

I don't tell the tourists that.

I tell them about the paths the woman used to walk, about the shops she used to go to, and how friendly she was to everyone, and how she used to go to see the sheep on the riverbank when the two men were on their travels, and how she might not have known what they . . . And how she fell in love with a shepherd and even spent a while with the shepherd by the riverbank, on a bed of wool, 'cause the two men used to go away for a long time, sometimes with their weapons, and the woman used to get lonely . . . no, the shepherd's moved on now, long gone now, when he found out the woman and the two men . . . and that they had weapons and they robbed banks as well and they . . . well, it just broke his . . .

And the tourists nod and sway their heads and stroke their chins and look at the gap. We take them to the river as well, criss-cross the park with them. 'She used to sit here, on this park bench, she even carved something . . .' and there really is a heart and two letters and an arrow piercing the heart.

The others roll their eyes, pretend they're doing the Hitler salute behind the tourists' backs, but they don't say anything 'cause they know my stories make money.

But when I go too over the top they get mad at me, even though we always share the money the tourists give me, and then they chase me up against a wall, stand so close that I can't get away, and I wish Valon was here to help me.

Then they ask me if I love Germany, if I'd show my pussy to dirty Turks and Yugos, all that kind of stuff. It hurts.

There were Americans here not that long ago. I didn't tell them anything about the sheep, didn't tell them about the woman from the vanished building falling in love with the shepherd. I went to the park at night and carved the heart into the bench. The V's too big, and the two lines carry on past where they meet at the bottom, so it looks almost like an X. I'm too young to fall in love.

Sometimes, when Valon drives me to my vanished village and we lie on one of the roofs in the next-door village, where no one lives any more 'cause it will be vanishing soon too, and we look at the pit where the dragons are grubbing in the earth and inching closer and closer, I tell him about the woman and the two men. Valon didn't live in the town back then either. I tell him the story like a fairy tale, as if the three of them were cursed. 'And every night they set off with their weapons and wrought misery over the world.'

'And the woman was with them too?' Valon asks. 'With a weapon?' And I want to tell him about love and redemption and a coffin made of glass, but he's stopped listening. He's somewhere else and looking at the dragons with big dark eyes as they crawl through the dust, as they stir up the dust. There are so many different kinds of dust, the really fine white kind and black dust from coal, some taste bitter,

others kinda sweet. When I was really little I knew them all, where they come from in the layers of earth which our house has vanished into, where the dragons dig their burrows.

'Why do you miss them if they've eaten up your village?' Valon asks, and I move a bit closer to him so he can feel me shrugging.

'Don't know.'

I can't tell the Americans romantic fairy tales. 'Americans want action,' the others whisper to me.

So that's why I lead the Americans past the vacant lots by the station. 'Look at our battlefields.' Take them to the empty old hotel.

I'm pretty good at English and the others stand listening in amazement as I tell the Americans my stories. I don't want the others to push me up against a wall again.

There was a fire at the hotel. Just now, and before that as well.

And I embroider on *before that*, so much so that the Americans can't keep their mouths shut.

The hotel was already empty and burnt when I moved to town with my parents. Some kind of insurance scam, my dad suspected, but I don't tell the Amis that. 'They fight here, like Bonnie and Clyde!' And the Amis are amazed and nod, 'cause they know who Bonnie and Clyde are, and I tell them more stories, wilder and wilder.

The woman up on the roof with a machine gun and the two men, 'the two boys shoot their way free' from 'so many police' while the woman, 'the lady', covers for them.

'But they died in a camper?' the Amis ask, and I tell them about the two men escaping from the burning hotel and fighting their way through to their caravan, the woman still on the roof with her machine gun. The Amis are amazed and nod and shake their heads. 'Crazy Nazis!' I'm glad there aren't any black Amis here, or the others would make their jokes and say their chimney-sweep stuff, roll down their lower lips and make a thick upper lip with their tongues, and we wouldn't get any money and then they'd blame me again. The boys and the lady.

'What did the Amis say, and what did you say, and why were they so shocked?'

The others are wound up like clockwork and leaping around, and now we're inside the hotel, where the lobby used to be. It smells burnt, broken glass everywhere, we want to go up on the roof that's nothing but singed beams now, the others say something about a dare but I know they want to see the town and the river and the mountains from up there, throw paper planes at the station, close their eyes and look into the sun.

We creep slowly out of the lobby up to the first floor, 'cause we heard noises there. I'm still proud 'cause the Amis believed everything I told them, once upon a time, and I keep putting my hand on the coins in my pocket. The walls are covered in swastikas and scribbles. I'm going to draw a heart and a V on the ragged wallpaper when the others aren't watching.

'Yugos' whore.' Hands on my back, fists, and my head bangs against one of the doors as we run along the corridor. Number 18.

'Leave me alone!' I don't know why they're pushing and shoving me 'cause I've done everything right, with the Americans and everything else.

I'm running along the corridor, glass crunching beneath my feet, I see a big bed in one room, the mattresses ripped up and foam spilling out. 'Why do you like the dragons?' and then I stumble over a man lying on the floor in front of me. He's in a dirty sleeping bag, his hair long and grey and greasy. We smell right away that he's drunk.

He's sicked up on the wall as well, and we push the sleeping bag over to the wall with our feet to the puke, push his face into it. He slurs some words, his eyes still closed.

Two boys plant themselves in front of him and pee on his sleeping bag, we girls giggle and look away.

The man tries to crawl out of his sleeping bag but the boys keep kicking him in the side, so he rolls up against the wall with a groan. When I'm with Valon visiting the dragons I show him the place where our house used to be. He can hardly remember his village, he was very little when his parents came here with him. The rest of his family stayed, vanished along with the village, and sometimes he talks about

them, stories he got from his parents, but Valon says it feels like he knew them all, uncles and aunties and grandparents. Then his eyes go dark and we're two bronze shapes and we stare into the distance, unmoving.

'Let's go somewhere else,' I say, and jangle the coins in my pocket, 'we've got money, we can go to the cinema or . . .' My voice sounds strange in the corridor, you can hardly hear it, it vanishes behind the open doors, into the empty rooms where the windows are boarded shut. 'We can go to the station, buy comics . . .' But no one hears me. I want to run away, but I stay close, near the others.

They pour Korn on the man, who's still rolled up against the wall in his sleeping bag. He holds both hands over his head for protection and groans quietly.

When I'm visiting the dragons with Valon, I tell him about my grandad who didn't want to leave. We'd already moved to town then and we went to see him at the weekends, and my dad kept trying to persuade him to move, said the flat next door was free, there were even sheep grazing on the banks of the river! But Grandad sat on the bench outside his house, looked over at the oak tree by the bus stop where the old weather-beaten memorial stood, where we kids used to trace the letters and names and years, barely visible by then, with our fingertips. When I was really little, I thought the dead were lying right underneath the oak tree and the stone, but they'd died somewhere completely different, *fallen*, we read, and when I was really little I thought people had just fallen over there, stumbled and then got up again. Grandad's here in town in a graveyard now and I bet he's not happy. He was just sitting dead on his bench one day when we came to visit, his head on his chest. Valon thinks the dead live on. I don't, really.

And he says memories are in our blood. That's why he flinches when the others light fireworks, and that's why his eyes sometimes go all dark and he's somewhere else and far away, when we're lying on one of the roofs in the next village and staring at the big, never-ending pit.

I ask him if we can drive his moped to *his* village one day, even if it is far away, since it's the school holidays soon and he's got enough money from the building site, and he laughs at that and comes back, and we watch the dust drifting through the pit, flickering in sunlight fractured by jets of water, the dust that settles and then rises back up again and swathes the giant diggers.

The sleeping bag with the man in it catches fire, and the others run away and I'm the only one who stays and watches the flames go out on their own and the man coughing and crawling out into one of the other rooms.

I put the money from the Yanks down in the doorway and back off towards the stairs.

The others will be back at the station. I know what building site Valon's working on. I'll go and hide there and watch him. When he sees me, he'll wave and call out 'Little sister'. I'm not in love, I'm too young for that.

Valon gets on his moped and I sit behind him. We drive somewhere, we just drive around to nowhere in particular, and when I turn around I see our town, where the dragons live. ∎

TRANSLATOR'S NOTE: In November 2011, a flat in Zwickau occupied by the three known members of the neo-Nazi terrorist group, National Socialist Underground, was set on fire, causing an explosion. Beate Zschäpe survived but her co-conspirators Uwe Mundlos and Uwe Böhnhardt died that day. Fearing discovery, they set their motorhome on fire and shot themselves. The far-right group murdered at least ten people, committed three bombings and robbed fifteen banks. Zschäpe was arrested and eventually received a life sentence for nine murders, an attack on police leading to a further murder, arson leading to two attempted murders and membership of a terrorist organisation. Four accessories to the crimes were also imprisoned.

The National Socialist Underground murders were a series of racist attacks perpetrated throughout Germany between 2000 and 2007. Ten people died and one was wounded. The primary targets had migration backgrounds. For years, the German press and police were convinced the murders were the result of turf wars of the Turkish-German mafia. They referred to them colloquially as the 'Kebab Murders'. The German intelligence services had infiltrated the NSU, but its own agents, suspected of right-wing sympathies themselves, appeared to have obstructed the investigations into the full extent of the NSU, which almost certainly consisted of more than the two men and woman, canonised by the German far right, and referred to obliquely in Clemens Meyer's story on pages 233–42.

In 2007, Halit Yozgat, an owner of an internet cafe in Kassel, was shot and killed in his shop. Inside the internet cafe at the time of the murder was Hessian intelligence agent, Andreas Temme. Temme claims he did not hear the shot, nor see the victim. Nor did Temme claim to notice the sprinkles of blood on the counter where he placed his payment in coins when he left. (The veracity of this testimony is scrutinised in the images opposite, created by Forensic Architecture for the purpose of a people's trial of Temme.) Under questioning in a German court, Temme stated it was simply a coincidence he was in the cafe at the time and that he had been surfing dating websites. Temme did not come forward following a police round-up, and after he was tracked down, claimed that he did not volunteer any information because he was worried that his wife would discover his online proclivities. One of the prosecution's witnesses – a policeman from the village where Temme grew up – testified that in his youth, Temme was known as 'Little Adolf'. When the local police tried to dig deeper into allegations that Temme had a personal library of Nazi literature and weapons manuals, the interior minister of the state of Hesse, Volker Bouffier, shielded him from further investigations and from the press. Temme has meanwhile retired from the Hessian intelligence services, but continues to draw his pension. ∎

FORENSIC ARCHITECTURE
Digital Reenactment - PC-2, 2017
A view from within Forensic Architecture's modelling software shows a figure, representing Andreas Temme, sat at his computer in the Yozgat's internet cafe

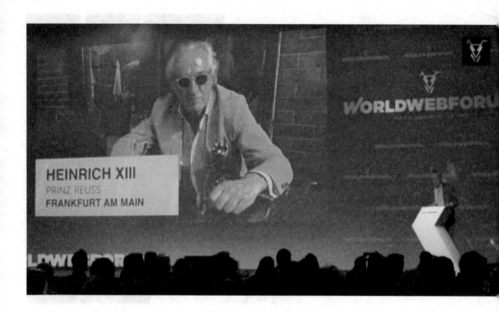

Heinrich XIII Prince Reuss speaking at Worldwebforum

A VERY GERMAN COUP

Jan Wilm

In the early hours of 7 December last year, German authorities carried out the largest counter-terrorist operation in the country's post-war history. Three thousand police raided more than 160 sites across the Federal Republic. They made twenty-three arrests in seven of the sixteen federal states, and apprehended two further suspects in Austria and Italy. They seized 273 firearms, more than 44,000 rounds of ammunition, 259 knives, along with a considerable array of swords, axes, coshes, crossbows, night-vision goggles, satellite phones and Ecstasy pills. Nearly half a million euros in cash was discovered, and more than fifty kilograms of gold and other precious metals.

The suspected ringleader was a 71-year-old real-estate developer with an engineering degree who lived in a pre-war walk-up building not far from me, in the upscale Westend district of Frankfurt. Heinrich XIII Prince Reuss identified himself as a member of the 'blue-blooded elite', and was known for taking care to emphasise his aristocratic connections and monarchical fervour in a country that has gone without an emperor since 1918. His neighbours described him to me as an aloof, slightly eccentric man, who strongly favoured corduroy. The police arrested him for spearheading a terrorist organisation which had plotted to overthrow the German government and install a cabinet with Prince Reuss as the new head of state.

The House of Reuss is one of the oldest 'noble' families of Germany, with links to self-styled royals across Europe. Among its members is Anni-Frid Lyngstad, one of the A's in the Swedish band ABBA, who was married to another Heinrich. Regnal names are unvaried in the House of Reuss. The Heinrichs' regnal numbers reach well into the high twenties; each century, the ordinals begin anew. There are thirty-three living Heinrichs. The thirteenth has one sister and four brothers, who are all named Heinrich. Perhaps to avoid confusion, the family's nickname for Heinrich XIII is 'Enrico'. They have now distanced themselves from the man the German media has delighted in dubbing the *Putschprinz,* or the *Terrorfürst.*

For nearly a year, German authorities kept the plotters under surveillance. Through intercepted communications on messenger services, tapped phones and public YouTube channels, they gathered intelligence about the progress of the putsch. The plotters – who called themselves the 'Patriotic Union' – had allocated ministerial posts for a cabinet that would take over on 'Day X'. The judge and former Alternative for Germany (AfD) Bundestag member Birgit Malsack-Winkemann was to be minister of justice. The military arm of the Union was to be run by former Bundeswehr paratrooper Rüdiger von Pescatore, who was dishonourably discharged in 1996 for stealing weapons from the army. (Following a suspended sentence, von Pescatore moved to Pomerode, a German enclave in Brazil. He returned to Germany in 2021 to, as he put it, 'help out a friend'.)

The celebrity chef Frank Heppner, father of Real Madrid football player David Alaba's girlfriend, was to be responsible for what the Germans call *das leibliche Wohl* – bodily well-being. Heppner was to cater the putsch. He had bought a mobile home with a kitchenette, including an emergency generator and cooking utensils. He was set to operate the cafeterias for the new government.

Over the course of two years before their arrest, the insurrectionists – who consisted largely of former police and military personnel, but

also included a tenor, an art historian and a clairvoyant – held target practice, threatened to execute traitors within the group, and made members sign non-disclosure agreements. They drafted plans for license plates for the military vehicles of their new state, and had ordered rubber stamps for the authentication of documents. It was, after all, to be a German coup.

Unlike the Federal Republic of Germany, Enrico's new state would not have a chancellor or president. It was to return Germany to the *Kaiserreich*, the German Empire, that ended with the abdication of Queen Victoria's favourite grandson, Kaiser Wilhelm II, during the First World War. Heinrich, on the basis of his bloodline, was to be its unelected monarch. Berlin would no longer be the seat of government. Instead, the emperor was to rule from the spa town of Bad Lobenstein in Thuringia, where Enrico owns a small neo-Gothic castle, the *Jagdschloss Waidmannsheil*. Starting in November 2021, the council met roughly once a month at the castle to plot the coup.

M ost members of the Patriotic Union are on remand awaiting trial. According to court documents concerning their current pre-trial detention, the ring was formed in late 2021 and meticulously schemed 'to overthrow the existing state order in Germany and replace it with their own form of – already rudimentarily designed – government'. The Public Prosecutor General, Peter Frank, is convinced the Patriotic Union 'made concrete preparations to forcibly gain access to the German parliament with an armed group of up to sixteen people.' After gaining access to the Bundestag, the commando unit was supposed to arrest and tie up Chancellor Olaf Scholz and his cabinet, and parade the manacled ministers in the streets and in front of TV cameras to inspire the masses for the new German order.

The plan was outlandish, but the threat of violence was not. As a former member of parliament, Malsack-Winkemann retained parliamentary access. In September 2022, she gave three of the plotters a tour of the Bundestag. She showed them an underground

entrance into the main building, and indicated where Scholz's cabinet sat during Bundestag sessions. When Malsack-Winkemann was arrested in her Berlin-Wannsee home, authorities found more than 7,000 rounds of ammunition, a revolver, and a semi-automatic rifle with a mounted telescopic sight.

According to the court documents, members of the Union believed they were mandated by an 'Alliance' – 'a technically superior secret society of dissident government, intelligence services and militaries of different states, such as the Russian Federation and the United States.' On an unspecified 'Day X', the Alliance would authorise the Union to eliminate the Deep State holding Germany hostage. In late 2022, the members of the Union were apparently growing impatient. When would Day X finally come, and what would be the long-awaited signal to commence the coup? Several possibilities were floated: a stock market crash, a natural disaster, the death of Queen Elizabeth II – and the remote prospect that Vladimir Putin might sound the starting gun with an electromagnetic pulse.

Court documents describe the alleged terrorists as diagonal thinkers, conspiracy theorists, supporters of national-socialist ideas, and adherents of QAnon. But the common thread among the plotters and their supporters was their view of the German past. The Patriotic Union was an extreme outgrowth of the much broader Reichsbürger movement in Germany. Last year it was estimated by German officials that over 23,000 people belong to the movement – more than double the number in 2017. Some Reichsbürger Telegram channels have more than 100,000 followers.

The Reichsbürger openly long for nothing less than the return of the *Kaiserreich*. It's a solution that allows them to be comfortably reactionary while appearing to sidestep the taint of Nazism. Their rationale is that occupied Germany never signed a formal peace treaty after the Second World War. This was true for much of the post-war period, though it determinedly overlooks the so-called 'Two Plus Four Agreement' during unification in 1990, when the Allies – the Soviet

Union, the US, the UK and France – all agreed to withdraw their formal powers over Germany, which finally became a single, fully sovereign state. For the Reichsbürger, this was all diplomatic window-dressing; for them, the post-war German Federal Republic remains an illegitimate occupied state. (The presence of more than 35,000 US troops in the country helps bolster their case.) The Reichsbürger use the term 'Deutschland GmbH' to mock the Federal Republic as a corporation serving the interests of global finance – 'Germany, Inc.' They state the country does not have a constitution, a claim based on semantics and jumbled historical context. The German constitution is called *Grundgesetz* ('Basic Law'); the term *Verfassung* ('constitution') was avoided after the Second World War, since the drafters believed it would be an interim document for a divided Germany, which, when unified, could hold a nationwide constitutional referendum (which, as the Reichsbürger like to point out, never happened). Unlike previous constitutions in Germany's history – the Frankfurt Constitution of 1849, the Bismarck Constitution of 1871, the Weimar Constitution of 1919 – German 'Basic Law' of 1949 has lasted; it was never replaced and became the constitution of a unified Germany in 1990.

The Reichsbürger disagree, and as proof of their unrelenting scepticism, they reject the German legal code, Germany's current borders, as well as IDs issued by the state. They prefer to carry homemade documents.

Spearheaded in 1985 by the Berlin train dispatcher Wolfgang Gerhard Günter Ebel, the Reichsbürger were long dismissed by the government and police as a harmless swarm on the fringe. They were not considered a threat on a par with the 1970s neo-Nazi group 'Citizen's Initiative' founded by Manfred Roeder, who actively plotted overthrowing the German state, claiming a 1975 letter of affirmation from Hitler's official successor, Admiral Dönitz, as his source of legitimacy. By contrast, the Reichsbürger appeared to be made of softer stuff. They attracted a diverse blend of homeopathically minded esoterics and contrarians. After Ebel died in 2014, the movement grew in the face of what it took to be

Chancellor Angela Merkel's 'alternativelessness'. The Greek debt crisis, the political crisis over refugees – these social fractures and Merkel's handling of them gave added impetus to the movement's belief in Germany's evermore exposed vacuum of sovereignty. They catapulted to national attention in 2016, when, during a raid of a Reichsbürger property, one of their members shot and killed a police officer.

The last violent coup attempt in Europe that got anywhere was the legendary 1981 capture of the Spanish parliament for eighteen hours by a disgruntled group of Francoists. The televised coup attempt, immortalised in Javier Cercas's book *The Anatomy of a Moment*, created the sort of media spectacle that the German terrorists desired. What distinguishes last year's plot – well beyond the 2020 storming of the steps of the Bundestag by Covid anti-vaxxers – is the level of careful premeditation combined with the strenuousness of its delusions. To grasp the cosplay ambitions of a handful of 'good Germans' who wanted to resurrect the German Empire after its historical burial, and strike out against what they took to be a feeble continuation of the Nazi state, requires plunging into the online portals and fantasy chambers of the Reichsbürger. When examining Enrico himself, however, the coup fever appears to have some material causes.

Starting in the 1990s, Enrico, with his mother, fought a series of legal battles against the German state to reclaim art, land and property seized by the state from the family after the Second World War. In 2005, a court confirmed the legality of the expropriations; in 2008, the Reusses and the state of Thuringia reached a settlement: hundreds of artworks were restituted, most of which were auctioned off. The Reusses also received Schloss Thallwitz, a baroque castle in Saxony, which has since fallen into disrepair. In 2020, the German federal government, the state of Thuringia, and a foundation paid Enrico 4 million euros for 338 hectares of forest, which his family had bought back from the state in 1997 at a discounted rate as

compensation for the expropriations. Embarrassingly for German authorities, and at odds with Enrico's professed hostility to the state, two days before his arrest, Enrico made a deal to buy 394 hectares of state forest in Thuringia for roughly a million euros.

In recent years, Enrico has been able to voice his ideas in prominent places. Playing on the cachet that royalty still carries in many entrepreneurial circles across Europe, he has connected with groups that share his resentment of democratic institutions. In 2019, Enrico made a public speech at a conference in Zurich called the Worldwebforum, a would-be Davos for digital entrepreneurs, which was founded as a gathering space for software executives and engineers by the Swiss Bitcoin impresario, Fabian Hediger. Guests over the years have included a manager of the Bank for International Settlements, Andréa Maechler, Swiss right-wing populist Ueli Maurer, and Extinction Rebellion co-founder Roger Hallam. In his Zurich speech, Enrico reported that the post-war German state has caused his family enormous 'suffering'. In his address, which a slide titles 'Experience the Rise and Fall of the Blue-Blooded Elite', he unfurls one Reichsbürger talking point after another to a smattering of applause from the audience. The remarkable aspect is less what Heinrich says than that he has been given a pulpit by a group of tech-sector elites who no longer bother to distinguish between libertarianism and rose-tinted neo-feudalism.

In Zurich – wearing a Prussian steel-coloured suit, his silver hair slicked back – Enrico spoke of his family as 'a dispossessed and stateless dynasty', and of 'the causes of abolishing the monarchy and the suffering that came with it'. He described the happy lives people led in absolutist Europe. Feudal subjects were like contented children who, when in need, could scamper to their patriarchal sovereign: 'Who are you supposed to turn [to] today? To your parliamentarian? Local? Federal? Or EU level? Good luck!'

For Reichsbürger and other fellow-travellers, the appeal of the Kaiser is that he was the last German sovereign respected not only

for his political power, but for his property. He enjoyed the aura of might, not because he was right, or charismatic, but because he was rich. The Kaiser-as-capitalist image is beloved by quasi-Kaisers of the business world. The Silicon Valley billionaire and Trump donor Peter Thiel has stated, 'I no longer believe that freedom and democracy are compatible.' It's hardly surprising that Thiel's dreams of tax-free havens and floating units in international waters beyond the reach of governments and their laws can find happy precedents in the democracy-inoculated kingdoms, duchies and principalities of the German Empire.

In a second speech Enrico gave in Switzerland in 2019, he addressed a small room in Geneva. He was at the United Nations at the invitation of the Russian Federation. 'Via my mother we are related to the House Romanoff, one of the reasons we like Russia,' he said. The occasion was apparently a conference on people with disabilities. Enrico spoke about his daughter who was born with Down syndrome. (After his divorce from the daughter of an Iranian banker, Enrico's daughter lived with him part-time.) He linked his daughter to his grievances against the state, claiming that his daughter was prohibited from working, because she was uninsurable. (This was a deliberate falsification, since people with disabilities are naturally able to work in Germany, which has universal healthcare.) Working toward his main point, Enrico argued that even though his daughter lived with him, she needed to pay her own *Rundfunkbeitrag*, the television and radio fee every German household pays, like a tax. It's a favourite point of contention that Reichsbürger like to describe as *Zwangsbeitrag*, a compulsory fee that is indicative of state control of the media. The man who is the owner of a castle, and who was behind a *coup d'état* in the largest state in the European Union last year, addressed international bodies on the unjustness of an annual €220.23 TV and radio tax.

Enrico's arrest last year marked an anniversary of sorts for Frankfurt. It was the first highly publicised capture of a terrorist in the city in fifty years. In 1972, the police surrounded Andreas Baader, Holger Meins, and Jan-Carl Raspe of the Red Army Faction at the garage they used as an explosive laboratory in the Dornbusch neighbourhood. Raspe was captured upon exiting a mauve Porsche Targa; following a lengthy shoot-out with police, Meins, sporting only black underwear, and Baader, wearing sunglasses, were apprehended. Enrico's arrest last year was, by contrast, a subdued affair. The police gently led him down the stairs of his apartment in an olive tweed jacket, a silk ascot, and brown corduroys. One of the ironies of German society today is that the chief threat to its well-being comes from the sliver that benefits more than any other from the status quo. There, more than the disenchanted lower ranks, resentments fester and bloom, and fanatical utopias come to seem mere matters of execution. The last time I passed along Heinrich's street in Frankfurt, his black Audi, which was left after the raid, was no longer parked outside his house. The mail that flowed from his mailbox for weeks had been cleared away. His name has been removed. The city guides have not yet made the house a stop for tourists, but coup fever in Germany, however comic, however absurd, may not yet be a malady of the past. ∎

MEHDI GHADYANLOO
Courtesy of the artist and Almine Rech

MODEL COUNTRY

Shida Bazyar

TRANSLATED FROM THE GERMAN BY RUTH MARTIN

Laleh, 1999

Each person on a chair, each chair a country. Maja doesn't have
braces any more and since she had them removed you might
almost take her for an adult. She looks at me and says, I did not have
sexual relations with that woman and her large white teeth flash – she
is the United States of America and everyone laughs. The teacher
laughs too, says, Alright everyone, settle down. She is thin and smells
of university. Maja needs to talk about Bill Clinton's policies, she says,
not his personal life. I don't laugh. I look at Maja and think, of course
she chose the USA, I would have too, only no one asked me, because
everyone said Laleh should be Iran; everyone thinks that's logical. We
are sitting spaced around this gym hall, ordered not geographically
but by interests, which is the same thing, the teacher says. Israel is
sitting opposite me. Israel's name is Patrick, but everyone calls him
Paddy, though no one listens to the Kelly Family any more. And the
presenter's yellow card says 7, and it's 7's turn to speak and I look at
Paddy and say, We don't accept the existence of Israel, because that is
what's on my card, but I say it quietly, because it doesn't sound good.
And when Maja puffs herself up and shows her red veto card, I say,
But now we've got a new president, we're more reformist. That isn't

on my card, but it's how Papa explained it to the neighbours recently and I think, if I say something clever-sounding right at the start, then people might not notice if I don't speak again after that. Paddy looks at me like he's wondering if he should care that I'm denying his right to exist and I think Paddy must be rummaging around in his brain for what *reformist* means. Paddy says, Hmm, but they're not dangerous, are they? Right? I mean, the countries down there aren't rich enough to have really dangerous weapons? And there's a moment's silence, before France speaks up. France is called David and he says state and religion need to be separated and beside me Syria puts a hand up and says, But that doesn't apply to Israel?!, and then I stop listening. I think I really don't care. I still don't get what the thing is about Israel. A soup of information, of suicide bombings, of old men, of attacks, of news items, for about the last hundred years, at least. A soup of the same words over and over on the eight o'clock news, before we can turn over to watch films on the other channels. Maja keeps her eye on me, as if I understand very well what Syria has just said.

David turns to me. When David speaks, it's slow and gentle and so clever that it almost tips back into being boring. I don't trust myself to look at him, because when I do all I can think about is what he looks like when he's kissing and I'm watching him. And hoping he doesn't notice. Marie, who has lucked out and is an international group of observers rather than a country, is wrapping a strand of blonde hair around her finger and giving me a conspiratorial smile as David talks. David is delivering a monologue, and I don't understand any of it, but I nod, nod eagerly in his direction, because I know that what he's saying has something to do with me. David is saying, Even a fanatical state in the Middle East is a product of imperialist power struggles in foreign territories. I nod. The teacher gives me the speaking card. I'm supposed to respond to France. And she points out that David has just been speaking as David and should actually be speaking as France and David says that makes him sick and it's democratic idiocy and the teacher says, Alright Laleh, do respond to what David's said, but speak as Iran. And I think, crap. What David said sounded so

good. But what is there to add? Victim. I'm a victim. Iran is a victim. We're the victim of America, I say quickly. Can you be more specific? the teacher asks, pen in hand, writing it all down on the thing she refers to in English as a *flip chart*. In my whole school career, the whole of the last decade, I've never had a lesson that involves coloured cards and marker pens and flip charts, and the only reason we're doing it now is because this is a little show we're putting on for the men from the ministry, who are sitting in the back row. I say, The people are the victims in this country. The teacher is holding the pen on the spot where she wants to write next but she isn't writing, she's just looking at me. It's like David said, I explain, all the other countries have their fingers in the pie. I think that's always true. If you're not talking about, like, a world power. The teacher lowers her pen, turns to the class, looks at me for a while and then says, Are you talking as Laleh now, or as the Islamic Republic of Iran? I don't say anything, because the Western states sitting opposite me are holding their cards up. And then I take the card from my lap and read out, For a long time, under the monarchy of the shah, the country was an important exporter of oil to the USA and Great Britain and enjoyed great wealth. Since the revolution of 1979, the country that used to be known as Persia has been a religious state with restrictive laws. And as I'm reading, I hear the teacher's pen eagerly writing this down and I wonder whether anyone has noticed that really, I'm completely clueless. That really, I just learn what I've copied off the board in history lessons. That I don't actually follow the news, although it's constantly on at home. All I know is that when I was little, we were supposed to be going on holiday, but then suddenly we were here and it was just the four of us, and my brother got proper milk instead of powdered, and scented Nivea cream, and my mother made cakes for us in a pan and the children in the hostel called themselves and me and everyone else *Kanaken*. I know Iran consists of chicks and blue doors, of people and smells and a backyard with a barefoot grandfather in it. And lately of three plane tickets, pinned to the kitchen board, ordinary bits of paper with ordinary words on them.

A t the airport: the duty-free shop, the newspapers, in different scripts and different languages with different front pages, because it's July and July is silly season, as our social studies teacher explained to us. *Peace? The price, the risk, the consequences.* I leaf through the magazine. Damp fingers on glossy paper; Bill Clinton is smiling at me and saving Kosovo. I got the second-highest mark in the test on NATO, the best results in my year, and I don't know exactly what's going on in Kosovo. The girl on the front cover looks like the child from Michael Jackson's 'Earth Song'. *The price, the risk, the consequences.* The price was 900 marks for a plane ticket. Tara is only nine so her flight was half price. Mama is still enrolled as a student, though she's already had her graduation, but her student ID is valid until October, and the discounts are as well. I'm at school and I pay full price. Iran Air could have earned more from us if Mo hadn't already been booked onto his sailing course. Iran Air could have earned even more if Papa had said he was coming, too. If I'd dared to ask him the real reason why he wasn't coming. But I didn't. Instead, when Mo asked me, I acted like it was obvious. It's too dangerous for Papa, I said, and he believed me, because of course I'm older and, like the adults, I never talk about what happened in the time before Germany. When I answer Mo's questions, I'm also answering my own in a way, and am then satisfied that I've resolved the issue for both of us. All the same, I'm pretty glad he isn't flying with us and I can spend at least a few weeks without him getting on my nerves. Iran Air doesn't need the income from Mo and Papa, I think; Iran Air is already making the biggest profits of all time since Helmut Kohl left and German citizenship arrived, since this Khātami arrived, with a shorter beard than the other ayatollahs, since the first people dared to fly back. Since Khale Shirin started coming to visit us in the afternoons and telling us over and over about progress and developments and how simple the forms are to fill out, and then showing us photos of her and her daughter Yasaman at sunset barbecues in the parks of Tehran, thirty people gathered around them, even though they've been living in Germany for twelve years

just like us. Yasaman was insanely proud of the photos, which made me think all the more that we should do what the others were doing, go to the embassy, sort out the paperwork, book the plane tickets and go. In the last year Iran Air's profits must have increased fivefold, I think. Iran Air must have had to build new planes. Because who actually flew before? Refugees with visas and tourists with nerves of steel. Now the market is booming; now each time I go to the cinema with Yasaman she brings a different handbag, covered in little crystals and gold bells, and she bought them all there, in Iran. I take the copy of *Der Spiegel* to the till – maybe it can explain to me what I didn't understand at school. In case one of my relatives wants to talk to me about Kosovo. Or Bill Clinton. Anyway, apparently Bill Clinton has nearly resolved the conflict in the Middle East, although in my head his grin automatically becomes Maja's grin. The woman in the shop looks at me as if she's wondering whether I understand the language the magazine is written in. All these languages being spoken here, in Germany's largest airport, Europe's largest international airport, and my head is just filled with useless information and I don't know where I got it from or why. I'm wearing the mantō, but the hijab is still lying casually across my shoulders, so of course she's looking at me and feeling confused, and I put the magazine on the counter in order to press the last of my change into her hand. *The price, the risk, the consequences.* Is it dangerous? Frau Sommer asked. I don't know, I thought. But we probably wouldn't be doing it if our lives were at risk, I thought even more quietly. No, I said, straightening Paul's raincoat on the hook and arranging his wellies more neatly on the doormat. She gives me 10 marks an hour for looking after Paul, but she talks so much after the kids have gone to bed that I have to factor in those hours as well. The woman at the till gives me my change, I take the magazine, and turn my back on her and the Bill Clintons on the other papers. No, it isn't dangerous, everyone's doing it now! I told Frau Sommer, like it was an obvious fact that everyone knew, only once again she didn't. When we booked our plane tickets and it was clear Papa wasn't coming with us, I imagined there was a list of names

and a row of fat-bellied men who sit at border control with the list. They look at some names and say, These are dangerous, and then for others they say, These aren't. And now the fat-bellied men have started wearing glasses with frosted lenses, frosted and slightly tinted, and so they have some trouble reading the names. If they were to take the glasses off for a second, it would all be over: they'd see the lists again and start putting people in prison. But recently they've been wearing these glasses day and night. And is your Papa staying here all on his own? Frau Sommer asked. She must have asked Mama exactly the same thing, I'm sure she did, but she wanted to hear it again from me. She turned her small, shining blue eyes on me, and I looked at her blue eyeshadow, which was much darker than her eyes. Someone should tell her those are two different shades of blue, I thought. Well, yes, I said. But Papa will survive, it's only three weeks. It's a shame he can't go back, said Frau Sommer, I'm sure he would have liked to. I moved my hand from Paul's boots straight to my Dockers, so she would get that I really was leaving now. Frau Sommer looked at the flowery material I've sewn into the seam of my trousers, a large triangle of orange flowers, which turn my old Levi's into flares. I hastily started telling her about my new sewing machine and the evening class, and she didn't ask any more questions.

Maybe there are names that aren't on the fat-bellied men's lists – names that the men keep in their thick heads, behind the frosted glasses, or in their hairy ears; those names aren't going to get past them and there'll be no fooling around with lists and glasses when it comes to them. Maybe Papa has one of those names. Behzad Hedayat – the words echo in their minds. But how come Frau Sommer knows that, I think. If Frau Sommer was sitting on a wooden chair in the school gym, she'd be Germany. She seems to know things from the past that Mama and Papa have never told me. Because they're over and done with, maybe.

Mama and Tara are sitting opposite me on the airport's rows of cold plastic chairs and I am looking intelligently at the pages of *Der Spiegel*. Tara is talking in her Mickey Mouse voice, and Mama says,

You can't take that magazine with you. And her face is stern, as stern as it is when you've done something that isn't allowed, or are just about to. I say, Yes, of course, I know. And am annoyed that I just spent money on it, when Mama had already taken away Tara's Spice Girls tapes. The rules are actually very simple. Things that are fun are not permitted. Films, music, nice clothes. And politics. You just have to keep this in mind and keep tucking your hair back under your hijab. But if it's that simple, then why is Mama staring at the ground? Not talking to us, apart from to tell us off, not listening to Tara's Mickey Mouse voice, as she talks about her kid stuff and tries to make Mama laugh? But Mama isn't laughing.

At the start we laughed. Put the hijabs on at home, in front of the big mirror in Mama and Papa's bedroom. Put a hijab on Mo, and Mama's long coat. The only thing that could hide Marie's blonde curls was the tablecloth. We lined up in height order, looked in the mirror and laughed.

But we weren't laughing in the photo booth outside the supermarket. Only Tara was still laughing then. Tara, who we had dressed in a long-sleeved checked shirt and a small black headscarf. Tara was the first in the photo booth, and when she was finished, four photos of her little face dropped out of the box. Four times Tara, smiling uncertainly and looking strangely pale, but very cute with it. She didn't even look at the photo, just took off the hijab, gave it to me, didn't laugh any more. Then she walked to the toy department without saying a word. At first Papa was puzzled and then he went after her without speaking either. Mo cursed and asked why he had to go in there too, when he wasn't even flying with us. Mama told him he needed an Iranian passport all the same, and I said, Count yourself lucky, at least you'll look normal in your photo. Mo went in and came out holding his Game Boy. I waited for the Game Boy to appear in the photo as well, but the photo was just of a pale, morose Mo, the fuzz of hair on his upper lip looking dark. Have a shave, I said, and he said, Have a shave yourself. Then me in the photo booth. Me alone

with my face on the screen. Not pale, but green. The hijab slips and while the machine is still doing the countdown a few strands of hair fall across my forehead, and I quickly tuck a few strands of hair back under the hijab. What happens if there is hair in the photo? Does it get rejected by the embassy? What if the photos aren't rejected, but we still get turned away at passport control, because an embassy worker wasn't paying attention, because I wasn't paying attention, because the machine started the countdown too quickly? The clock is ticking, the numbers are going backwards, for a second I think of New Year's Eve, and then suddenly the machine is making its noise. The screen says, Print your photos? I see one large, wide-open eye and a hand covering half my face. See half the fuzzy hair on my upper lip and think, Mo is right. Wonder what will happen if I select the photo. If I just say, Well, if hair isn't allowed in the photo, then that rules out half my face. If the hair on my head isn't allowed, then I'll put a hand over my facial hair, too. The machine looks back at me and changes its message. Print photos. It made that decision without any countdown. Please be patient: your passport photos are being printed. I step out of the booth and look into Mama's reproachful face. I need another 5 marks, I say. It was no good. ∎

ARVON MASTERCLASS: YOU ARE A WRITER

Two hours of inspiring tuition from the finest writers at work today

FRIDAY 1 DEC · 11-1PM

SCREENWRITING
Jed Mercurio

How to develop a compelling and multifaceted thriller for the screen.

TUESDAY 5 DEC · 7-9PM

LANDSCAPES & PLACE
John Grindrod

New ways to write yourself into buildings, landscapes and locations.

THURSDAY 7 DEC · 11-1PM

CARIBBEAN POETS, PT 2
Jason Allen-Paisant

Exploring the canon of Black Caribbean poets with Jason Allen-Paisant.

FRIDAY 15 DEC · 11-1PM

DIALOGUE IN FICTION
Charlotte Mendelson

Write engaging and believable conversations — like real life, but better.

FRIDAY 12 JAN · 11-1PM

WRITING EMERGENCY
Kerri ní Dochartaigh

Write the natural world without glossing over the climate emergency.

TUESDAY 16 JAN · 7-9PM

INSPIRING CHARACTERS
Matt Cain

Learn to develop engaging characters that readers can't let go.

TUESDAY 6 FEB · 7-9PM

PERSONAL EXPERIENCE
Alice Vincent

Transform personal stories by combining memoir with narrative non-fiction.

FRIDAY 9 FEB · 11-1PM

ADAPTING MODERN PLAYS
Inua Ellams

Discover ways to reinvigorate and breathe new life into classic plays.

TUESDAY 13 FEB · 7-9PM

POETRY OF JOY
Caleb Parkin

Write sensuous poems that tap into the joy found in our bodies and complicated lives.

FRIDAY 23 FEB · 11-7PM

WRITING THE UNKNOWN
Rupert Thomson

Embrace the unpredictability of a blank page, and the terrain of its secret pleasures.

TUESDAY 27 FEB · 7-9PM

CHALLENGING ESSAYS
Thea Lenarduzzi

Liberate your ideas, creating non-fiction that takes risks and challenges norms.

FRIDAY 8 MAR · 11-1PM

PERSONAL & POLITICAL
Rachel Hewitt

Imbue personal autobiography with the keen insights of social commentary.

ARVON

LOTTERY FUNDED

Supported using public funding by
ARTS COUNCIL ENGLAND

Book now
arvon.org/masterclass
Online via Zoom
Concessions available

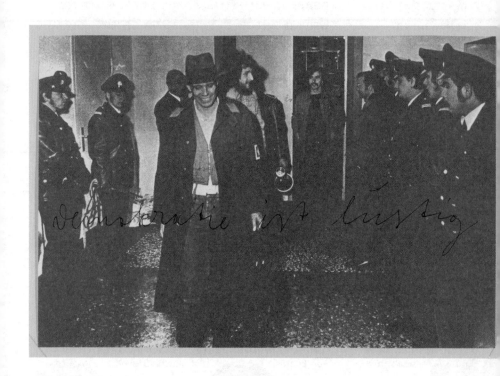

JOSEPH BEUYS
Demokratie ist lustig, 1973
bpk / Bayerische Staatsgemäldesammlungen / Sibylle Forster
DACS 2023

HOW LUSTIG IS IT?

Peter Kuras

Germans don't really have a word for 'funny', which seems appropriate enough. The country's reputation for humourlessness isn't entirely unearned, as anyone who has heard their own joke explained back to them in clipped English knows too well. There are words that get close – *witzig, komisch, drollig, humorvoll,* and *spaßig* all somehow mean something close to funny. But the word Germans are most likely to use to describe the things that make them laugh reveals a culture that takes its merriment very seriously. English retains a certain suspicion of comedy: 'funny' derives from the Middle English 'fon', meaning to make 'a fool' of or 'to be a fool'. When Anglo speakers say something is 'funny' it's often unclear whether they mean 'funny ha ha' or 'funny strange'. The German 'lustig', on the other hand, suggests neither madness nor idiocy, but pleasure and desire.

The greatest humour in the language has a kind of erotic intensity rare in the English-speaking world – Hollywood and Bollywood divisions between leading men and comic actors don't really work for German speakers. The carnality and comedy of performers such as Klaus Kinski and Christoph Waltz have always been inseparable. Cary Grant used his wit to disarm his good looks. He made himself approachable and likeable by being funny. For Kinski and Waltz, by

contrast, the comic often serves as a kind of seduction – you laugh at Waltz playing a Nazi and feel uncomfortable about the part of you that finds him compelling and attractive.

The lines between the comic (*Lustspiel*) and the tragic (*Trauerspiel*) have rarely been as neat in German-speaking lands. Take Till Eulenspiegel, Germany's answer to Robin Hood. Eulenspiegel was an apocryphal wandering joker who delighted in fooling powerful nobles and wealthy burghers. East Germany's main satirical magazine was named in his honour, and to play with his story has been a rite of passage for generations of German authors. Daniel Kehlmann's recent novelistic account of his life begins with one of the trickster's most famous gags: walking on a tightrope, Eulenspiegel convinces the citizens of a village to throw him their left shoes. Footwear was not taken for granted in pre-Industrial Europe. When Eulenspiegel drops them in a heap from his perch above the crowd, a mad rush to collect their property begins. One man is killed. Another is maimed. Till moves on. The villagers remember the joke as a moral demonstration of the pettiness and violence that lurks behind bucolic facades (the surplus of savagery of the Thirty Years War made for cheap laughs).

In English, we say a joke was a riot. In German, they mean it: *einen Streich spielen*, the word for a prank or a practical joke, literally means 'to play a beating'. A *coup d'état* is a *Staatsstreich*. Much of the best comedy in the language depends on the possibility of real harm for its effect, and its early literature is full of brutal gags like Eulenspiegel's manufactured riot. Hans Jakob Christoffel von Grimmelshausen's *Der abenteuerliche Simplicissimus Teutsch* (1668/1669) begins with the murder of the protagonist's family by a roving band of soldiers, and follows him through conscription by various armies. He's accused of espionage; subjected to deliberate alcohol poisoning in an attempt to induce brain damage; sentenced to death; shipwrecked; and enslaved. At some point, he thinks that by cross-dressing he might avoid conscription into yet another army, until the very real possibility of rape presents itself and he decides to take his chances fighting.

German literature later shed this kind of rude, brutal humour – the *Bildungsbürgertum* who became the country's dominant cultural force were too high-minded for comedy from the depths. The canonical works that established German as the dominant language of Mitteleuropean culture were largely devoid of humour. Goethe distrusted comedy; he thought it indicated a malfunctioning of reason. The generations of authors who followed him inherited his distaste for the comic. In the late-nineteenth-century, German literary humour was consigned to the margins, and remained most alive in German-Jewish culture. The Jewish art of self-deprecating humour (on full display in Freud's *Jokes and Their Relation to the Unconscious*) was instrumentalised by Nazi propagandists who took jokes about Jewish dialects, miserliness and hygiene very, very seriously. Not that fascists didn't enjoy Jewish humour – they forced their victims to perform humiliating cabaret bits in hope of forestalling the inevitable. But humour was never a Nazi strong point. Hitler's favorite comedian was the Swiss-German clown Grock, whose gags included falling off his piano chair and treating his clarinet like a rifle.

The danger and the erotic charge of German comedy flourished after the war, when physical performance reemerged as a part of high culture. Once again, Germans staged mischievous interventions in the mold of Till Eulenspiegel. In *Demokratie ist Lustig* (1973), Joseph Beuys created a series of screenprints depicting the moment when he was expelled from the Düsseldorf Academy, where he had taught for decades, after protesting their selective admission policy. The screenprints of Beuys walking nonchalantly past rows of grave-looking men have an undeniably humorous eroticism. Beuys, with his wide and easy smile, seems lithe and vital next to the artificially upright officers. He looks like he's off to buy ice cream. Beuys isn't really funny. But he's very *lustig*.

This kind of comedy can't be easily contained. When it's filmed – as in Werner Herzog's *Mein liebster Feind – Klaus Kinski,* or Marcus Mittermeier's *Muxmäuschenstill* – it's a harrowing viewing experience, in part because we sense that Kinski's sanity really is at stake. Often,

German humour only works when it retains the status of a prank, even if those pranks sometimes become serious. *Die Partei* began as a joke political party in Germany but found surprising electoral success and now mixes a sober kind of leftish politics with provocative campaigning – they've faced legal challenges for a poster reading FEMINISM, YOU CUNTS over a drawing of a bloody tampon, as well as for one that simply said: A NAZI COULD BE HANGING HERE.

Germany's most visible heirs to Eulenspiegel are the Zentrum für Politische Schönheit, a group of action artists who made international headlines when they installed a replica of Berlin's Memorial to the Murdered Jews of Europe outside the home of far-right firebrand Björn Höcke. They follow in a tradition of left-wing provocation established by Christoph Schlingensief and Friedensreich Hundertwasser. But it is not inherently progressive, nor is prankery an exclusive property of the German left. The reactionary activist group the Identitäre Bewegung responded to the Zentrum für Politische Schönheit's provocation by installing a Memorial to the Victims of Multiculturalism and Islamic Terrorism outside of the Brandenburger Tor in Berlin.

The German grotesque tradition is too akin to anarchy to have much in common with Anglo and Latin comedic traditions that grew out of the bourgeoisie's ascendance in the nineteenth century. It doesn't aspire to teach its initiates manners, nor instruct them how to laugh at both peasants and royals. That doesn't mean it lacks an interest in justice. Alexander Kluge, along with his collaborator Oskar Negt, offers the sharpest theorisation of the connection between German politics and German laughter. They take the Grimm Brothers' shortest fairy tale as the *locus classicus* of Germany's grotesque comedy:

> There once was an obstinate child who would not do what its mother wanted, so God found no pleasure in it and made it sicken so that no doctor could help it. Before long, it lay on its death bed. When it was laid in its grave

and covered in earth, its hand stretched out again and when they put its arm back in and covered it with fresh earth, it didn't help at all. The arm kept reaching out, time and again, until its mother took a switch and beat the child. Once she had done so, the child withdrew and could rest under the earth.

The tale isn't funny. But it is *lustig* – the superhuman élan and stubbornness of the child makes an otherwise brutal story entertaining almost despite itself. The point isn't to laugh, it's to be captivated by the child's mirthful obstinacy. The anarchical energy cannot be channelled rationally; it offers laughter beyond the horizon of survival. Germany may never have had a revolution – it was never witty enough for that. But the hand keeps reaching from the earth, insisting another world is possible. ■

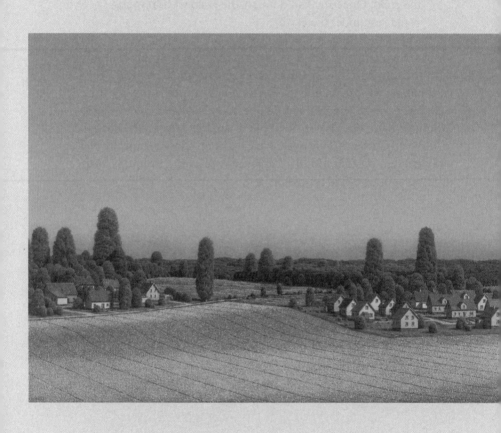

OUT OF GERMANY

Michael Hofmann

If there exists such a thing as *tiefes Deutschland,* like *France profonde,* it might be here, one of the claimed birthplaces of the clown and fool Tyl Eulenspiegel; close to the family seat of the fantasist-cum-fabulist Baron von Münchhausen; within sight of the totemic witching mountain which we irreverently call Fuji, the Brocken, on the southern horizon (Heine's *Harzreise,* Goethe's *Faust*), a perfect pimple hairy with antennae (it was and still is a listening post); and not far from the old German-German border. Though fairly much in the middle of things these days, it feels like border country. Because of the phenomenon known as *Grenzflucht* – a tendency to shrivel within one's frontiers – the region is still underpopulated. It hasn't really knitted together; the timetables still make it hard to go east, to Halle, to Magdeburg. You can still tell which 'side' you are on, even thirty years after unification when there are supposedly no longer sides. There was historic emigration from the little, no-account princedoms of Lower Saxony and Sachsen-Anhalt. It took the importation and cultivation of the potato to keep people from starving, and the sugar beet to make a very few of them rich, the nineteenth-century sugar barons in their ostentatious, so-called 'beet castles', their *Rübenburgen.* George III's mercenaries, known as 'Hessians', were recruited from here: the place names Hanover and Brunswick still have a ring in

English. It was repeatedly fought over, in the Thirty Years War, the Seven Years War, the Napoleonic Wars. If Robert Lowell can be believed, Frederick the Great exhorted his men into battle by calling: 'Move, you bastards, do you want to live forever?' The implicit answer: 'No, sir!'

From the States it took us three flights to get to the city, then from the city three trains and a bus that stitched a kind of right-angled Cretan wave-pattern among the villages. North of us is the Elm, a wooded ridge bearing supposedly the largest contiguous beechwoods in Germany, and to the south is the Asse, more wooded hills, but more especially also the old salt mines where a now fully de-nuclearised Germany in its wisdom stored nuclear waste in thousands of salt-corroded barrels. The Green movement started here in the seventies, with its wonky yellow crossed-out capital A (for 'Atom' and 'Asse'), and its sunny badges ATOMKRAFT? NEIN, DANKE! Wim Wenders shot part of his haunting early film *Kings of the Road* not far away.

I never meant to live in the country, much less in the country of Germany, having left about sixty years ago, and having thought for about the last twenty that I would work my job in the States and live out my days in England. The last few years took care of that. This Saxon is a victim of Anglo-Saxonia. But back in the day, I said *Nein, danke* to Germany, and opted to live in countries that themselves like to say no. It's strange to confront and take back my rejection, which was thought to be for life. I tried, in my twenties and thirties and beyond, to be a good little immigrant. I renounced Germany and renounced German. I denied that either had aesthetic virtue. I was reluctant to speak it, couldn't write it, and didn't want to live in it. Germany to me was always the newer country, rebuilt after the Second World War – and formed, as I was, in and by England, I held that only an old, shabby country could be beautiful and habitable. I denied the language, and wished I could unlearn it – the one Frederick the Great (him again) used with his horses.

Flying over it recently, the country looks well presented: fields, villages, lakes, woods. Nothing to excess, nothing lunar, nothing

hideous. In late spring, it was bright, even fauve: crisp green maize, a kind of bluish barley, maximum rapeseed with its shocking yellow, the soil pinkish, turning to mauve when wet. The towns were red-brick, many of them with tiled roofs. I couldn't take against the place. Many of the buildings hereabouts are half-timbered, with wooden uprights and diagonals filled in with stone and clabber, and usually painted white. Contrary to what I had supposed, it is an old landscape, and there is nature, not just the soulless, chemical efficiency I once ascribed to it. There are *Katzenkopf* cobbled streets, and lindens planted in 1871, just now reaching the sesquicentenary end of their lives. There are cuckoos, skylarks, red-tailed kites. Orderly mobs of deer in the fields, and huntsmen's perches everywhere. Muscular hares. A lynx was spotted not long ago on someone's infrared camera. Looking up an angle at some of the fields, they are a wash of red from the poppies. Monet could have set up his easel here. It is pleasant – to me, confusingly so.

Perhaps it wouldn't be Germany if it wasn't also in a pother. On almost every front, the country has problems. Not the kind of technocratic, trivial problems other countries might wish they had – real problems. Things don't function; the trains don't run on time. Where will the much-needed lithium come from for the new batteries that will power everything? Or not. The *Bundeswehr*'s rifles don't shoot any straighter than the men's and women's football teams of late, and their fantastically expensive new tanks don't do well in hot weather.

After seeming for some decades to be comfortably and confidently cresting a permanent wave, closer to the future and far more affirmative about it than most other countries, Germany feels uncomfortable now. The gradient, formerly level, is tipping downhill. Health, education, transport, are all problem areas. A latent ungovernability, a stubborn self-division besetting many Western nations, is in progress here as well. There is a sense that the country has for a long time been facing the wrong way, towards Russia, towards China, with exports, with industrial policy, with

ecology, with migrants, with food safety, with supply chains, with inflation, with pensions, with inequality. There is a German saying, '*es wird nicht so heiss gegessen, wie gekocht*' ('you don't eat as hot as you cook', effectively a version of 'cheer up, it may never happen'), but pessimistic Germans are obsessed with the heat of what's in the pot, and seem to think there's little chance of 'it' not happening. An otherwise doughty, biddable, hard-working population shows a disturbing propensity for panic mixed with self-pity.

It's time for the *Schützenfest*, the village fete. A traffic sign has been put up that I've never seen before, showing a man on his hands and knees, or knees and one hand, holding a glass of beer in the other. Drunk crossing. We scrape the gutters clear of weeds, getting used to not looking up at passing cars. In the evening, weather permitting, we will walk up to the tiny cemetery, the Sandberg, to commune with Barbara's parents, her brother, her aunts, her grandparents and great-grandparents. Between hedges, it's a little meandering avenue along a ridge between two rows of birches. Her father, in particular, who was a Russian prisoner of war until 1949 or 1950, will have liked the setting. Myself, I can't hardly wait. The village has its first solar panels on the roof of the old, decommissioned schoolhouse. There are windmills here all over the place – known in the amiable German slang as *Spargel*, asparagus stalks. One gets good at overlooking them, though there must be scores of them within view, mostly in two or three clumps, ten or twenty miles east and west. At night, their red warning lights gleam like the eyes of Grendel's mother in *Beowulf,* a little malignantly. They are taking care of business. ∎

HAVE A GOOD TRIP
WITH TRABANT

Martin Roemers

Introduction by Durs Grünbein

TRANSLATED FROM THE GERMAN BY KAREN LEEDER

'My unchristian forbears: for their whole lives / had got along without God,' I once wrote. But not without a car, you might add. When the Nazis dreamed up the 'people's car' – the *Volkswagen* – and encouraged Germans to invest their savings into its production with the promise of ownership, my grandfather made the contribution out of his first pay packet. He never saw the money again. The war not only consumed millions of lives, but also the credit of all those small savers. In the aftermath of 1945, one of the illusions that continued to circulate uninhibited in occupied Germany was the hope of owning a car. It was a driving force, quite a literal one, behind the economic miracle in the West.

In East Germany (GDR), the Trabant – the Communist people's car – occupied a more peculiar place in people's imaginations. It was born in 1957, in the shadow of the successful brands from the West – Mercedes, BMW, Porsche. A home-grown commodity that endured no competition, it was at the same time stymied by arrested development. The Trabant was an isolated invention, a one-off, that outlasted the state that produced it, just like East Germany's iconic traffic-light men, the *Ampelmännchen*. In the global imagination

today, Trabants are *Ampelmännchen* on four wheels: fetish objects from a past with no future.

The Trabant was produced in the state-owned car factory VEB Sachsenring Automobilwerke Zwickau in Saxony. It was poorly equipped with a small two-stroke engine. The special oil-and-gas mixture it required resulted in blue smoke exhaust. The true innovation of the Trabant was its body, made from a polymer called Duroplast. This was definitely a step into the future. Metal was in short supply in the GDR: the state enlisted the pharmaceutical industry to supply car production with high-strength reinforced plastics. The classic model series was the Trabant 601 (26 hp), which was produced from 1964 onward. More than 2 million of them rolled off the assembly line until 1990. It was never enough; demand far exceeded output. Automobile deprivation was a constant source of resentment among the population, who saw their dream of mobility, even within the narrow confines of the 'socialist camp', disappointed.

Was the Trabant considered a privilege? It was hard to say in a shortage economy. Most people had to join the queue, submit an application, and wait a long time. Fourteen years was not uncommon. Word got around that there were injustices in the distribution of the coveted vehicles. Why had one's neighbor got his faster? Because he was a party member, an employee of the MfS (Stasi or secret police), an officer in the National People's Army? Then there was the shame associated with the object of desire: everyone knew that it was not exactly sexy, not like the cool sports cars you saw in films from the West: the Chevrolet, the Lancia, the Citroën, the Austin. The Trabant was the visible sign that East Germans were left behind when it came to car design. A hat box that rattled along like a tractor: the Trabant stank, looked stupid, clumsy; it was a toy car, nothing for a real man. Trabant jokes made the rounds. Question: 'What do a Trabant and a condom have in common?' Answer: 'Both decrease the pleasure of the ride.'

East German government officials did not drive East German-made cars. Standing on the side of the road as a GDR citizen on one of the public holidays, the sight of the leaders of the official youth organizations – the Pioneers, the Free German Youth and other assorted bigwigs – roaring past in foreign cars certainly gave you pause about the principles of state socialism. On television, you watched Erich Honecker, the leader of the GDR, step out to meet the heads of state from a black stretch limousine manufactured by Volvo. Was that him now returning behind the tinted windows? It was enough to make you feel completely at home again in the garage with your Trabant.

For some of my fellow East Germans, the Trabant even prompted a feeling of safety. Maybe this is where nostalgia for the East – Ostalgie – has its roots. I still remember how my father would arrive in terrible pain after the long journeys every summer from Dresden up to the Baltic Sea, hours spent on the motorway. 'Do you remember?' asks my mother. 'He had difficulty getting out of the Trabant.' But that probably had more to do with his lumbago. Most people managed for their whole lives in the cramped little cage.

When the barriers fell along the inner-German border in 1989, a stream of Trabants poured into the West. I was there at the Bornholm Bridge. The scene was broadcast around the world. The better-off among the Easterners who passed through the Wall demonstrated a self-confidence that may well have astonished contemporary witnesses. Look, they seemed to say, this way we won't be arriving on foot, but in the armor of our cars. It was as if they wanted to give an ironic twist to the meaning of the brand name ('Trabant': a bodyguard or foot soldier). I still have the din of the terrible old crates ringing in my ears: the rattle of the two-stroke engines. My madeleine has the stench of blue exhaust fumes.

In April 1991, a few weeks before the assembly lines came to a standstill and production came to an end, an enterprising Dutch photographer arrived at the Zwickau plant. He set out to record a doomed world. Like August Sander, whose camera scientifically registered the professions and ordinary people of the Weimar Republic, Martin Roemers documented something soon to vanish. He captures the everyday moments of working lives, which the participants could not imagine ending. Yet everything happened very quickly. Here you can see the last bits of manual work, the worn-out faces that hold their own in front of the camera, the individual workers in their different outfits – mechanics, painters and welders, many women among them – people on their breaks, the young woman in the canteen.

You sense the workers at the Zwickau plant know that the writing is on the wall. The man reading the newspaper, *Auto Bild*, with the headline A NEW MERCEDES EVERY YEAR; the woman in the apron dress, leaning against the pipework; the woman holding the drill, a tattoo on her right forearm; a man with his lunch in his hand; one in the smoking corner; another lost in the assembly room, behind him a wall plastered with pin-ups opening up like the jaws of the future, symbols of the counter-culture – that of the hyper-sexualized West. The longer you look, the more you become suspicious of any idea of authenticity. It's as if the scenes have been staged for one last performance. The details are what count, the little things that reveal more than the photographer (and the viewer) could have known at the time. The scrapyard with the excavator grab hanging menacingly in the air burns itself into your memory, as does the slogan on the factory gate: HAVE A GOOD TRIP WITH TRABANT. Black-and-white pictures that capture the mood of an end-time. It's the gaze of a Western photographer fixed on another continent, as distant as Africa. A document of recent colonial history. How else to view the ruins? ■

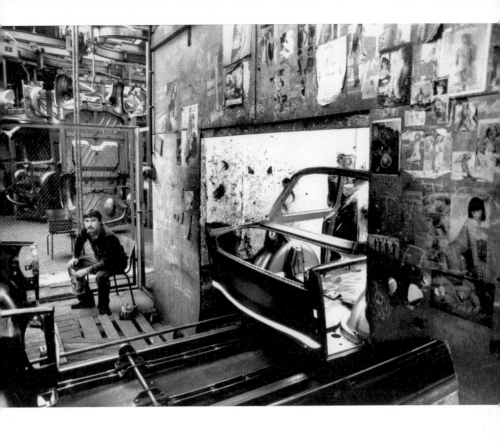

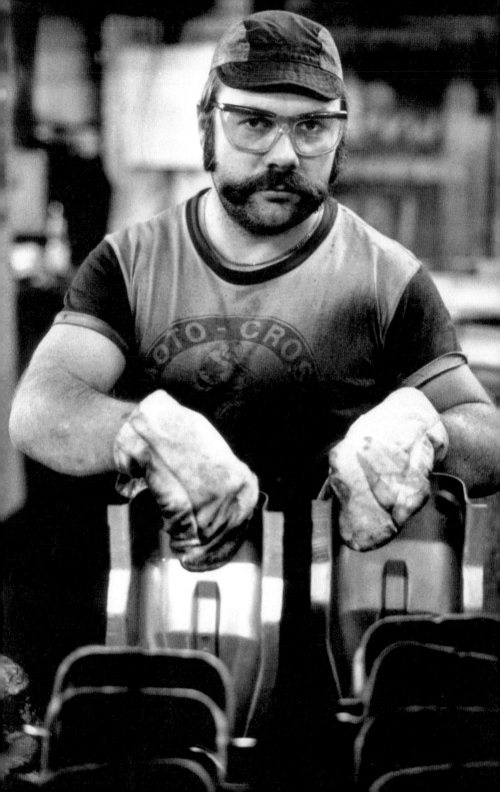

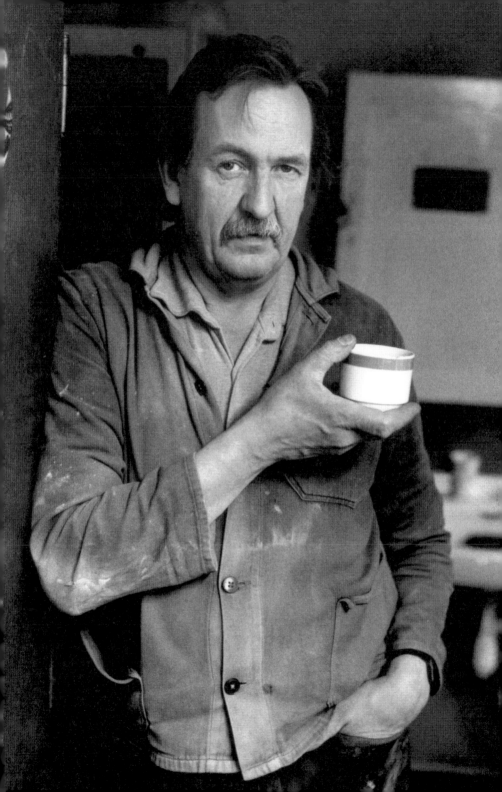

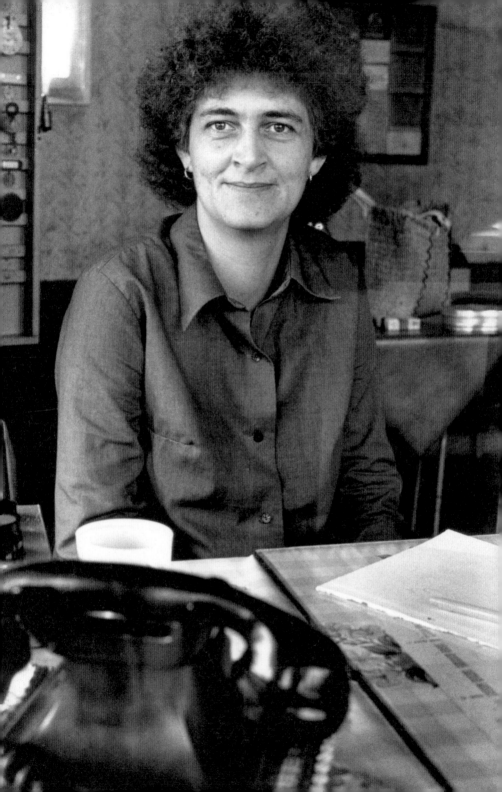

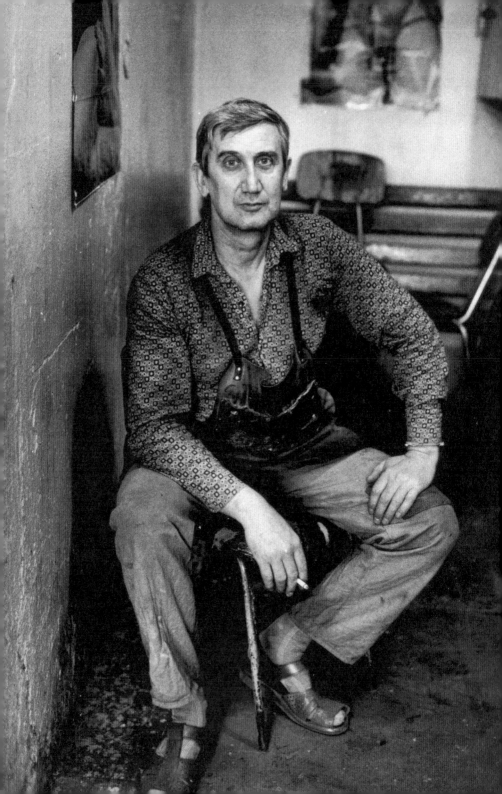

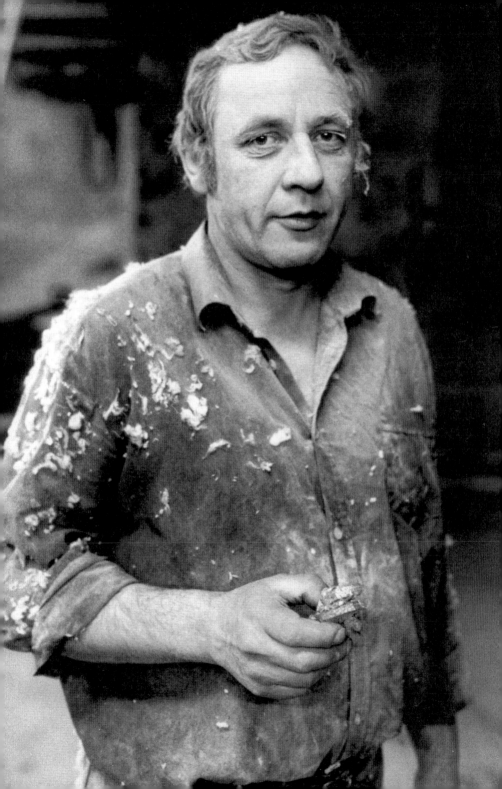

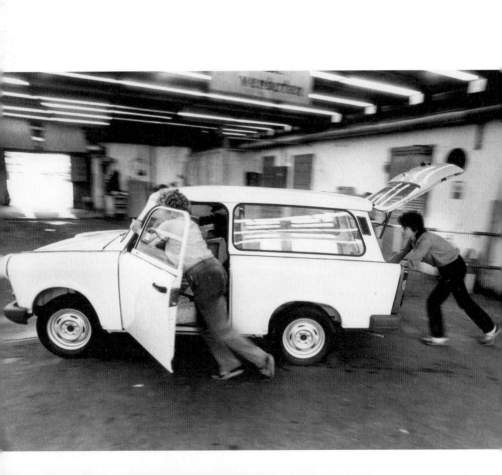

'Author' as a myth of days gone by? – No, actually not.

'Sit!' he said to the troubling interior part of himself – and so he sat there, the dog, he sat and sat.

What's your favourite thing to do? – Keep a lookout. – But you mostly look at the floor?! – So?

An entirely different Big Dipper: swarms of migratory birds in the heights of the sky, now southward, now northward, and in between again and again turning and shearing off elseward.

Looking over one's shoulder: inexhaustible. – So long as it doesn't turn into a method? – And if it does: a good method, for once.

The untranslatable German language, time and again: 'to have the after seeing' [*das Nachsehen haben*] 'to have the before love' [*vorlieb nehmen*]; every language nearly untranslatable? – So translate! (*Saludos a Miguel de Cervantes*)

This too is company: 'in the company' of a fingered glove spread on the backrest of a stone bench at the edge of a village green. Is it really necessary to speak in such detail of a 'fingered glove'? Yes, it is necessary, and to add that the woollen fingers, frosted white, glitter in the sun of the new year. (Picardie)

Ambition, yes, but at the same time: descend from the one you look up to.

Ideal: cheerful negligence.

In the old dictionary the right verb for the sound of the 'lonely chirper' on winter nights, often hours before first light: *minyrïzo*. Onomatopoetic? Onomaphonetic.

So many seem respectable, even briefly wonderful, from a distance, but are diminished by diminishing distance? No, they remain respectable, even wonderful. It's you who are diminished by the distance you diminished.

Morning raindrop on the bare early-spring branches, gleam for me.

Two types of epic narration: in one, life plays along with someone and everyone, and the other? – How life plays, somehow, anyhow.

I managed to leave a mess be – and see: it wasn't a mess at all.

'The very first epic': the pain and joy of letting existence seep, hardly noticeable at first, and then all the more perceptibly word for word into the depths, the deeper depths, the deepest depths of our existence. – Our collective delusion? – Beautiful delusion.

'Order is half of life' – and the other half? – You get one guess.

Misfortunes, at least the little ones, the quotidian ones, also resonate. Listen; pay attention.

'Every drawing is a triumph over the disorder of the world.' (Maria Lassnig, 1992)

'You continue to receive proofs of love.' (daily horoscope)

'Let's lose our way together!' (declaration of love)

PETER HANDKE

A single distant passer-by on the Sunday-morning street. With the light of the sun playing around him, he seems to be greeting me, continuously, while walking incessantly.

A kind of duty: to let seriousness turn into 'serious play'. (G)

'Love isn't loved.' – Yes, and we can't quit quitting.

'You can row your boat where you please.' (daily horoscope)

The occasionally surging feelings of gratitude for those who have ever been close to me, and who have since 'faded away'. The compulsion to pay some tribute to them, now, and now. – To 'pay tribute'? – To pay tribute.

I'm not going anywhere today. Tomorrow either. – A laudable plan! ∎

Translated from the German by Peter Kuras

Opposite: SUHRKAMP

Images taken from Peter Handke's *Vor der Baumschattenwand nachts: Zeichen und Anflüge von der Peripherie 2007–2015*

Next spread: SUHRKAMP

Image taken from Peter Handke's *Die Zeit und die Räume: Notizbuch 24. April – 26. August 1978*

Slowenisches Dorf,
Bienenmuseum

Pappel am
Sommernachmittag,
"Niemandsbucht"

Barterrasse
"Niemandsbucht"

PETER HANDKE

WERNER TÜBKE
Detail of *Bauernkriegspanorama*, 1976–89
DACS 2023

REUNIFIED GERMAN IMAGES

Fredric Jameson

Aesthetic debates invite political investment. Before Stalinism, Adorno claims, modernism in the arts was more than compatible with revolutionary politics. In the Cold War, abstract expressionism became a weapon in US foreign policy, to the chagrin of the henceforth marginalized WPA muralists, social and magical realists, storytelling painters of all kinds. In Germany, Günter Grass, himself no mean draftsman, complained bitterly about this tyranny of the abstract in his autobiography. An intense German polemic over figuration, however, had to await reunification, when the most interesting East German production – the so-called New (or Second, or Third) Leipzig School – became caught up in this already fraught symbolic quarrel. So it is that the most prolific of these figurative painters, Neo Rauch, a veritable Balzac of the storytelling image, has run aground of attacks reading him alternatively as 'East German' (that is, communist) or national-fascist, inviting his own unnecessary (political) self-defense of what Thomas Mann called an 'unpolitical man'.

Political or not, the element Rauch works in is certainly what we call History. This is rare enough in an ahistorical late capitalism in which only the extremes of Left and Right retain a keen sense of historicity. The pieces of the past that drift down into Rauch's

canvases, however, are too fragmented to bear much in the way of a political charge. He tells us that they come to him at night, imperiously soliciting expression; and what they preeminently express is the fragmentation of German history, which, at the center of Europe, experienced war on many fronts, from the Roman Empire to the Thirty Years War, and on into the long and bloody twentieth century. Their representations demand a reunification they can only find on the canvas and through the energetic interpretations of their beholders.

Rauch's canvases may be oneiric, but we must be careful, however strong the temptation, not to assimilate them to surrealism, which was marked, I would like to say, by a quintessentially French, and even Parisian, unconscious, however worldwide its later diffusion, and despite illustrious German adherents such as Max Ernst (Rauch's daytime self, an eloquent commentator and theorist of his own works, parries with the more Germanic figure of Max Beckmann).

What Rauch has in common with surrealism is a rigorous method paradoxically called 'free association', a practice which aims to release a flow of images otherwise blocked by Freud's 'reality principle'. Rauch also retains the practice of the surrealist image as Reverdy defined it: 'a juxtaposition of two more or less distant realities. The more the relationship between the two juxtaposed realities is distant and true, the stronger the image will be . . .' In Rauch this 'juxtaposition' – far too mild a word for his crashes and dissonances, his Ovidian metamorphoses and his inexplicable gaps – is the crack through which a genuinely historical contradiction seeps like radiation.

Saxony and its capital Leipzig – almost as distant from GDR Berlin as from the multiple West German cultural centers – bequeathed the painter a stock of raw materials: the images of defeat. The very landscape – a non-Rust Belt terrain of the undeveloped rather than the overdeveloped, not the exhaustion of Detroit so much as the vacant lots of forced abandonment – is shaped and defined by projects arrested in midcourse: graveyards of appliances which did not have time to be worn out by the daily life of a successfully

industrialized society: unfinished houses, incomplete electrical grids, pipes, tools, excavations for never-erected buildings. This essential historical incompleteness now releases all the ghosts of an unrealized past, who wander through the paintings in their outmoded (generally Romantic) costumes, alongside survivors whose unoccupied gazes betray their lack of connection with one another. Instead we find disembodied clashes, disinterested thwartings, a violent dramaturgy of the distracted and the uninvolved, rebus, caricature, cartoon, historical pageants, the dramatic opera of enigmatic encounters, a staged charade of the freeze-framed moments of a past that went nowhere. Chekhov offered us a stage full of characters talking to themselves rather than each other. Here we have whole historical periods which have nothing to say to one another, and yet just as strangely fight it out.

It was not always so. Rauch belongs to the younger Leipzig generation that began by experimenting with strange sci-fi constructions, and a minimum of human inhabitants (whether operators or victims). In his early work planes of repressive material intersect: constellations of objects that contradict social physics, while a sci-fi robotic space asserts its primacy. All these expressions of 'dissidence' preoccupied Rauch and his generation in the early years, in an appeal of willpower to generate new styles and new gestures. At some point, around 2000, Rauch found the more congenial path of narrative – of characters and incomprehensible stories and interactions – preferable to playing with spaces that recede into backgrounds of stage direction and scenery.

The older generation did not know this kind of release. In the twilight years of the GDR, one of Rauch's elders, the great historical painter Werner Tübke, commemorated the history of Germany's revolutionary defeats in a memorial to Thomas Müntzer and his peasant army, crushed in 1525 at the battle of Frankenhausen. There, an immense circular building houses Tübke's well-nigh encyclopedic Renaissance-style fresco worthy of Diego Rivera, nothing less than a history of the world, whose religious elements alienated the party

which so generously financed it. (Erich Honecker refused to attend its inauguration.) Isolated in an East German landscape where it remains difficult to access, this impossible tourist attraction is yet another remnant left behind by an abandoned future, like the Hindu and Buddhist caves scattered through India. Tübke thereby authorized a representational style which would entitle Rauch to claim an apolitical indifference.

Do we then find in Rauch's work a 'surrealism without the unconscious'? Not exactly. But I would argue for a form of the

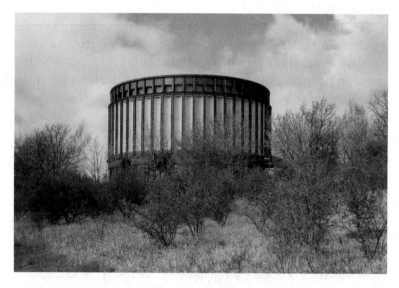

Panorama Museum. Bad Frankenhausen, Germany. Shutterstock

'unconscious' which Derrida, following Freud on melancholy and the later theorists Nicolas Abraham and Mária Török, called 'encryption' – the formation of a kind of cyst or crypt within the self of unliquidated entities, in which historical traumas bide their time, unassimilated, unincorporated, prepared at any moment to reemerge as fresh ghosts demanding their representation on the painted surface. The process indeed may be compared to reality itself, when a wealthy West Germany annexed its socialist sibling without any genuine assimilation, leaving the latter as the source of violent drives and impulses incompatible with the Americanized culture of an officially reunified Germania. Here, if anywhere, we may situate the allegorical temptation that threatens Rauch's work.

This work, after the youthful period described above, which one can scarcely characterize as 'dissident', may be divided into episodes and scenes: the simpler but not necessarily smaller works, organized around what looks like a single theme, and the monumental paintings in which a whole variety of thematic groupings are scattered across the canvas, at their best in a kind of orgiastic spectacle which the viewer is called on to unify – but not too quickly! – so as not to lose the dissonances and the quintessential fragmentation. Indeed, with Rauch, it is always best to see a roomful of these productions in order to register their common populations and their family likenesses rather than to commit one's viewing to the discipline of a single 'masterwork'.

The war between representation and abstraction presupposed, at least among the adherents of the latter, that you could simply peel off storytelling and its accoutrements from art and attain a purer and more intense relationship with the fundamentals: oil paint, colors, geometrical shapes. The result would achieve that stunned fascination called aesthetic pleasure. But this is to ignore a different kind of dynamic of formal 'separation' within Rauch's 'storytelling' itself. His characters rarely look at one another, each lost in a world apart; the groups are isolated from one another and from their surroundings; even the often monstrous evolution of ominous objects takes place in isolation. Yet all this is also happening to the raw materials of

representation as such. In an episodic painting like *Krönung I* (*Coronation I*, 2008) – particularly if you have the good luck to see it in reality – the colored paint of the costumes, the brownish yellow of the 'pretender', the gray and red of the officiant, rise off the garments which appear to glow from the inside with their own inner being. The recurrent combinations of these autonomous colors – midnight blue, indigo, rust red, purple, a strident yellow – blot out the air and light of an open sky, and seem to make of our contemplation of the painting a kind of grotto. The yellow in particular becomes a character in its own right, like a kind of shriek: it is given the honor of its own portrait in a painting like *Paranoia* (2007), where an anxious couple await the opening of a yellow curtain, while the completed revelation – an almost wholly yellow canvas – hangs on the wall behind them.

Rauch's separation of objects from one another is confirmed by their reunification in transmutations of all kinds – the extremities of the heir in *Krönung I* turn out to be a money-bag on the one arm, a monstrous lightbulb on the other. Figures emerge from the earth or disappear back into it, as in *Die Fuge* (*Flight*, 2007). Human faces begin to grow on strange animals. We follow the inner potentialities of rods and staves from painting to painting, where everything latent in the word squirming becomes at one and the same time hoses, eels and intubated tubes, before returning to their vocation of holding off bodies or bloodlessly intercepting or wounding them. Then there are the gnats or fireflies, whose avatars are little candles and which torment faces like that of our monarch-to-be or, better still, the magnificent portrait *Ungeheuer* (*Ogre*, 2006). A terrible evolution – angels or insects – is ratified by the fully grown post-human winged figures assisted offstage in *Bon Si* (2006). Mixed figures abound, as in the cynically observant table-centaur who dominates a musical duo in *Reiter* (*Rider*, 2010). I am even tempted to say that here, as in Brecht, there is an autonomy of the gesture: the multitudinous figures are so many, supports for the gestures which they hold as in a tableau, each unrelated to those of their neighbors. And to be sure, what unifies the heterogeneous content of the scenes is often

their preparation as a spectacle, meant to be viewed by an absent public. Thus, in *Interview* (2006), the two interlocutors, as limp as corpses, are vainly held in place by stagehands obedient to offstage commands.

So it is that, whatever the content of the great scenes – pageants, assemblies, arsons, *Volksfeste*, a market, a construction site – we the viewers, alongside the occasional presence of the lone artist in the corner, are also built in and called upon to invent the unity and identity of these batches of uncoordinated figures and elements. Sometimes the omnipresent titles (or subtitles) have enough authority to nudge us in a satisfying direction; and sometimes not. These are, as it were, the cold cases, the unsolved mysteries, to which as detectives we return again and again: *Schilfland* (*Marshland*, 2009) for example, where a frieze of incommensurable spaces leads us across the swampland of the title. We begin on the left with a grotto, in which workmen standing outside houses with lit windows hold a giant fish (the avatar perhaps of those wriggling staves we mentioned: frequent inhabitants, nightmarish or not, of Rauch's paintings). This hollow space is not redeemed by a draftsman presumably sketching its cavity from its outer edge. Meanwhile, across the swamp, a naked woman inexplicably floats on open air (there are few nudes in Rauch), and a man strides through the water, his face bedeviled by those same gnats I mentioned above. A sheaf of swamp leaves comes out of his mouth, and he holds what looks to be a typewriter case. This figure seems to me the most tragic in all of Rauch, his darkened eyes betokening some lost emotion, his inexpressive face an enigmatic mixture which we cannot identify and for which we have no words. Here too a facade with lighted windows seems to consecrate a combination of typically German elements we cannot fathom, while in the front a strange little cartoon figure, its midriff opening in a Daliesque drawer as an appendage, dances joyously to the impossibility of representing any kind of transition from these recessive spaces to the swampland between them. Need I say more?

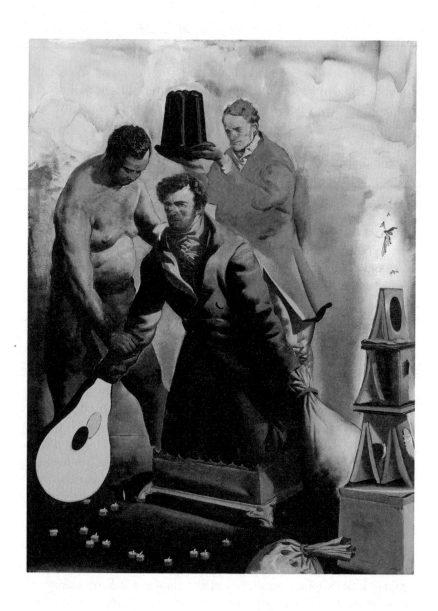

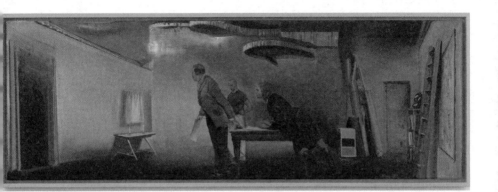

NEO RAUCH / VG BILD-KUNST, BONN
Paranoia, 2007
Photography by Uwe Walter
Courtesy of the artist, Galerie EIGEN + ART, Leipzig / Berlin and David Zwirner

A scene which ought to be more allegorically readable, *Die Fuge,* gives us imprisonment at one end and release on the other. Firemen appear to be excavating in the middle, throwing up the masses of dirt which open a kind of earth-tent for the shackled prisoner whose beard-mask appears to mark him as some kind of (nineteenth-century) anarchist threat, which allows us to conjecture that the dirt pile is in reality a demolished house among whose tiles the firemen are working. At the other end, a pair of conjoined twin girls rise ecstatically into the sky à la Pasolini accompanied by an indistinct male companion, brother or otherwise, against the background of a solid frame which may well be destined for another demolition. Within it, against the background of what may be surfboards or Picasso-style African masks, a youth is placidly reading, surrounded by a few of those blobs which in Rauch designate the limits of expression. A fireman has been flattened in the foreground along with a table, while in the distance a truly massive mountain sets the scene. But the scene for what?

Bergson thought the past was an immense cone whose moving tip wrote the present, its simultaneous contents interrelated in such a way as to stretch back into pre-history. So also this art, in which centuries of German history elected this particular set of haptic eyes and visually instinctive hands to serve as a painterly conduit for a stream of images, the unrelated fragments of a discontinuous collective experience. Maybe all art is that; or maybe unique circumstances are required for a Neo Rauch to fulfill what is certainly a historic destiny. ■

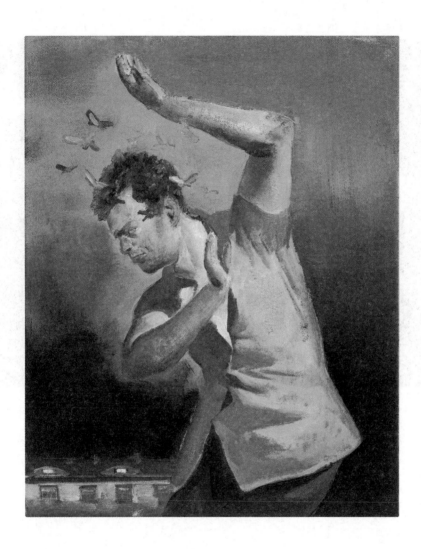

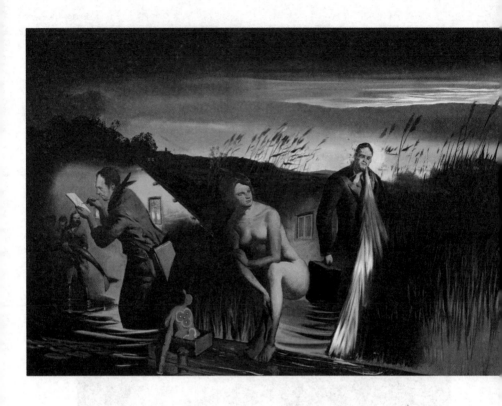

Die Fuge, 2007
Photography by Uwe Walter
Courtesy of the artist, Galerie EIGEN + ART, Leipzig / Berlin and David Zwirner

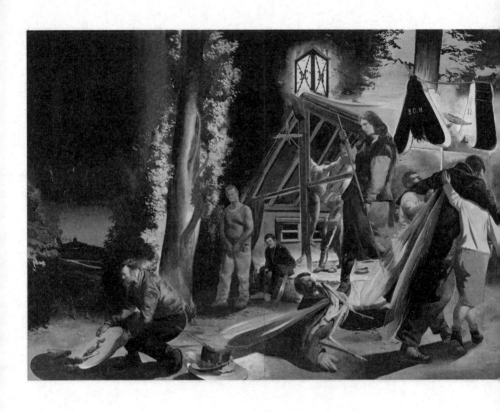

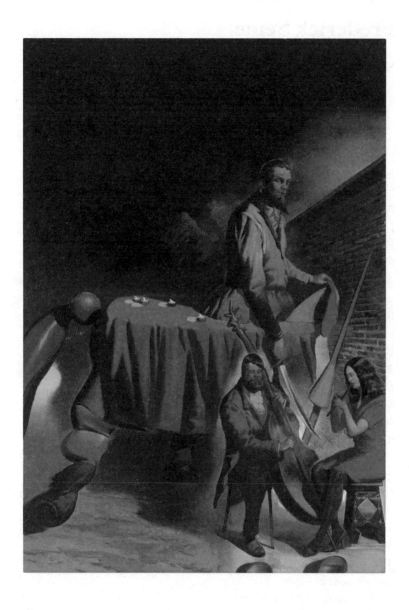

Frederick Seidel

SO WHAT

I like my coffee sweet so what,
Four sugars to the cup.
I like tea sandwiches at Claridge's,
A plate of perfect with the crust trimmed off.
I like to look out on Brook Street
From rooms on the Brook Street side.
From there I walk to my nearby tailor
And my nearby shotgun maker.

Face the truth.
Poetry doesn't matter in the least.
But, as to *Purdey* poetry, a fabulous new Purdey
28-Bore Over & Under
Shotgun shoots quail with delicate puffs of thunder
While singing always beautiful
Springtime Christmas carols
Through its beautiful London barrels.

There's nothing on earth as beautiful as a Purdey
Over & Under, or as urbane, or as insane,
Except Volodymyr Zelenskyy,
The incredible president of Ukraine.
Moonlight is falling straight down on Manhattan.
The streets tonight so what
Are smooth as satin.
I like to there and touch it here.

I'm standing on the landing
Of the splendid Claridge's staircase.
I'm standing on the landing.
I look down at the lobby.
The marble shines like syrup.
So what they whip the marble with a riding crop
To keep the lava from Vesuvius away from us
And keep Pompeii plush and posh.

What's happening is a tragedy
Non-stop on our smart TV.
We look at it for hours and see
Tragedy and see
Nothing is more useless than poetry.
Tell the rabbi, confess it to your priest.
Poetry doesn't matter in the least.
Mariupol, Bucha, Odesa – Putin's nightmare feast.

London is melodious.
Mount Street Gardens is across the street so what
From Audley House where Purdey's is,
But atrocities in Ukraine are not far away,
And World War III not so far away.
Birdsong is serious.
Poetry is meaningless.
Poetry is a disgrace on a warm spring day in March.

You look at the sky with unconditional love.
What are the odds?
You count the clouds.
A man with a big plastic bag
Is kidnapping pigeons

In bunches off the streets of Manhattan
To sell to gun clubs in the suburbs
Where they will be released and shot for sport.

Tolstoy and Turgenev target
Hospitals and schools and Jews.
Pushkin and Pasternak and Babel light the fuse.
Tsvetaeva and Akhmatova don't refuse.
Mandelstam lights up the sky
Above his gulag with unconditional love
For long-range missiles. Tchaikovsky and Death
Want to defeat Ukraine.

Someone is being pushed off
The 96th Street subway platform onto the tracks and
The oncoming train screams. So what.
The problem of homelessness in the subways –
Having nowhere to undress –
Infests the downtown No. 3 Express.
You lift a hundred-thousand-dollar Purdey Trigger Plate
Over & Under wonder to your shoulder and levitate.

The gun goes *pop pop* so what
And the birds drop and you can't stop!
Just like that time on Ragged Island, off the coast of Maine,
Where pranksters had wickedly released a white rabbit pair
That proceeded to multiply and eat the innocent island bare.
You grabbed your gun for some grim fun
And a million rabbits – not knowing they were white –
Hid stock-still in plain sight.

So what.

THE
BURLINGTON
MAGAZINE

30% off for new readers

Visit our website for more information

shop.burlington.org.uk

CONTRIBUTORS

Shida Bazyar's 'Model Country' is an extract from her debut novel *Nachts ist es leise in Teheran*. It has won several awards and been translated into Dutch, Farsi, French and Turkish. Her second novel, *Sisters in Arms,* won the Ernst Toller Award and was nominated for the German Book Prize.

Susan Bernofsky is the translator of seven works of fiction by the Swiss-German author Robert Walser, as well as novels and poetry by Yoko Tawada, Jenny Erpenbeck, Uljana Wolf, Franz Kafka, Hermann Hesse and others. She is a Guggenheim, Cullman and Berlin Prize fellow, and teaches literary translation at the Columbia University School of the Arts.

Martyn Crucefix is the author of six collections of poetry. His translation of Rilke's *Duino Elegies* was shortlisted for the 2007 Popescu Prize for European Poetry Translation, while *These Numbered Days*, translations of poems by Peter Huchel, won the 2020 Schlegel-Tieck Prize. His latest collection is *Between a Drowning Man.*

Elfriede Czurda is a poet, writer and translator living in Vienna. Her writing includes *Kerner: Ein Abenteuerroman, Die Giftmörderinnen, Die Schläferin, Untrüglicher Ortssinn* and *Dunkelziffer.*

Adrian Daub is a writer for various newspapers and magazines in the US, Germany and Switzerland. He teaches at Stanford University. His most recent books include *What Tech Calls Thinking* and *Cancel Culture Transfer.*

Katy Derbyshire is the translator of Olga Grjasnowa, Sandra Hoffmann and Selim Özdoğan (with Ayça Türkoğlu). Her 2017 translation of Clemens Meyer's *Bricks and Mortar* won the Straelen Translation Prize in Germany.

Emily Dische-Becker is a writer, organiser and curator, as well as a researcher for Forensis/Forensic Architecture, living in Berlin. She is on the steering committee of the Jerusalem Declaration on Antisemitism and the Germany director of Diaspora Alliance. She was an adviser for public programmes at Documenta fifteen and recently co-organised an international conference entitled 'Hijacking Memory: The Holocaust and the New Right' in Berlin.

Hanna Engelmeier is a writer, literary critic and researcher at Kulturwissenschaftliches Institut Essen. Her work has been published by *Süddeutsche Zeitung, Frankfurter Allgemeine Zeitung* and *Merkur*, among others. She is the author of *On Solace. Four Exercises.*

Ilyes Griyeb is a self-taught photographer living between Paris and Meknès. His work has been featured in *i-D, AnOther, Vanity Fair, M Le Monde* and *FT Weekend*. He is a co-founder of the collective NAAR.

Durs Grünbein is Professor for Poetics and Aesthetics at the Kunstakademie Düsseldorf. His next book in English, to be published later this year, is *Psyche Running: Selected Poems, 2005–2022*.

Jürgen Habermas is Emeritus Professor of Philosophy at the Johann Wolfgang Goethe University of Frankfurt. His two most recent books are *A New Structural Transformation of the Public Sphere and Deliberative Politics* and *Also a History of Philosophy, Volume 1: The Project of a Genealogy of Postmetaphysical Thinking*. The second volume of the latter work will be published in English in 2024.

Peter Handke was awarded the Nobel Prize in Literature in 2019. His books include *The Left-Handed Woman* and *A Sorrow Beyond Dreams*. His two novellas, *The Second Sword* and *My Day in the Other Land*, will appear in English translation in a single volume next year.

Elena Helfrecht is a German visual artist. Her work has been exhibited and featured internationally and is held in public and private collections.

Judith Hermann is a writer living in Berlin. Her books include *Sommerhaus, später, Nichts als Gespenster, Alice, Aller Liebe Anfang, Lettipark* and *Daheim*. She is the recipient of the Danish Blixen Prize for Short Stories, the Kleist Prize and the Friedrich Hölderlin Prize.

Michael Hofmann is a poet, translator and critic. His latest book of poems is *One Lark, One Horse*. He recently translated Jenny Erpenbeck's novel *Kairos*.

Fredric Jameson is Knut Schmidt-Nielsen Professor of Comparative Literature, Professor of Romance Studies and Director of the Institute for Critical Theory at Duke University. He is the author of more than thirty books, including *Postmodernism, or, The Cultural Logic of Late Capitalism*. He received the 2008 Holberg International Prize and the 2012 MLA Lifetime Achievement Award for his scholarship.

Alexander Kluge is a lawyer, author and filmmaker. His publications include *Napoleon Kommentar, Schramme am Himmel, Das Buch der Kommentare* and, most recently, *The Separatrix Project*, a volume written together with Katharina Grosse. In 2021 he received the Mortier Award at the Salzburg Festival.

Peter Kuras is a writer and translator living in Berlin. He has written about politics and culture for the *Economist*, the *Times Literary Supplement*, the *Guardian* and *Der Freitag*.

Karen Leeder is a writer, critic and the Schwarz-Taylor Chair of German Language and Literature at the University of Oxford. She has translated a number of German writers into English and won the Schlegel-Tieck Prize in 2021 for

her translation of Durs Grünbein's *Porcelain*. Her next Grünbein volume, *Psyche Running*, will appear in December 2023.

Ruth Martin is a translator from the German. She has translated authors including Joseph Roth, Hannah Arendt, Nino Haratischwili and Shida Bazyar. She has taught translation at the University of Kent and the Bristol Translates summer school, and is a former co-chair of the Translators Association.

Clemens Meyer is a writer living in Leipzig. His debut novel, *While We Were Dreaming*, was longlisted for the International Booker Prize in 2023. His other books include *All the Lights*, *Dark Satellites* and *Bricks and Mortar*.

Lauren Oyler's essays on books and culture appear regularly in the *New Yorker*, the *New York Times*, the *London Review of Books* and *Harper's*. Her first novel, *Fake Accounts*, was shortlisted for the Bollinger Everyman Wodehouse Prize for comic fiction. *No Judgement*, a collection of critical essays, will be published in 2024. She lives in Berlin.

Max Pensky is Professor of Philosophy at Binghamton University. His translations of Jürgen Habermas's political writings include the collections *The Past as Future*, *The Postnational Constellation* and *Time of Transitions*.

George Prochnik is the author of *I Dream with Open Eyes* and *The Impossible Exile*, which received the

National Jewish Book Award for Biography/Memoir in 2014. He has written for the *New York Times*, the *New Yorker*, the *Literary Review* and the *LA Review of Books*. He is editor-at-large for *Cabinet* magazine and was awarded a Guggenheim Fellowship in 2021.

Leif Randt is a freelance writer living in Maintal and Berlin. His novels include *Leuchtspielhaus* and *Planet Magnon*. 'Allegro Pastell' is an extract from his novel of the same title, which was nominated for the German Book Prize. He has co-curated the online platform Tegel Media since 2017.

Peter Richter is a writer and journalist living in Berlin. Previously an arts correspondent for *Süddeutsche Zeitung* in New York, he is the author of several books of fiction and non-fiction. His most recent novels include *August* and *89/90*, which was longlisted for the German Book Prize.

Martin Roemers is a Dutch artist and photographer. His books, exhibitions and projects include *Kabul, The Never-Ending War*, *The Eyes of War*, *Metropolis* and *Relics of the Cold War*. He is the recipient of two World Press Photo awards and received the Stipend for Established Artists of the Mondriaan Fund in 2021.

Ryan Ruby is the author of *The Zero and the One: A Novel*. For his essays and reviews, which have appeared in *Harper's*, the *New York Times* and *New Left Review*, he received the 2023

Robert B. Silvers Prize for Literary Criticism. He lives in Berlin.

Frederick Seidel's books include *The Cosmos Trilogy, Ooga-Booga, Poems 1959–2009, Nice Weather, Widening Income Inequality, Peaches Goes It Alone* and *Selected Poems.* His new collection, *So What,* will be published in June 2024.

Lutz Seiler is a poet, novelist and essayist living in Wilhelmshorst and Stockholm. Since 1997 he has been the literary director and custodian of the Peter Huchel Haus. His novel *Star 111*, his volume of non-fiction *In Case of Loss* and the poetry collection *Pitch & Glint* are now available in English. In 2023 he was awarded the Georg Büchner Prize.

Yoko Tawada lives in Berlin and is the author of several novels, poems, plays and essays in both Japanese and German. She is the author of the story collections *Where Europe Begins* and *Facing the Bridge,* as well as the novels *The Naked Eye, The Bridegroom Was a Dog, Memoirs of a Polar Bear* and *The Emissary. Celan and the Trans-Tibetan Angel* is forthcoming in 2024.

Rosmarie Waldrop is a poet and translator living in Providence, Rhode Island. She has translated French authors such as Edmond Jabès and Jacques Roubaud, and German writers including Friederike Mayröcker and Ulf Stolterfoht. Her latest book of poems is *The Nick of Time.*

Eyal Weizman is the founder and director of Forensic Architecture, general secretary of Forensis e.V., and professor of Spatial and Visual Cultures at Goldsmiths, University of London. His books include *Hollow Land, Investigative Aesthetics, The Roundabout Revolutions, The Conflict Shoreline* and *Forensic Architecture.*

Imogen West-Knights is a writer and journalist based in London. She writes regularly for the *Guardian*, the *Financial Times*, the *New York Times* and *Slate.* Her first novel, *Deep Down,* was published in March 2023.

Shaun Whiteside is a translator from the German, French, Italian and Dutch. Most recently his translation of *Aftermath* by Harald Jähner was shortlisted for the 2021 Baillie Gifford Prize and the 2022 British Academy Book Prize for Global Cultural Understanding.

Jan Wilm is a writer and translator based in Frankfurt. He is the author of *The Slow Philosophy of J.M. Coetzee,* the critical memoir *Ror.Wolf.Lesen.,* as well as short stories and essays. He has translated works by Maggie Nelson, Isabel Wilkerson, Frank B. Wilderson III and Adam Thirlwell, among others.

Nell Zink is the author of six novels, most recently *Avalon.* She has taught at the Vienna Poetry School and the University of Bern. She first visited Germany in 1983 and has lived there since 2000.

THE LONDON MAGAZINE

Est. 1732

Founded in 1732, *The London Magazine* is England's oldest literary periodical, having published original writing by the likes of Raymond Carver, T.S. Eliot, Ted Hughes, John Keats, Sylvia Plath, Jean Rhys, Evelyn Waugh, H. G. Wells and William Wordsworth. Today, we pride ourselves on publishing the best new voices in literature, ranging from poetry and essays, short stories and reviews.

Subscribe to *The London Magazine* for only £30 a year. Scan the QR code or visit our website and enter code: **grantareader.**